Amy Twigger Holroyd is a designer, ¹
Through her knitwear label, Keep & Sha:
emerging field of fashion and sustainabil
been sold and exhibited worldwide and featured in many books and
publications, from *Vogue* to *Fashion Theory*. She is a senior lecturer in
Design, Culture and Context at Nottingham Trent University.

'A fashion *tour de force*. It is clothing where we the people, our ideas and our fingers – nimble or otherwise – matter.'

Kate Fletcher, Professor of Sustainability, Design, Fashion at University of the Arts London, author of *Craft of Use*

'*Folk Fashion* takes an in-depth look at the implications of the handmade clothing movement. It's a must-read for anyone interested in how the act of making affects our world.'

Sarai Mitnick, founder of *Colette Patterns* and *Seamwork* Magazine

'This book is an inspiring reminder of the wealth that making brings into our lives. From evoking the spirits of the craftspeople that came before us to creating more meaningful relationships with both the materials and our community as we go, Twigger Holroyd deftly shares what a force folk fashion can be.'

Betsy Greer, author of *Craftivism: The Art of Craft and Activism*

FOLK FASHION

Understanding Homemade Clothes

Amy Twigger Holroyd

BLOOMSBURY VISUAL ARTS
LONDON · NEW YORK · OXFORD · NEW DELHI · SYDNEY

BLOOMSBURY VISUAL ARTS
Bloomsbury Publishing Plc
50 Bedford Square, London, WC1B 3DP, UK
1385 Broadway, New York, NY 10018, USA

BLOOMSBURY, BLOOMSBURY VISUAL ARTS and the Diana logo
are trademarks of Bloomsbury Publishing Plc

First published in Great Britain by I.B. Tauris 2017
This edition published by Bloomsbury Visual Arts 2019
Reprinted 2019

ISBN: PB: 978-1-3501-5949-5

Typeset by JCS Publishing Services Ltd, jcs-publishing.co.uk
Printed and bound in Great Britain

To find out more about our authors and books visit
www.bloomsbury.com and sign up for our newsletters.

For Caspian

Contents

Illustrations

| ILLUSTRATIONS |

| ILLUSTRATIONS |

Acknowledgements

I am immensely grateful to the knitters – Alex, Anne, Catherine, Julia, Kiki and Margaret – who took part in my PhD research project with such enthusiasm and generosity. Likewise, I sincerely thank the interviewees – Carol, Christine, Laura, Rachael, Rosie and Tom – for sharing their experiences and insights with me so openly. Many thanks, too, to the great bunch of people who have helped to run the Keep & Share knitting tent over the years, and the hundreds of people who have contributed to the communal projects hosted there: the countless conversations, as well as written comments, have contributed immeasurably to my understandings of homemade clothes. In a similar vein, I thank all those makers whose blogs, tweets, updates and images I have had such fun browsing, and everyone who has chatted to me about making, at workshops, projects and fairs. All of these encounters, however brief, have fed into my thinking. Thanks also to all those – far too many to list – who have supported my practice over the years. Special mention must go to Marissa Harmon for her fantastic assistance in running the knitting workshops.

I am grateful to Birmingham Institute of Art and Design (BIAD), a faculty of Birmingham City University, for funding my doctoral research; I thank my BIAD supervisors, Professor Colin Gale and Dr Anne Boultwood, for their invaluable guidance. Thank you to Professor Kate Fletcher and Professor Rebecca Earley for their inspirational leadership in the exploration of fashion, textiles and sustainability. I am grateful to my former colleagues at the University of Leeds and the Design Routes project, and particularly Professor Tom Cassidy, for their support. I thank Professor David Gauntlett for his encouragement and advice in the development of this book, and for many illuminating conversations about making. Many thanks to Deb Twigger for her

tireless proofreading – and for teaching me to sew all those years ago. Thanks also to Daz Twigger, Simon Holroyd and Rachael Matthews for taking the time to read the whole manuscript and offering such thoughtful feedback. I am grateful to my editor, Philippa Brewster, for her support and wise suggestions; likewise, I thank the anonymous peer reviewer for the expert insights which helped me to tighten up the text. Many thanks, too, to all those who kindly provided me with images for the book.

Huge thanks are due to Simon for helping me to develop my ideas through endless discussion, and for always making the tea. And finally, loving gratitude to Cass: thank you for not minding your mother combining cuddling with typing in your first few months of life, and for bringing me joy every day.

The Hereford Knitters

Alex is a retired chartered accountant. She is always busy, involved with two local walking groups and the local theatre. She enjoys gardening and knits a great deal, describing herself as 'obsessive about it'.

At the time of the reknitting project, **Anne** worked full time as a social worker. She spends a lot of her spare time visiting friends and family in different parts of the country and recently returned to knitting.

Catherine spends much of her time caring for her disabled son. Before she had children she was first an artist and then an academic researcher. Although she has little time to herself, she has recently started making again.

Julia is retired and enjoys handicrafts, gardening, reading and music. She attends a weekly craft group, where she has learned new skills; she nearly always has more than one project on the go.

Kiki works two days a week and enjoys gardening, walking, reading, playing the guitar, cooking, socialising and holidays in her camper van. She describes her knitting career as 'a bit discouraging'.

Margaret works part-time, doing accounts for small businesses. She and her partner own a wood, grow vegetables and keep sheep. For her, knitting is a 'lifelong interest and passion'.

The Interviewees

Carol studied fashion and textiles when she was younger and returned to sewing a few years ago. She particularly enjoys working with vintage fabrics and patterns and is usually wearing something homemade.

Christine Cyr Clisset is a New York-based journalist and sewing blogger who runs the Thread Cult podcast, a series of fascinating interviews with textile creatives; she has also edited two best-selling crafts books (see daughterfish.com and threadcult.com).

Laura Blackwell is a textile designer who loves to make her own clothes, sharing her projects on her blog and via Instagram. She has recently started teaching dressmaking classes at a fabric shop in West Yorkshire (see kathyimlost.co.uk).

Rachael Matthews is an artist and owner of Prick Your Finger, a wool shop, school and gallery. She co-founded the Cast Off Knitting Club for Girls and Boys in 2000 and has authored three knit and crochet books (see prickyourfinger.com).

Rosie Martin is the director of creative fashion label, DIYcouture. She produces accessible visual sewing instructions for easily adaptable contemporary garments and runs clothes-making workshops in London (see diy-couture.co.uk).

Tom van Deijnen – better known in the craft world as Tomofholland – seeks to highlight the contemporary relevance of clothes repair through his Visible Mending Programme as well as being a dedicated hand knitter (see tomofholland.com).

Throughout the book I share the experiences of other makers via excerpts from their blogs. Links to these blogs can be found in the notes for each chapter.

1

Introducing Folk Fashion

What is folk fashion? Perhaps the words conjure up a mental image of a 'peasant' blouse, richly stitched with hand embroidery, or perhaps they suggest a discussion of the great variety of regional textile traditions found across the world. But no: when I say 'folk fashion', I am not referring to specific styles of clothing, nor to established traditions of making. Rather, I mean the making and mending of garments for ourselves, family and friends; the items these activities produce; and the wearing of those clothes once they are made. I use folk fashion as a catch-all term: an umbrella concept that encompasses everyone involved in making their own clothes, and everything they make. Thus, folk fashion garments can be of any type whatsoever, with no fixed aesthetic.

The most important characteristic of folk fashion is that it is not practised professionally, although there are plenty of professionals aiming to support this activity through workshops, instructions and patterns. While folk fashion is produced by amateurs, it does not indicate a particular level of skill. Many people who knit and sew for themselves turn out beautifully finished items, and these pieces are just as much included under my folk fashion banner as somewhat cruder garments, which we might more commonly associate with the word 'homemade'. While in the past many people would have had to make and mend their own clothes out of necessity, today folk fashion is, in the main, taken up as a pleasurable activity and a valued outlet for creativity.

I am stepping into dangerous territory by using the word 'folk'. Whether applied to music, art or craft, the term is highly contested and carries a great deal of cultural baggage. For me, folk implies a participatory and inclusive contemporary culture, open to anyone who wants to get involved. My interpretation stands in contrast to

the dominant historical understanding – used by, amongst others, the Brothers Grimm – of 'the folk' as 'the lower stratum of society, the so-called *vulgus in populo*, the illiterate in a literate society, rural people as opposed to urban people'.[1] As if this patronising definition were not bad enough, the traditions, dress and music of these people have frequently been manipulated by elites and instrumentalised in the interests of nationalism. Writing about the history of folk music, Stefan Szczelkun argues that influential English song collector Cecil Sharp 'took a romanticised, cleaned up, censored and edited version of a past rural culture and represented it as the ideal for a national song and dance'.[2] Similar processes have taken place in terms of dress. Historian Lou Taylor describes how Eastern European countries such as Poland and Romania established state structures to exploit local textile traditions as a vehicle for patriotic propaganda in the postwar era.[3]

Yet folk is a mutable term, and alternative meanings are in circulation. In 2005, Folk Archive, an exhibition curated by artists Jeremy Deller and Alan Kane, opened at London's Barbican Art Gallery. The selected works – including diverse cultural forms, from decorated cakes to hobby horses – represented the artists' view of what constitutes contemporary folk art. As they explained, they define folk art as 'the vast range of energetic and engaging local creativity from outside prescribed art arenas'.[4] Deller has even suggested that YouTube videos are a new form of folk art.[5] For Deller and Kane, 'the folk' are not some peasant underclass, but rather, simply, people. This understanding resonates strongly with my concept of folk fashion: in both cases, we are concerned with cultural production by non-professionals, creating work for their own enjoyment and self-expression. While my initial motivation for coming up with the concept of folk fashion was pragmatic – I needed a concise term that could refer to homemade garments as well as the acts of making, mending and wearing them – I am pleased to be able to align myself with Deller and Kane, and their valuing of 'everyday' creativity.

And what of 'fashion'? While not as inflammatory as folk, this term has a similarly nebulous definition. There are many different interpretations of this ubiquitous word, and fashions can be recognised in many areas – from tangible things such as cars and houses to immaterial

things such as music and philosophy. In its broadest sense, the term refers to cultural forms which are invented, accepted and discarded. I am interested in fashion in the sphere of clothing and dress, so the description offered by sociologist Joanne Entwistle is helpful: 'a system of dress characterized by an internal logic of regular and systematic change'.[6] Some people argue that not all clothing in the contemporary context should be described as fashion. Theorist Ingrid Loschek, for example, suggests that clothing becomes fashion only when it is adopted and identified as such by a large proportion of a community.[7] From this perspective, many homemade clothes would not be considered to be fashion. But Entwistle points out that the fashion system – this ever-changing system of dress – is so influential that 'even dress which is labelled "old-fashioned" and dress which is consciously oppositional is meaningful only because of its relationship to the dominant aesthetic propagated by fashion'.[8] Essentially, all clothing decisions are framed by the fashion system, and so – like it or not – we are all engaged in it. Thus, as eminent fashion theorist Elizabeth Wilson argues, 'in modern western societies no clothes are outside fashion; fashion sets the terms of all sartorial behaviour'.[9] Wilson's inclusive understanding makes sense to me. Rather than setting up a binary categorisation of clothes versus fashion, it recognises that all clothes, whatever their style and whatever the intentions of their wearer, are connected to the fashion system. On a similar note, sustainable fashion expert Kate Fletcher proposes that practices of garment use – mending, for example – 'are a fundamental part of the fashion process. Users may be far away from fashion capitals. What we wear may be old hat. But it is part of the fashion whole all the same.'[10]

Some people making their own clothes will be motivated by the desire to fit in with current fashions and others to rebel against them; a third group will be largely unconcerned with what is deemed to be fashionable at a given moment, instead pursuing a personal vision for the garments they aim to create. All of these makers, and all of these homemade clothes, fall within the scope of folk fashion. Likewise, a home dressmaker making a type of garment that would usually be mass-produced – such as a sweatshirt or a pair of jeans – is as much a folk

fashion maker as a knitter producing an item that clearly corresponds with an established local craft tradition, such as a Fair Isle jumper.

Starting the Quest

Folk fashion is close to my heart: I have been involved in this world, in one way or another, my whole life. My mum made a lot of clothes for my siblings and me when we were little. I picked up a taste for sewing from her – along with a passion for knitting from my grandmother – and started to make my own clothes when I was a teenager. I enjoyed this process so much that I went on to study fashion and textiles and set up my own knitwear label, Keep & Share, in 2004. Craft has always been integral to the philosophy of Keep & Share; my pieces are made using craft techniques in my studio by me or – in the past, when I was producing on a bigger scale – one of my in-house machine knitters. After a few years of running the label, I became interested in supporting other people's making, extending my activities to run hand- and machine-knitting workshops and participatory projects in a range of settings.[11] These experiences brought me into contact with scores of amateur makers: people who, as I still did myself, spent time and effort sewing and knitting garments for themselves or their family and friends to wear. As we knitted together, the stories came spilling out: the successes and disasters, the never-finished projects, the tricky finishing tasks that never turn out *quite* right. Happily, I met plenty of people who find making their own clothes to be an empowering, positive experience. Yet for many makers, folk fashion is riddled with ambivalences and idiosyncrasies. Despite my professional training, I had suffered my own share of disappointments. By talking to others I realised that this was not unusual, and in 2010 I embarked on a PhD to study this topic in much more detail.

As part of my research, I hunted for previous academic writing about making and wearing homemade clothes, and was puzzled to find very little. A growing number of researchers are examining the process of making – I will draw on some of this excellent work later

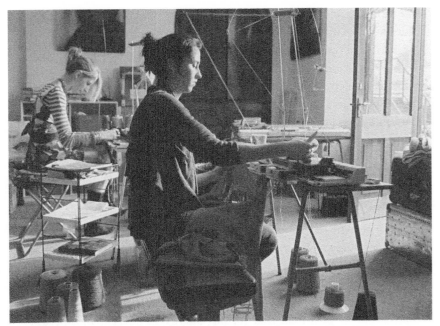

1. Machine knitting in the Keep & Share studio.

in the book – yet I came across very few books or articles discussing how it feels to wear something you have made yourself. I did discover some fascinating tales of homemade clothes in the past,[12] but found contemporary accounts to be incredibly scarce. This is particularly odd in the light of the striking resurgence of sewing and knitting in recent years. An abundance of published material instructs us in what to make, and how, but there is a strange absence of makers reflecting on their experiences.

This book is the story of my quest to understand folk fashion. On this journey I have gathered many stories of making and wearing homemade clothes, and used theories of fashion, craft and culture to make sense of them. Because the imperative of sustainability has shaped my work for over a decade, I am driven to explore the ways in which folk fashion can contribute to a more satisfying, equitable and environmentally responsible fashion system. While I am fascinated by

the vibrancy and complexity of what is happening now, I cannot help but look beyond the present. As a designer and maker I have a strong urge to build upon my understanding of a situation to make an impact: to initiate change. Therefore, I am aiming to analyse a set of creative practices which are often overlooked or even belittled, and to propose a vision of how sewers, knitters and menders – myself included – might recalibrate our practices to maximise the radical potential of our actions.

Although I have gathered most of my research from within the UK, contributions from makers and writers from North America and Continental Europe demonstrate that the experience of folk fashion transcends national boundaries. This is particularly the case now that knitting and sewing enthusiasts are able to connect so effectively online with others who share their passions. Yet it is important to note that I am not attempting a global study: many countries, regions and communities with long-standing cultures of domestic fashion making fall outside my scope. These contexts are fascinating, of course, but I would need much more room, and research, to do them justice. Essentially, I am looking at folk fashion in 'post-industrial' regions such as the UK, North America, Australia and Western Europe, which have major problems in terms of overconsumption, and in communities where shop-bought clothes dominate, meaning that making your own clothes is an optional – and relatively unusual – activity.

With all this in mind, in the coming chapters I will be focusing on contemporary practice in the world of amateur fashion making, exploring both mainstream and emerging practices. Along with stories of those who are sewing and knitting clothes from commercial patterns, I will describe people who are 'hacking' these patterns, and makers designing for themselves. I will investigate the contemporary mending community and share an in-depth project I carried out as part of my research, developing ways of reworking existing garments using knitting techniques, skills and knowledge. I will consider what happens if ideas of creativity and making are applied to the wardrobe as a whole, rather than individual items. And I will be looking forward, aiming to understand not only what is happening now, but also ways that folk fashion might flourish and evolve in the future.

Making Conversations

In writing this book, I have drawn on my experiences of making my own clothes, and of supporting others to do the same. There is something about knitting, in particular, that seems to invite people to tell stories: of making their own clothes, of wearing things made by others, of people in their lives who knit. My making-related encounters with others inspired the research that grew into this book, and some of these secondhand anecdotes, plus occasional stories of my own making, appear in the following chapters. Still, I did not want the book to revolve around my personal experiences; I was keen to explore a diversity of perspectives and to share the stories of others, in their own words. Therefore, I set out to talk to a diverse range of people who sew, knit and mend their own clothes – and those who support them by teaching techniques, selling supplies, designing patterns and so on. Despite the varied skills, habits and tastes of these people, when I analysed and reflected on the conversations, I found that common themes emerged. These themes informed the development of my thinking about folk fashion, and in turn the content and structure of the book.

The first makers that I talked to were the six women who took part in my PhD research project in 2012–13. Because my research was focused on knitting, I had appealed for amateur knitters to take part, and these women – aged between 43 and 66 at the start of the project – kindly volunteered. The first stage of the research involved individual interviews, where I asked each woman about her experiences of fashion and knitting. We then started to meet as a group at my knitwear studio near Hereford, a small cathedral city in the Midlands of England. At the early sessions we knitted together and discussed a number of questions about making and wearing homemade clothes. We then moved on to four full-day workshops, roughly a month apart, where we tested the reknitting techniques I had developed. The project culminated in each of the knitters reworking a knitted item from her own wardrobe.

In academic research terms, the core of this strategy was the activity of making together, and capturing the rich conversation that spontaneously emerged from this process.[13] By working in this way, I

was able to gather incredibly rich qualitative research data. The group not only talked about the tasks in hand but also contextualised the new experiences they were having, relating them to memories from the past and hopes for the future. By working together with them over an extended period, I was able to capture the knitters' feelings at each stage of the project, from the anticipation of a new challenge, through the messy business of designing and making, to their reflections on the finished items and the experience as a whole. The valuable insights that I gained from my work with the Hereford knitting group (sometimes referred to as the 'Hereford knitters') run throughout the book – from the conversations about fashion, clothes and making that feature in Chapters 2, 3, 4 and 7, to their experiences of reknitting and designing, described in Chapters 5 and 6.

The project with the Hereford knitting group provided a fantastic foundation for my research. The demographic of the group, though, was relatively narrow: all women, in their forties, fifties and sixties, living in the same area. In order to diversify the range of perspectives feeding into my doctoral project, I needed to gather more stories and realised that my Keep & Share activities presented an ideal opportunity. Since 2009, I had run a free, drop-in communal knitting project from the 'knitting tent' which I took to several UK music festivals each summer. People could stop by and knit for as long as they liked, and all of their contributions added to a collaboratively produced web of knitting which gradually grew as the festival progressed. I was helped by a wonderful team of volunteer teachers, which meant that anyone could take part – from absolute beginners to experienced knitters. In recognition of the stories that flow when people pick up a pair of needles, I invited people to share their knitting-related memories on small cardboard tags and attach them to the knitting. Seeing the variety and richness of the comments I was gathering, in 2012 I suggested that people share their feelings about wearing homemade clothes; this prompted many responses which fed directly into my research, and this book. Although the tags are small, and therefore can carry only concise messages, they often mirror – and neatly encapsulate – issues and attitudes that emerged through much more extended discussions with other makers.

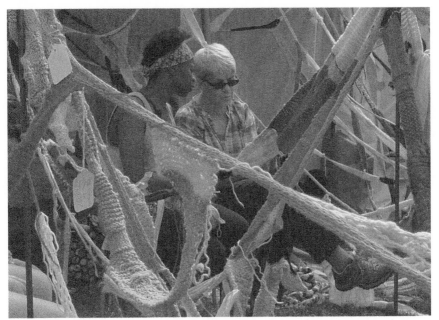

2. Communal knitting – and comments on tags – at the Keep & Share knitting tent.

When I came to write this book, I seized the opportunity to broaden my net once again. I carried out another round of interviews with a more diverse range of folk fashion makers, including people who support other makers through teaching, designing and selling. Because many makers take the time to record and reflect on their experiences in their blogs, I was able to gather further relevant firsthand insights from a range of online sources. These additional contributions extended my scope to include sewers and menders, as well as knitters; men, as well as women (although participation in folk fashion is predominantly female); and people representing a wider age range, and geographical spread, than the knitters who took part in my original research project. They challenged and extended my thinking, helping me to build a more well-rounded account of contemporary folk fashion culture.

Drawing on Theory

The central aim of this book is to explore and understand our experiences of making and wearing homemade clothes. While the discussion is built around the accounts of the people I talked to, I have drawn on theoretical academic writing to help me make sense of their comments. This writing emerges from several different areas; perhaps the most important of these is fashion theory. Two key concepts from fashion theory are particularly useful for understanding fashion experiences from the wearer's perspective. The first of these concepts is identity construction: the idea that in contemporary society we are each engaged in an ongoing process of constructing who we are, and use clothing as a means of 'surfacing' particular aspects of this identity. This process relies on the meanings associated with our clothes, which are both multiple (garments may be 'read' differently by different people, and in different contexts) and mobile (liable to change over time). I will be thinking in detail about the meanings that are associated with homemade clothes, in the past and today, and the implications of these meanings for anyone who chooses to construct their identity through folk fashion. I will also be considering how the tasks of sorting, managing and discarding clothes within the wardrobe are both important processes in terms of identity, and potent opportunities for creativity.

The second key concept relates to the ability of fashion to connect us with others, an important social function. This connection is shaped by identification and differentiation, the forces which drive us to fit in and belong while maintaining a sense of individuality and uniqueness. When dressing, we think about the people we will see that day – or rather, those who will see us – and our self-image is largely informed by the ways in which we imagine these others will perceive our appearance. Therefore, our decisions about fashion are affected by those around us, connecting us together in a tangle of perceptions and expectations. Once again, the meanings associated with homemade clothes affect these processes and, consequently, the way we feel about wearing things we have made ourselves.

Another useful body of academic work is craft theory, which explores the various motivations, benefits and challenges relating to the making process. Unfortunately, there is not a great deal of academic literature discussing amateur craft, and even less specifically focusing on folk fashion. Nevertheless, benefits tend to be common across different types of making, and so I have enjoyed gleaning insights drawn from a diverse range of creative activities – from the vibrant 'maker movement', which is primarily associated with new technologies such as 3-D printing, to architecture. Although I am looking at the experiences of amateur makers, studies of the practices of professional craftspeople are of some use, particularly for understanding the intimate conversation which develops between maker and material as a new piece is brought into being.

Some of the academic writing which has fed into this book comes from outside the spheres of fashion and craft, such as work relating to one of the central themes: openness. Openness is big news right now: the application of this idea within an increasing number of spheres – such as open-source software, open science, open manufacturing and open gaming – has been described as a 'megatrend'.[14] In each of these areas, hierarchical relationships and centralised authority are broken down, and the division between professional experts and amateur users is eroded. Overall, the role of the user is fundamentally shifted from passive observer to active contributor; thus, this idea is particularly relevant to folk fashion. Many link the growth of open culture to the rise of the internet, and especially web 2.0 technologies, which offer the opportunity for people to create, collaborate and share. David Gauntlett, an academic and writer who is especially interested in 'everyday' making, summarises this as a shift from a 'sit back and be told' culture (typified by broadcast television) towards more of a 'making and doing' culture (typified by YouTube and Wikipedia).[15]

In order to explore the idea of openness in fashion, I have developed a rather unconventional metaphor. I choose to see fashion as a commons and, more specifically, common land: a valuable resource, shared by a community. Within this resource, I see all of the garments in existence – new, old, fashionable and unfashionable. On a more conceptual

level, I see every way of dressing throughout history. Fashion depends on this broad, varied, vibrant resource; new fashions involve existing styles being revisited, recombined and recontextualised. I believe that it is important for us to have an open and accessible fashion commons in order to construct our identities and connect with others most effectively. However, I am concerned that mass production and industrialisation have 'enclosed' this commons, restricting access to styles and knowledge and limiting our ability to act independently. I will explore whether individual acts of making – which are, as I have explained, inherently linked with open culture – contribute to openness on a bigger scale. Could folk fashion open up the fashion commons to tip the balance of power towards wearers and makers, and away from manufacturers and retailers?

Elsewhere in the book I will connect with other types, and levels, of openness. I will discuss the concept of reknitting and learn about the emotions involved in opening, and altering, 'closed' items of clothing. I will also consider how folk fashion opens up opportunities for design which are not usually accessible to non-professionals, and observe how people without formal design training respond to these opportunities.

Fashion and Sustainability

An important thread running through this book is the complex, fascinating and important relationship between folk fashion and sustainability. Ideas about slow and sustainable fashion have been at the heart of my own design philosophy since I launched my label well over a decade ago. A desire to live more sustainably is also a key motivation for many folk fashion makers. They see making their own clothes as a way of bypassing the environmental and social problems associated with mass-produced garments, and of reducing their own fashion consumption. I am convinced that amateur making does have genuine benefits in terms of sustainability. Yet many people – particularly non-makers – make a rather lazy assumption that amateur making is an inherently sustainable mode of fashion participation.

This is over-simplistic: my experience tells me that the situation is rather more complicated.

The scale of the clothing industry is staggering. In 2000, sales of clothing totalled over $1 trillion worldwide, with the industry employing 26.5 million people.[16] The environmental and social problems associated with this industry are significant and well documented, with negative impacts occurring in all phases of a garment's lifecycle.[17] Fibre and clothing production, transport and (in particular) domestic washing and drying of clothing all consume huge amounts of energy. Problems arise from the use of toxic chemicals in manufacturing, and from the vast amounts of water used in cotton production. Meanwhile, textile and clothing workers are subject to abysmal working conditions. A report on conditions for workers producing clothes for the UK high street in the Indian city of Gurgaon, for example, describes 'systematic exploitation, violence and repression, long and stressful working hours, casual employment relationships, and exclusion from the social rights, protection and benefits they should be entitled to'.[18] While it can be argued that clothing production brings valuable work to developing countries, low wages and a lack of training mean that workers are often still trapped in poverty.[19] The majority of discarded clothes end up in landfill; much of the remainder is shipped overseas for re-use, where it erodes local textile industries and traditions.[20]

The problems associated with clothing production have been exacerbated by the advent of 'fast fashion'. This phenomenon has brought falling prices – between 2005 and 2009, for example, average prices of women's outerwear fell by 22 per cent – and massive increases in the number of garments sold.[21] Between 2001 and 2005, sales by volume of women's clothing in the UK increased by 37 per cent,[22] and between 2006 and 2014 sales by volume of all clothing rose by 30 per cent.[23] According to Euromonitor, over 2 billion clothing items were sold in the UK in 2014;[24] in her book *Overdressed*, Elizabeth Cline states that nearly 20 billion garments are sold every year in the USA.[25]

When discussing the problems associated with the fashion industry, some people optimistically point to initiatives which reduce environmental and social impacts, hoping that such improvements

will allow the industry to maintain the incredibly high turnover of clothing it produces today. Yet, as economist Tim Jackson points out, the benefits of making products 'greener' will be lost if the scale of material throughput remains so far beyond the carrying capacity of the Earth.[26] To give a simple example: if a manufacturer decreases resource use and pollution by a fifth but sells twice as many garments as before, their negative impacts will still have increased significantly – rendering the whole exercise distressingly futile. Thus, it is our levels of consumption, which are many times those of less economically developed countries and far beyond natural limits, that must be addressed. Rather than incremental initiatives that tweak at the corners of an inherently unsustainable system, we need radical strategies that will dramatically reduce the volume of garments produced and rapidly discarded. These strategies are difficult to countenance in today's growth-dependent economic system. Thus, as Kate Fletcher argues in her book *Craft of Use: Post-Growth Fashion*, we need a paradigm shift in terms of both the fashion system and our understanding of prosperity more broadly.[27]

Although I am highlighting the fundamental need to address over-consumption in industrialised countries, it is important to avoid falling into the rather seductive trap of seeing any and all consumption as straightforwardly negative. After all, as Tim Jackson observes, material goods have been used symbolically in all known societies, throughout history.[28] Objects play an essential and unique role in culture; Grant McCracken argues that they 'contribute [...] to the construction of the culturally constituted world precisely because they are a vital, visible record of cultural meaning that is otherwise intangible'.[29] Many environmental arguments about consumerism conflate consumer society and material culture. This is unhelpful, as anthropologist Daniel Miller points out:

> whatever our environmental fears or concerns over materialism, we will not be helped by [...] an attitude to stuff, that simply tries to oppose ourselves to it; as though the more we think of ourselves as alien, we keep ourselves sacrosanct and pure.[30]

This might seem confusing: we need to reduce the amount we consume, yet we should not see material objects in a negative light because of the important role they play in our lives. Sustainable consumption expert Lucia Reisch resolves this apparent contradiction: she distinguishes between material satisfaction, which relates to the acquisition of objects or materials, and non-material satisfaction, which relates to use.[31] The idea of non-material satisfaction suggests that rather than attempting to eliminate objects from our lives, we need to learn to use them in a different way. This is not a rejection of 'stuff', but a change in our relationship with it: from ownership to use, and from 'having' to 'being'. These ideas are helpfully described in a six-point 'Manifesto for the New Materialism', which starts with the positive statement that 'liking "stuff" is okay, healthy even' before encouraging us to develop lasting relationships with our possessions, to mend and to share.[32] In the fashion sphere, many designers and activists are working to address these issues. They aim to develop a satisfying and appealing version of fashion which is not dependent on a rapid turnover of clothing items, but rather uses – as Kate Fletcher and Lynda Grose put it – 'material and non-material satisfiers to help us engage, connect and better understand about each other, our world and ourselves'.[33]

Sustainability and Well-Being

Having thought about the environmental and social impacts of the fashion system and briefly considered the complexities of consumption, I would like to step back to explore the concept of sustainability itself in more detail. The term is used a lot nowadays, yet people are often confused about what it means. This is unsurprising, given that it is an abstract concept with multiple competing definitions. The broad notion of sustainability was developed in the 1970s in response to the great challenges facing the Earth and its inhabitants: climate change, population growth, poverty, inequality, biodiversity loss and the depletion of natural resources. The most frequently cited definition of sustainability relates to sustainable development: 'development that

meets the needs of the present without compromising the ability of future generations to meet their own needs'.[34] Beyond this description, much discussion about sustainability revolves around the integration of environment, society and economy. These widespread understandings of sustainability have been criticised, however, for their shortsightedness and lack of vision. John Ehrenfeld, for example, describes sustainable development as 'simply an extrapolation of the past', which can only lessen the effects of unsustainable behaviour without changing inherently unsustainable systems.[35] This is an incredibly important point: if our working understanding of sustainability is simply based on making our systems and lifestyles 'less bad' – as demonstrated by the incremental initiatives favoured by the fashion industry – we are unlikely to achieve the fundamental changes which are evidently necessary. Instead, Ehrenfeld offers an aspirational definition of sustainability: 'the possibility that humans and other life will flourish on the Earth forever'.[36] This positive definition appeals to me immensely; in its simplicity, it invites us to consider alternatives to the systems which structure the world today. Therefore, it is this approach to sustainability that will be framing my thinking within this book.

When we start to think about sustainability as flourishing, a new element enters the picture, alongside the familiar environmental and social factors and concerns about overconsumption: individual well-being. A focus on the individual within sustainability thinking may seem surprising, given that individualism and selfishness arguably underlie many of the global problems that we face today. Even so, many people propose that well-being and sustainability are inherently linked. Tim Jackson, for example, suggests that our current economic system has both created many environmental and social problems and violated our individual well-being. As he points out, this means we are losing twice over:

> That environmental damage should turn out to be the environmental price we have to pay for achieving human well-being would be unfortunate. That environmental damage is an external cost of a misguided and unsuccessful attempt to achieve human well-being is tragic.[37]

On a more positive note, Jackson points out that if this negative relationship is inverted, the opportunity for a 'double dividend' arises. Similarly, design researchers Carolina Escobar-Tello and Tracy Bhamra observe that 'the characteristics of sustainability overlap with the triggers of happiness'.[38] From this perspective, well-being and sustainability can be seen as two interconnected elements of human flourishing, and well-being can be used as a way of approaching and exploring sustainability.

There are many different perspectives on well-being; it is another contested (and politicised) area. Some use 'happiness', 'well-being' and 'satisfaction with life' interchangeably. Others argue that well-being encompasses more than happiness and life satisfaction, involving the actualisation of human potentials and a 'quest for contentment'.[39] The New Economics Foundation proposes that to enjoy positive well-being people need a sense of individual vitality; to undertake activities which are meaningful, engaging, and make them feel competent and autonomous; a stock of inner resources to cope and be resilient; and a sense of relatedness to other people through supportive relationships and a sense of connection with others.[40] Focusing on flourishing in terms of psychological well-being, Carol Ryff and Corey Lee Keyes have developed a list of six aspects of human potential: autonomy, personal growth, self-acceptance, life purpose, mastery and positive relatedness.[41] An alternative approach is proposed by the development economist Manfred Max-Neef. He offers a list of basic needs which he believes constitute well-being: subsistence, protection, affection, understanding, participation, leisure, creation, identity and freedom. He defines these needs as 'essential attributes related to human evolution' which are interrelated, interactive and non-hierarchical.[42] Max-Neef's work is particularly useful for the dynamic way in which it relates satisfiers to needs; he explains that the means of satisfying needs vary widely across cultures and historical periods. Different satisfiers may be more or less successful, fulfilling needs to different levels of intensity.

Many people working with concepts of well-being are concerned with policy; they are tasked with supporting well-being within communities, and must develop strategies for doing so. Thus, much discussion relates to the challenge of measurement: assessing the subjective experience

of well-being in a coherent and consistent way. Fortunately, my task is more straightforward. In this book, I am not trying to quantify the well-being of folk fashion makers, nor to compare folk fashion practices with other activities. Rather, I want to gain a qualitative understanding of the ways in which folk fashion practices might contribute to, or hinder, individual flourishing. To do so, I am taking a strategically broad view of well-being, incorporating all of those characteristics described above. This enables me to consider other people's opinions, expressed from diverse viewpoints. It also allows me to consider the emotions associated with the immediate act of making alongside the deeper satisfactions that come into view when considering folk fashion practices from a more holistic perspective.

Folk Fashion = Sustainable?

Does folk fashion make a positive contribution to sustainability? I would like briefly to examine the arguments that support this view. When considering this question, it is important to note that sustainability benefits could emerge from folk fashion practices even in cases where makers are not primarily motivated by environmental or social issues and have never thought about their activities in such terms. For this reason, I am thinking of folk fashion as being 'incidentally sustainable': that is, not necessarily directly connected to sustainability initiatives, but with many potentially positive attributes in that regard.

One of the most straightforward claims for folk fashion being a sustainable practice is that making clothes at home minimises the social and environmental impacts associated with globalised industrial garment manufacture. Another is that mending enables us to extend the lifetimes of our clothes. A further argument is that the slowness of making offers benefits in terms of sustainability because it slows consumption and also builds emotional attachment, which prompts us to keep wearing our homemade items over an extended period. For Rosie Martin, who facilitates amateur fashion making through her company DIYcouture, this slowness is an important goal. She explains: 'DIYcouture hopes

3. Bringing new life through darning.

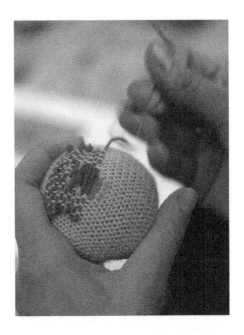

in a small way to slow down the process of consumption, helping people to produce long-lasting garments that are precious, rather than disposable.'[43] The intrinsic rewards associated with making and remaking present an important – though less immediately apparent – argument; they contribute to well-being, which I consider to be an important element of, and route to, sustainability more broadly.

A further way in which making can be said to contribute to a paradigm of sustainability is by prompting critical thinking about the material world, which can lead to a change in behaviour. Philosopher-*cum*-motorbike mechanic Matthew Crawford, for example, argues that those who are 'able to think materially about material goods, hence critically, [have] some independence from the manipulations of marketing'.[44] David Gauntlett suggests that 'in making things you feel more engaged with the world and more connected to your environments. And therefore, you are more likely to care for that world, rather than being the sit-back, switched-off consumer.'[45] A related point is that when people learn to sew, knit and mend they become more self-

reliant, and therefore more resilient. Resilience – 'the ability of a system, person or community to tolerate and adapt to significant shocks' – is a central concept within the grassroots Transition movement, which explores ways in which communities can shift to more sustainable lifestyles.[46] Geographers Chantel Carr and Chris Gibson argue that making skills are crucial for resilience, explaining that 'the ability to work with materials, and to make, repair or repurpose physical things, are vital skills, for a future where such resources become increasingly limited'.[47]

The final argument for folk fashion as a sustainable practice is perhaps the most fundamental: that it provides us with an alternative way of participating in fashion – and satisfying our human needs for identity and participation – which is not dependent on buying ready-made clothes from the dominant forces of the high street. Fashion writer Rachel Kinnard, for example, suggests that 'a culture of home-based clothing production […] represents a genuine alternative to the main-stream fashion system'.[48] On a similar note, textile researcher Emma Neuberg argues that the emergent culture of making 'marks a cultural shift in consumers' attitudes by challenging the individual's relationship with passive consumerism and, in particular, the consumption of mass-produced fashion'.[49]

But I must not get carried away: remember those tales of woe I heard from many makers, frustrated by their failed projects and reluctant to wear the things they had made? It is hard to believe that those pieces were treasured and worn for many years; more likely, they were pushed to the back of a cupboard and forgotten, just like an ill-advised pur-chase from the shops. If we acknowledge – as we surely must – that the experience of making and wearing folk fashion in contemporary culture is complex, then we have to accept that the relationship between folk fashion and sustainability is complex, too. In the following chapters I will attempt to get to grips with the folk fashion experience; in Chapter 8 I will return to the theme of sustainability, and see what new conclusions I can reach.

Notes

1 Alan Dundes, 'Foreword', in Philip V. Bohlman, *The Study of Folk Music in the Modern World* (Bloomington: Indiana University Press, 1988), pp. ix–x, p. ix.

2 Stefan Szczelkun, *The Conspiracy of Good Taste* (London: Working Press, 1993), p. 3.

3 Lou Taylor, 'State involvement with peasant crafts in East/Central Europe 1947–97: the cases of Poland and Romania', in Tanya Harrod (ed.), *Obscure Objects of Desire: Reviewing the Crafts in the Twentieth Century* (London: Crafts Council, 1997), pp. 53–65.

4 Jeremy Deller and Alan Kane, *Folk Archive: Contemporary Popular Art from the UK* (London: Book Works, 2005), p. 2.

5 Jeremy Deller, 'A la mode', *Observer*, 15 October 2006. Available at theguardian.com/arts/features/story/0,,1920726,00.html (accessed 30 April 2016).

6 Joanne Entwistle, *The Fashioned Body: Fashion, Dress, and Modern Social Theory* (Cambridge: Polity, 2000), p. 45.

7 Ingrid Loschek, *When Clothes Become Fashion* (Oxford: Berg, 2009).

8 Entwistle, *The Fashioned Body*, p. 48.

9 Elizabeth Wilson, *Adorned in Dreams: Fashion and Modernity* (Berkeley: University of California Press, 1987), p. 3.

10 Kate Fletcher, *Craft of Use: Post-Growth Fashion* (Abingdon: Routledge, 2016), p. 185.

11 Find out more about Keep & Share at keepandshare.co.uk. Further discussion can be found in Amy Twigger Holroyd, *Keep & Share: The First Ten Years* (Leeds: Keep & Share, 2014). Available at keepandshare. co.uk/sites/default/files/downloads/Keep-and-Share-the-first-ten-years.pdf (accessed 5 May 2016).

12 Accounts of folk fashion practices in the past include: Catherine Cerny, 'Quilted apparel and gender identity: an American case study', in Ruth Barnes and Joanne B. Eicher (eds), *Dress and Gender: Making and Meaning in Cultural Context* (Oxford: Berg, 1992), pp. 106–20; Angela Partington, 'Popular fashion and working-class affluence', in Juliet Ash and Elizabeth Wilson (eds), *Chic Thrills: A Fashion Reader* (Berkeley: University of California Press, 1992), pp. 145–61; Cheryl Buckley,

'On the margins: theorizing the history and significance of making and designing clothes at home', *Journal of Design History* 11/2 (1998), pp. 157–71; Carol Tulloch, 'There's no place like home: home dressmaking and creativity in the Jamaican community of the 1940s to the 1960s', in Barbara Burman (ed.), *The Culture of Sewing: Gender, Consumption and Home Dressmaking* (Oxford: Berg, 1999), pp. 111–28; Rachel Moseley, 'Respectability sewn up: dressmaking and film star style in the fifties and sixties', *European Journal of Cultural Studies* 4/4 (2001), pp. 473–90; Sarah A. Gordon, '"Boundless possibilities": home sewing and the meanings of women's domestic work in the United States, 1890–1930', *Journal of Women's History* 16/2 (2004), pp. 68–91; Marcia McLean, '"I dearly loved that machine": women and the objects of home sewing in the 1940s', in Maureen Daly Goggin and Beth Fowkes Tobin (eds), *Women and the Material Culture of Needlework and Textiles, 1750–1950* (Farnham: Ashgate, 2009), pp. 69–89.

13 Further discussion of my making-based methodology can be found in: Amy Twigger Holroyd, 'Folk fashion: amateur re-knitting as a strategy for sustainability', PhD thesis, Birmingham City University, 2013. Available at bit.ly/folk-fashion (accessed 7 October 2016); Emma Shercliff and Amy Twigger Holroyd, 'Making with others: working with textile craft groups as a means of research', *Studies in Material Thinking* 14 (2016), Paper 07, pp. 3–17. Available at materialthinking.org/sites/default/files/papers/0176_SMT_V14_P07_FA.pdf (accessed 5 May 2016).

14 Michel Avital, 'The generative bedrock of open design', in Bas van Abel, Lucas Evers, Roel Klaassen and Peter Troxler (eds), *Open Design Now: Why Design Cannot Remain Exclusive* (Amsterdam: BIS Publishers, 2011), pp. 48–58, p. 51.

15 David Gauntlett, *Making Is Connecting* (Cambridge: Polity, 2011).

16 Julian M. Allwood, Søren Ellebaek Laursen, Cecilia Malvido de Rodriguez and Nancy M. P. Bocken, *Well Dressed? The Present and Future Sustainability of Clothing and Textiles in the United Kingdom* (Cambridge: Institute for Manufacturing, University of Cambridge, 2006). Available at ifm.eng.cam.ac.uk/resources/sustainability/well-dressed/ (accessed 6 October 2016).

17 Forum for the Future, *Fashioning Sustainability: A Review of the Sustainability Impacts of the Clothing Industry* (Forum for the Future,

2007). Available at forumforthefuture.org/sites/default/files/project/downloads/fashionsustain.pdf (accessed 6 October 2016).

18 Samantha Maher, *Taking Liberties: The Story Behind the UK High Street* (London/Bristol: War on Want/Labour Behind the Label, 2010), p. 3. Available at https://cleanclothes.org/resources/national-cccs/taking-liberties-systematic-exploitation-in-indian-garment-hub (accessed 6 October 2016).

19 Allwood, Laursen, Malvido de Rodriguez and Bocken, *Well Dressed?*.

20 Andrew Brooks, *Clothing Poverty: The Hidden World of Fast Fashion and Second-Hand Clothes* (London: Zed Books, 2015).

21 Dominic Fenn (ed.), *Key Note Clothing and Footwear Industry: Market Review 2010*, 13th edn (Teddington: Key Note, 2010).

22 Allwood, Laursen, Malvido de Rodriguez and Bocken, *Well Dressed?*.

23 Office for National Statistics, *Retail Sales, August 2015* (17 September 2015). Available at ons.gov.uk/ons/rel/rsi/retail-sales/august-2015/index.html (accessed 6 October 2016).

24 Euromonitor, *Apparel and Footwear in the United Kingdom: Industry Overview* (London: Euromonitor International, 2015).

25 Elizabeth L. Cline, *Overdressed: The Shockingly High Cost of Cheap Fashion* (New York: Penguin, 2013).

26 Tim Jackson, 'Live better by consuming less? Is there a "double dividend" in sustainable consumption?', *Journal of Industrial Ecology* 9/1–2 (2005), pp. 19–36.

27 Fletcher, *Craft of Use*.

28 Jackson, 'Live better by consuming less?'.

29 Grant D. McCracken, *Culture and Consumption: New Approaches to the Symbolic Character of Consumer Goods and Activities* (Bloomington: Indiana University Press, 1990), p. 74.

30 Daniel Miller, *Stuff* (Cambridge: Polity, 2009), p. 5.

31 Lucia A. Reisch, 'Time and wealth: the role of time and temporalities for sustainable patterns of consumption', *Time & Society* 10/2–3 (2001), pp. 367–85.

32 The New Materialism, *Manifesto for the New Materialism* (2012). Available at thenewmaterialism.org/newmaterialismmanifesto (accessed 6 October 2016).

33 Kate Fletcher and Lynda Grose, *Fashion & Sustainability: Design for Change* (London: Laurence King, 2011), p. 5.

34 Gro Harlem Brundtland, *Our Common Future: Report of the World Commission on Environment and Development* (1987), p. 41. Available at un-documents.net/our-common-future.pdf (accessed 6 October 2016).

35 John R. Ehrenfeld, 'Searching for sustainability: no quick fix', *Reflections: The SoL Journal* 5/8 (2004), p. 8.

36 John R. Ehrenfeld, *Sustainability by Design: A Subversive Strategy for Transforming Our Consumer Culture* (New Haven: Yale University Press, 2008), p. 49.

37 Jackson, 'Live better by consuming less?', p. 25.

38 Carolina Escobar-Tello and Tracy Bhamra, 'Happiness and its role in sustainable design', conference paper, 8th European Academy of Design Conference (Robert Gordon University, Aberdeen, 1–3 April 2009), p. 152. Available at researchgate.net/publication/256841848_Happiness_and_its_Role_in_Sustainable_Design (accessed 6 October 2016).

39 Beverley A. Searle, *Well-Being: In Search of a Good Life?* (Bristol: Policy Press, 2008), p. 4.

40 New Economics Foundation, *National Accounts of Well-Being: Bringing Real Wealth onto the Balance Sheet* (2009). Available at nationalaccountsofwellbeing.org/public-data/files/national-accounts-of-well-being-report.pdf (accessed 6 October 2016).

41 Carol D. Ryff and Corey Lee M. Keyes. 'The structure of psychological well-being revisited', *Journal of Personality and Social Psychology* 69/4 (1995), pp. 719–29.

42 Manfred Max-Neef, 'Development and human needs', in Paul Ekins and Manfred Max-Neef (eds), *Real-Life Economics: Understanding Wealth Creation* (London: Routledge, 1992), pp. 197–213, p. 204.

43 Rosie Martin, *How to Make a Cloak* (London: Street Stroke Hothouse Press, 2010), p. 3.

44 Matthew Crawford, *The Case for Working with Your Hands: Or Why Office Work is Bad for Us and Fixing Things Feels Good* (London: Penguin, 2009), p. 18.

45 David Gauntlett and Amy Twigger Holroyd, 'On making, sustainability and the importance of small steps: a conversation', *Conjunctions: Transdisciplinary Journal of Cultural Participation* 1/1 (2014), p. 13. Available at http://dx.doi.org/10.7146/tjcp.v1i1.18602 (accessed 6 October 2016).

46 Transition Town Totnes, 'What is resilience?' Available at transitiontowntotnes.org/about/what-is-transition/what-is-resilience/ (accessed 6 October 2016).

47 Chantel Carr and Chris Gibson, 'Geographies of making: rethinking materials and skills for volatile futures', *Progress in Human Geography* 40/3 (2016), pp. 298–9.

48 Rachel Kinnard, 'Disruption through download: BurdaStyle.com and the home sewing community', *Journal of Design Strategies* 7 (2015), pp. 98–104, p. 99. Available at sds.parsons.edu/designdialogues/?post_type=article&p=716 (accessed 6 October 2016).

49 Emma Neuberg, 'Foreword', in Melanie Bowles and the People's Print, *Print, Make, Wear* (London: Laurence King, 2015), pp. 6–7, p. 6.

2

The Resurgence of Folk Fashion

However horrified you may be by the phenomenon of trendy knitting, The People love it. They're mad for it. This could be the Noughties version of cocaine. There were people knitting guitars, people knitting with cable flex, people knitting mini versions of themselves because, let's face it, life in a big city is lonely.[1]

Jacques Peretti's caustic description of the emergent phenomenon of 'trendy knitting' was prompted by a meeting of the boldly unconventional Cast Off Knitting Club for Boys and Girls on London's Brick Lane. His report for the *Guardian* was just one of a slew of articles which, in the early 2000s, declared knitting to be the 'next big thing'.[2] These early predictions were impressively accurate: the 'People' have shown in ever-increasing numbers that they love not only knitting, but sewing and mending too. In fact, hands-on making of all types has gained cultural currency in recent years, with the explosion of the 'maker movement' driving interest in digitally enabled making practices alongside traditional crafts such as pottery and woodworking.

Folk Fashion Communities

Describing folk fashion culture is tricky, because it is so varied: not one culture but many, formed of an ever-shifting assemblage of overlapping and intersecting communities, networks and subcultures. For a start, folk fashion activities are rather diverse. Sewing your own clothes is quite a different experience to knitting a garment by hand, and mending is different again. Related crafts such as spinning, crocheting, weaving, quilting, embroidering and machine knitting provide yet more variations.

For some makers these practices overlap – like the many knitters and weavers who, as they gain experience, develop an interest in spinning – and there are people who will happily move between any and all of these textile-making activities. Still, there can be conflicts between members of these groups. I have frequently come across hand knitters who dismiss machine knitting as 'cheating', sewers who bemoan the slowness of hand knitting, and knitters who detest any task involving sewing. There is variety within each activity, too. While everyone who makes their own clothes is undertaking largely the same process, there is an incredibly broad range of stuff being made in terms of style, fed by a diverse array of information, inspiration and practical supplies. Makers also differ in terms of skill, intensity of activity and level of experience: within the sphere of 'people who make clothes' would be new starters, old hands, returners, dabblers, steady progressors and committed enthusiasts. Again, these groups sometimes interconnect and even inspire each other, but they may also seek to distinguish themselves through their differences. Some sewers gain a particular sense of identity through solely using patterns from 'indie' (independent) designers, rather than the big companies who dominate the sewing-pattern market. Meanwhile, research by American sociologist Corey Fields found young, 'hip' knitters defining themselves in opposition to 'grandma' knitters, whom they perceived as being old-fashioned.[3] Furthermore, although makers are now connecting and sharing their enthusiasms online, meaning that people who join together in pursuing a niche interest might be spread across the globe, I would expect to find cultural differences between practices of making in different parts of the world.

The Twenty-First-Century Resurgence

It is widely acknowledged that since the turn of the millennium a resurgence has taken place in terms of folk fashion practices. Fiona Hackney describes a 'new energy' at work, meaning that 'the crafts [...] have changed beyond all recognition in recent years'.[4] Knitting led the way in this revival; art historian Alla Myzelev proposes that 'in the last

fifteen years it has gone through a tremendous revival and perhaps as no other craft at the present time is in the state of transition'.[5] The upsurge of interest in sewing took place towards the end of the 2000s. As blogger Rachel Pinheiro explains, 'people have begun to find each other and share ideas as they have never been able to before. There are fresh ideas in terms of design and colour, and a change of aesthetic. It's brought a whole new audience to the hobby.'[6]

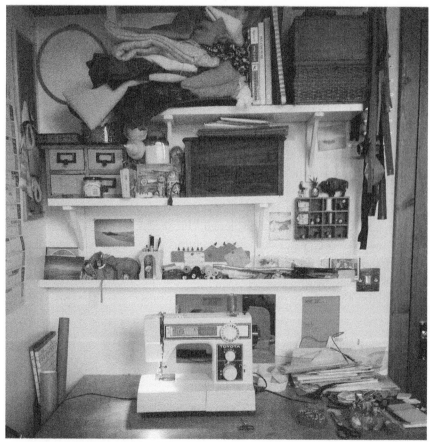

4. Rosie Martin's sewing space, as documented for Sewvember, a collaborative online project.

The growth in knitting and sewing activity can be tracked, to some extent, through statistics. Articles on this topic in the press regularly cite increased sales of materials and equipment, usually at UK high-street stalwart John Lewis.[7] Web searches provide another source of information. A review of Google data shows searches for 'knitting', 'sewing' and 'crochet' steadily increasing since records began in 2004, although these figures must reflect increasing internet usage over this time, as well as a growing interest in making.[8] Other statistics provide a useful insight into actual levels of participation (although I treat some of these, whose definitions and survey methodologies are rather oblique, with caution). A National Endowment for the Arts report, based on census data, shows that 13 per cent of adults in the USA participated in weaving, crocheting, quilting, needlepoint, knitting or sewing in 2012.[9] More specifically, the US Craft and Hobby Association reports that 18.7 million people had participated in fabric and sewing crafts, and 11.9 million people in knitting, in the same year.[10] Of course, the intensity of this participation varies; a core of 517,000 'enthusiasts' is identified by the National NeedleArts Association amongst these millions of American knitters.[11] Meanwhile, the UK Craft and Hobby Trade Association recently reported that 3.5 million people in the UK make their own clothes with a sewing machine, 433,000 of whom started sewing only in the last year. The UK Hand Knitting Association claims there to be 7.5 million knitters and crocheters in the country.[12]

Folk fashion does not mean only the creation of new items, but also the use of sewing and knitting skills to repair and remake existing garments. The practice of mending has undergone a significant transformation in the last five years or so, from outdated household chore to contemporary creative act. This may be surprising: research shows that for most people mending, if practised at all, is limited to small tasks such as replacing buttons and sewing up hems.[13] Yet the near-extinction of textile repair in its traditional guise has cleared the way for the emergence of what researcher Jonnet Middleton has termed 'new mending': makers actively choosing to spend time repairing their clothes, rediscovering techniques such as darning, and celebrating their repairs by making them visible.[14] In many ways the turn to mending is

5. 'Visible Mending Programme: That Green Cardigan' by Tom van Deijnen.

a direct consequence of the upsurge in knitting and sewing. Sewers, as they gain confidence, will use their skills for repair, while knitters are often keen to extend the life of the items – socks, in particular – that they have spent considerable time and effort on making.

Despite focusing on the recent resurgence of folk fashion, it is important for me to note that activity had not ground to a halt at the end of the twentieth century. As part of my research I interviewed Rachael Matthews: artist, owner of London yarn shop Prick Your Finger, and co-founder of the Cast Off Knitting Club mentioned earlier.[15] Rachael's work was frequently featured in the early press heralding the 'return' of knitting. As she explained:

> Some makers would find it a bit irritating to be told that there was a revival, because they never stopped doing it. So that was a thing that was really painful, about doing all that press. The point of doing all that was that it needed to become talked about, mainstream, that it wasn't something unusual and dead.

Indeed, knitters may have been somewhat bemused, or even annoyed, to be told that their craft was suddenly back, and back in fashion. There are folk fashion makers who have carried on with their established practices – making much the same things, in much the same way, as before. Still, it is important to note that the new energy, inspiration, materials, resources, events and conversations are being accessed by long-standing makers just as much as recent converts, and by people returning to sewing or knitting after a long break.

Drivers of the Revival

What has caused this revival? I see the influence of several inter-connecting cultural shifts. The growth of interest in sustainable living is one such shift, and an important motivation for many new folk fashion makers. One of my interviewees, Rosie Martin, spoke to me about her experiences of supporting sewers through her creative fashion label, DIYCouture.[16] She explained that many new sewers 'feel political about it, in a way. This is what they want to do, because they feel like having skills is important, and they want to be able to opt out of buying stuff.' I also interviewed Tom van Deijnen (known in the craft world as Tomofholland), a dedicated hand knitter and mender who has run darning workshops since 2011.[17] Tom said that a significant proportion of participants in his workshops want to learn to repair in order to avoid buying new clothes, and therefore circumvent the problems associated with sweatshop labour and mass production. Cultural studies scholar Susan Luckman agrees that 'Growing awareness of the environmental and social costs of the circulation of cheap consumer goods is giving rise to concerns about large-scale industrialisation' and thus driving interest in small-scale craft.[18]

The economic crash of 2008 and its aftermath are often mentioned as influencing the growth of interest in making. Yet there is no straightforward link between a limited income and increased making activity. After all, today it often costs more to make an item than simply to purchase something new from the shops. A member of

the Hereford knitting group, Alex, suggested that during a recession 'people tend to look to the past, and bring out the good bits – or the bits they remember as being good – and somehow it feels virtuous to be making or mending things'. Craft researcher Jo Turney agrees that 'at times of crisis, instability and anxiety, the past offers a sense of security otherwise absent' – and therefore that we draw on traditions such as knitting for a feeling of stability.[19] This interest in the past ties in with the current taste for vintage. In terms of folk fashion, the trend relates to both vintage-looking objects, such as 'granny square' blankets and 1950s-style dresses, and actual practices of making and mending. Tom van Deijnen explained that some people attending his darning workshops are interested in vintage clothes and vintage techniques, and particularly a 1940s-inspired 'make do and mend' mentality. Often objects and practices are linked, as Rachael Matthews described: 'There's the re-enactment knitter. They're so into their vintage that they've got to be authentic – so they've got to make the twinset on 2mm needles in Saharan Sand.' In her interview, Rosie Martin offered another perspective on the role of the economic crash, suggesting that it had been a prompt for forward-looking behavioural change:

> I don't think that suddenly everyone was poor, so they sewed. I guess it's to do with the spectacle of our throwaway capitalist culture coming to this massive head, and it being presented on the stage for us all to see. And it got people thinking about being more self-sufficient, or taking a different approach somehow.

Another factor that is widely recognised as driving an increase in amateur fashion making is the growth of the internet and, more specifically, the connective power of web 2.0.[20] Blogs, forums, online communities and social media have created platforms for makers to connect as never before, and niche areas of interest are blossoming as textile-making enthusiasts are able to share their projects, patterns, problems and tips online.[21] Thus, as cultural theorists Jack Bratich and Heidi Brush suggest, 'the knitting circle now meshes with the World Wide Web'.[22] Focusing on dressmaking, Jessica Bain describes 'the

development of a vibrant online presence, with substantial numbers of sewing bloggers and tweeters establishing an apparent community'.[23] Often, these online communities offer similar benefits to 'offline' groups – although, as David Gauntlett points out in his book *Making is Connecting*, the internet is enabling interactions to take place 'with a depth and speed that was not previously possible'.[24] Meanwhile, new internet-based opportunities are being developed. Bespoke digital fabric-printing services, for example, allow dressmakers not only to make their own garments, but also to produce their own unique fabrics – thus extending the scope for creativity in this particular folk fashion practice.

The Making and the Made

While these macro-level cultural shifts are undoubtedly having an influence, for many people the intrinsic benefits of the hands-on making process are the central attraction of folk fashion. Textile researcher Emma Shercliff suggests that the opportunity to work with the hands is particularly important today, explaining: 'If screen-based work can provoke a fractured, dislocated sense of self, by contrast handwork can encourage a focused awareness of the body as a whole being literally in touch with its environment.'[25] Describing the motivations of people who attend her sewing workshops, Rosie Martin highlighted the increasing prevalence of screen-based activity:

> They've got to a point where they feel that they want to do something that isn't computer based. They're frustrated that their nine to five, five days a week, is very much sitting at a computer. There's obviously something in them that feels that that's unnatural, and they want to explore.

Making attracts people who are somewhat frustrated by their jobs and are searching for an activity they feel to be more meaningful. It appeals to people with satisfying but demanding careers, who use

sewing or knitting as a means of stress relief, and (perhaps counter-intuitively) a way of making time for themselves. I have also spoken to people for whom making offers a much-valued escape from caring responsibilities and personal difficulties.

Meanwhile, many new makers are motivated to take up a craft by the objects that they want to create. Tom van Deijnen spoke about his experience of becoming a knitter:

> About eight or nine years ago, I saw this really expensive scarf in a shop that I couldn't afford. I was used to spending quite a lot of money on clothes then, but even I found it too expensive. And then I thought, I did actually learn how to knit when I was a child, so I can try and knit my scarf instead of buying it.

Christine Cyr Clisset, a New York-based journalist and sewing blogger who runs the Thread Cult podcast, told me a similar story about her initial interest in sewing.[26] She explained: 'One of the things that pushed me into sewing was that I wanted to wear the types of clothing that I saw in really nice boutique places. And I couldn't afford it, so I wanted to make my own.' While Tom and Christine were motivated by items they had seen in shops, Rosie Martin explained that she started to make for herself because she wanted what she described as 'weird' clothes: items made from outlandish prints that she could not buy ready-made. Thinking about the young women who come to her sewing classes, she identified a similar – though perhaps less extreme – desire for the unique: 'There definitely are fashion-interested girls, who are aware that what they see on the high street might not be that difficult to make. They're really interested in clothes, and having something different.' Rachael Matthews described how some makers are motivated to start making in order to create items for others. This might be an expectant mother (or friends or family members) wanting to knit for a new baby, or perhaps someone in a new relationship making something for their new partner.

A Changing Culture

As folk fashion grows in popularity, its culture changes and develops. New strands of activity are influencing these changes. Contemporary knitting and sewing practices now span 'craftivism', public interventions and fine art as well as the more familiar sphere of making clothes. Betsy Greer, who coined the term in 2003, defines craftivism simply as 'craft + activism'.[27] Craftivist practices may be primarily utilitarian, such as the American 'Afghans for Afghans' project which supplies woollen clothing to Afghan children, or symbolic, such as the cross-stitched mini protest banners promoted by the UK-based Craftivist Collective.[28] In recent years textile interventions within public space have become common, with the practice of yarnbombing spreading rapidly since it was initiated by Magda Sayeg in Texas in 2005.[29] Meanwhile, textile crafts have grown as a means of artistic expression. In 2007, curator David Revere McFadden explained that in the last decade, 'knitting has emerged from the "loving hands at home" hobbyist's den into museums and galleries worldwide.'[30] This is also the case with mending:

6. Mini protest banner by Craftivist Collective.

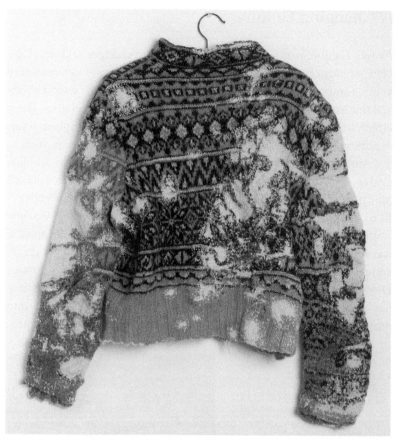

7. 'Norwegian Sweater' by Celia Pym, original damaged sweater from Annemor Sundbø's Ragpile Collection, 2010.

as writer and mender Eirlys Penn explains, 'Today, it's acquiring a new conspicuousness in the hands of artists and other practitioners who are finding in it resonances about disposability, healing, individuality and communality.'[31]

Although craftivists, yarnbombers and contemporary artists are creating different types of work from folk fashion makers, the vibrancy of this creative activity is spilling out and spreading, influencing the

ideas and aspirations of those who make their own clothes. In some cases the link is pretty direct: folk fashion makers in the indie craft scene engage with a self-consciously DIY ethos which often intermingles with craftivist initiatives.[32] As Greer points out, 'those who dare to step outside the fast-fashion mill also dare to start a conversation' – a conversation about the value of making in contemporary life, which has many political dimensions.[33] Meanwhile, I have seen that the diversity and individuality demonstrated in the activist and artistic strands of textile making are affecting folk fashion makers who are more conventional in their aesthetic tastes and less consciously political in their attitudes to craft. Margaret, a member of the Hereford knitting group who mainly knits garments for herself and her partner, reported that seeing the experimental and artistic knitting projects of others had inspired a desire to be more adventurous in her own work. She explained: 'They're so individual, and they're absolutely, in their own right, really interesting. So I think there's definitely a desire to make things that are individual, and just to experiment more.' In the workshops and projects I have run in recent years, I have encountered many knitters who said they wanted to feel more creative in their making, and to break out of their dependence on patterns. Likewise, this desire can be observed in the sewing sphere, with the emergence of 'pattern-hacking' – the inventive adaptation of existing sewing patterns – as a dynamic creative process.

Textile makers of all types are influenced by the established cultural associations of textile crafts, including their image as outdated and unskilled feminine activities. Practices such as sewing and knitting are firmly associated with femininity in the collective consciousness. This association both influences and reflects general levels of leisure-based participation; a UK National Statistics survey in 1997 (the last one to cover this topic) showed 12 times as many women as men engaged in dressmaking, needlework and knitting.[34] The connection of textiles with femininity and domesticity has – as Rozsika Parker demonstrated in her groundbreaking work *The Subversive Stitch* – a long and complex history.[35] Sadly, this connection carries with it an inherent sense of denigration which reflects the historically low status of craft in relation to fine art and of amateur activity in relation to professional

practice, as well as the patriarchal nature of our culture. As Jo Turney describes, needlecrafts are 'frequently the butt of jokes' and seen as 'old-fashioned, requiring little skill or design flair'.[36] Craftivist actions, public interventions and contemporary art pieces frequently challenge these negative perceptions. Susan Luckman describes 'concerted feminist and/or artist campaigns for recognition of the creative value of fibre arts especially in the face of its historical de-valuing as women's domestic, unpaid activity'.[37] Many within the new wave of folk fashion work from a similar perspective. Jack Bratich and Heidi Brush argue that 'much of the contemporary knitting movement often positions itself as subverting the conventional associations of knitting: domesticity and tender maternalism'.[38] Jessica Bain describes the many ways in which contemporary home dressmakers engage with feminism – both intentionally and incidentally.[39] Jonnet Middleton, meanwhile, suggests that 'the new vanguard of menders offers a persuasive vision of mending as a new form of desire, of self-expression and of self-realisation'.[40]

I would argue that the cultural associations of textile crafts are slowly shifting, partly due to these initiatives – but also due to the sheer vibrancy of contemporary folk fashion culture, and increased levels of participation. I have found that, when people have a go at sewing or knitting, they discover that it is nowhere near as easy as popular culture would have them believe. On more than one occasion I have witnessed initial quips by novice knitters about quickly whipping up a jumper give way to newfound admiration for those grandmothers who really could achieve such a feat. The heightened profile of making in general – driven by the maker movement – is having a similar effect. The ability to make something, whether that is sewing a dress, brewing beer or designing a 3-D printed widget, is seen in many circles as being positive and desirable. I would not go as far as Susan Luckman, who suggests that 'previously unfashionable women's crafts such as knitting and crochet have been stripped of their embarrassingly "old-school" or even outright anti-feminist connotations'.[41] These established connotations are not so easily shifted; yet new perceptions of sewing and knitting as creative and aspirational practices are certainly mixing with the long-standing meanings associated with these crafts.

Diverse Resources

Another significant change in folk fashion culture has been the emergence of a great wave of independent producers and a consequent increase in the variety of materials, patterns and instructions available to makers. This change has been enabled by the internet, which has fostered a DIY ethos by dramatically opening up opportunities for small-scale producers to reach individual customers. I find this development to be particularly noticeable in the market for knitting yarns. Knitters are now much more aware of alternative producers, whether long-established operations or new start-ups, and have access to a wide range of 'artisan' yarns. While plenty of people happily knit with acrylic, there is a greatly increased appreciation of natural fibres; in the top ten most popular yarns listed on the knitting website Ravelry, the majority are pure wool.[42] In fact, a subculture is emerging in the UK which values and celebrates the inherent properties of the wool from particular breeds of British sheep, supported by the growth of regional yarn festivals. Since a local cooperative founded Woolfest in Cumbria in 2005, similar events have been initiated in many areas, and – as Tom van Deijnen joked when we discussed this – 'every watering hole has a yarn festival now'. Although shops selling folk fashion materials largely disappeared from our high streets in the late twentieth century, the scene today is rather more vibrant, with a new generation of retailers opening up. As in so many other spheres, these local shops are having to think creatively in order to compete with online suppliers, which often offer lower prices or specialist ranges. Common strategies include providing in-house advice and running classes and clubs – and the bricks-and-mortar shops are aided, of course, by a common desire of customers to see and touch the materials before they buy. Hereford knitter Catherine described indulging her passion for fabric and yarn at a 'wonderful shop, just stuffed full of fabulous wool. I used to go in there and just stare at this wonderful wool.'

Independent producers have transformed the range of patterns available to makers, too. In terms of sewing, many independent pattern companies have emerged to offer alternatives to the 'big four' suppliers:

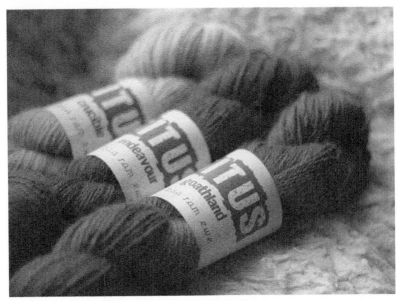

8. 'Titus' yarn by Baa Ram Ewe, spun in Yorkshire from Wensleydale and Bluefaced Leicester wool, combined with UK alpaca.

Simplicity, Vogue, Butterick and McCall's. While diverse in terms of garment style, these indie patterns have a notably different aesthetic to the traditional sewing pattern format (which can look rather dated): often photographed on real bodies, rather than communicated through stylised illustrations, and presented with a strong and contemporary graphic identity. A similar phenomenon has occurred in knitting, with individual patterns available from independent designers' websites, and also accessible via Ravelry. This is an astonishingly popular social network for knitters (its membership surpassed 5 million in early 2015)[43] which includes a searchable database of patterns: over 500,000 are currently listed. This database is a particularly valuable resource because of the rich user-generated content associated with each entry. Members can rate patterns, recommend alternative yarns, suggest adaptations and upload photographs of their completed projects. While many knitting and sewing patterns are now available for instant

download, the printed format is still popular – whether in the form of books, magazines or individual patterns. In fact, another statistic which points to the twenty-first-century resurgence of folk fashion is the striking increase in book sales: books in the 'handicrafts, arts and crafts' category – dominated by knitting, sewing and quilting titles – totalled £9.8 million in 2009, up 20 per cent on the previous year.[44] Online or in print, makers gain great pleasure from browsing patterns. The conversations I had with the Hereford knitting group showed that they saw this as a leisure activity in its own right.

Unsurprisingly, the increased diversity in terms of materials and patterns also applies to learning. Many of the newly published sewing and knitting books provide valuable instructions for beginners and improvers, as do workshops run at shops and fairs. Alongside these established formats is a new set of resources enabled – once more – by the internet. As sociologist Kate Orton-Johnson explains, 'For new knitters online resources are vital sites for learning and "becoming" a knitter occurs through and with the digital.'[45] YouTube has had a transformative effect on the learning of craft skills, hosting a dazzling array of instructional videos. Instructions are available, too, via blogs, with processes often demonstrated visually through step-by-step photographs. Many makers are using the internet as their first port of call when wanting to learn, or relearn, a particular technique; in 2014, 'how to crochet' and 'how to knit' featured in the top five 'how to' Google searches in the UK.[46] Rosie Martin pointed out the benefits of these instructions, which can be accessed time and again, at one's own pace, for beginners:

> The internet's full of people giving tips on how they do things, and showing that visually. So that gives people the tools to be able to start. In a way I think it's less intimidating than going to a class, because you're not fearing the judgement of a teacher, or doing something wrong. You're totally in control.

Of course, these online resources are not just being used by beginners; videos and blogs demonstrate an incredibly broad range of

processes, including highly specialised techniques and demonstrations of impressively obscure pieces of machinery. Meanwhile, online courses – which cater for both beginners and experienced makers – combine videos and written documentation with direct access to an expert teacher who can offer personalised advice.

A Supportive Community

There is an important role for professional facilitators in folk fashion: teaching skills, providing inspiration, designing patterns, and making and selling supplies. In many cases, it is these facilitators who get people excited about making for the first time and help them to progress to become confident independent practitioners. Nevertheless, it is important to remember that makers are supported not only by professionals, but also by fellow enthusiasts within the community. Knitting groups have sprung up all over the place in recent years; Stella Minahan and Julie Wolfram Cox explain that they can be found 'in clubs, pubs, cafes and private homes throughout Europe, the USA and Oceania'.[47] Anne, one of the Hereford knitters, described her experience of attending a local group: 'It's a nice congenial atmosphere. It's a real good source of knowledge, and it's nice to see what other people are doing, and just have the general chit-chat really.' By joining a group, makers are able to designate time for their craft; they can also support each other to make progress on their projects. Group activity has been important in the resurgence of mending. Jonnet Middleton says that 'Mending events, social initiatives and workshops are germinating in large cities and small towns alike, typically linked to craft-supplies shops, transition towns and artisan and activist individuals within fashion and craft communities.'[48] One such initiative is the Big Mend in Bath, which was started by Eirlys Penn (otherwise known as Scrapiana) in 2012. As she explains, 'The idea was to present an opportunity to attack the mending pile in a convivial atmosphere, with mending advice and necessary tools on hand.'[49]

Of course, a great deal of support is available through online making communities. Many of the blogs and YouTube videos that are accessed

by learners are created by passionate amateurs, keen to share their skills and experiences. Makers also support each other through a wide variety of incredibly active online forums. Sewing blogger Rachel Pinheiro explains: 'It really is a wonderful community to be part of. That's one of the great attractions of sewing, it's the people. We joke there is a special sewing gene that makes that person immediately friendly.'[50] Focused support can be gained by participating in a knitalong or sewalong: an online project where all participants make the same pattern at the same time, helping and encouraging each other. Laura Blackwell, a textile designer and blogger who sews her own clothes, told me, 'it's nice doing a pattern at the same time as everyone else because you hit the same hurdles at the same time as everyone else'.[51] Makers also connect by sharing images online. Laura described her usual habit: 'As soon as I finish something, I take a picture and then it's on Instagram straight away. And then you get that instant love where everyone goes, Ooh I like that, I like that, make me one!' Tom van Deijnen spoke about menders posting pictures of their completed repairs on Instagram,

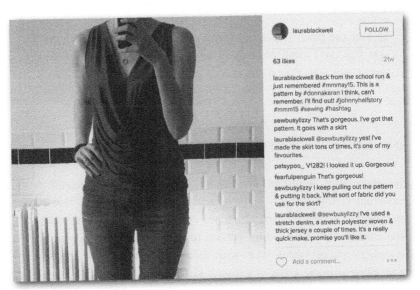

9. Laura Blackwell, sharing success on Instagram.

using the #visiblemending hashtag in order to showcase their work to other enthusiasts. Rosie Martin described a more coordinated online initiative:

> There was something called Sewvember that one sewing blogger [Bimble and Pimble] started.[52] There was a different prompt for every day of the month: technique, sewing space, view, tools. Everyone who participated took their photo and tagged it – and it was so much fun, it was amazing. You're connecting with sewers from all round the world that you'll never meet.

This collective online activity is incredibly valuable: it creates a sense of community, provides inspiration for other makers and increases the visibility of folk fashion. Despite the resurgence of activity, many makers today feel rather isolated and do not have peers nearby with whom to share their experiences. Christine Cyr Clisset talked to me about this issue:

> I think an interesting component of the current home sewing culture is that blogs are so important. You see what other people are making all over the place. Especially since, maybe, your close friends don't sew. I mean, I think when my grandmother was young, everybody sewed. But now, I'm an anomaly amongst my friends.

No Longer a Novelty?

As increasing numbers of makers develop their skills and gain experience, folk fashion culture becomes more mature. While some people will remain as dabblers, many become increasingly absorbed in the world of craft, spending greater time and effort on their projects, connecting more intensively with fellow enthusiasts and starting to specialise in niche areas of activity. Thus, the novelty of the revival is beginning to wear off. Rachael Matthews described:

I still get, every week, people coming in [to the shop] and saying, knitting's fashionable again, isn't it? But people are saying that less and less. So I think it is becoming just a more normal thing. I think even the novelty of yarnbombing, and the person that thinks that they're novel for knitting, it's wearing off a bit. It's just normalising.

Writing in 2011, Perri Lewis argued that knitting had moved from being the preserve of the 'cool kids' to a much more mainstream activity, partly due to the influence of the media. As she pointed out, 'middle-of-the-road TV presenter Kirstie Allsopp relieved knitting of a great deal of cool by featuring it on her Channel 4 craft show in 2009'.[53] Rosie Martin suggested that an important factor in sewing 'going mainstream' in the past few years in the UK has been the hit BBC TV series, *The Great British Sewing Bee*. Historian Joy Spanabel Emery similarly identifies the American series *Project Runway* as influencing the revival of dressmaking.[54]

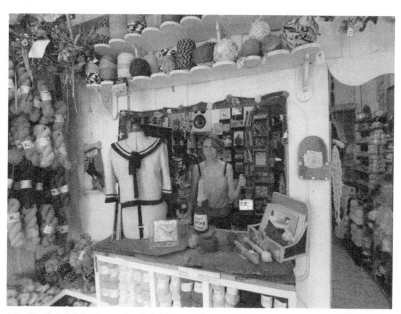

10. Rachael Matthews in Prick Your Finger: wool shop, school and gallery.

Although it may now seem somewhat less remarkable to meet someone who knits, sews or mends their own clothes, the minority status of male makers in this sphere is still seen by many as a cause for comment. While some men collude in this – Rachael Matthews described a type of male knitter who 'just thinks it's hilarious that he knits because he's a man, who will knit louder and bigger than everyone else' – in my experience, most men prefer to be treated like any other maker. In a blog post about men who knit, David Demchuk explained that questions from strangers when he knits in public are usually curious rather than consciously negative, although – as Mike Bates pointed out in the same post – there is an 'odd hint of latent gender prejudice' in any remark.[55] In another blog post, Tom West wrote about similar encounters when knitting in public:

> Many people see 'man' as a disability that I've managed to overcome in order to be able to knit. More than that, they don't understand why I'd do so to start with, for am I not happy with my 'man's stuff'? I always try to get these people to understand my relationship with knitting by asking them why they think women knit. The answers at each end of the spectrum are: the simple pleasure of making loops of yarn with pointy sticks, and the reclamation of the practice from the domestic sphere as both art and craft – for feminism! I always ask why I shouldn't enjoy it for the exact same reasons.[56]

As these accounts demonstrate, male folk fashion makers remain somewhat of a novelty to the outside world. In fact, from a vantage point within the rich and complex culture of folk fashion, it is easy to forget that making clothes in general – whoever you are – is still a pretty marginal activity, in comparison to the overwhelming dominance of shop-bought clothes and mainstream fashion. As Jonnet Middleton points out, 'Although vibrant mending cultures advance fresh-faced from the fringes, mending is still invisible to the majority of consumers.'[57] There is a long way to go if making is to march into the mainstream and become a recognised, everyday element of fashion culture.

Notes

1 Jacques Peretti, 'Knits his brows at a loopy trend', *Guardian Guide*, 23 March 2002. Available at castoff.info/press/pages/guardian_guide_29-3-02.html (accessed 6 October 2016).

2 For example: Jane Campbell, 'It's a knit-in', *Independent Review*, 23 March 2004. Available at independent.co.uk/news/uk/this-britain/its-a-knitin-65547.html (accessed 6 October 2016).

3 Corey D. Fields, 'Not your grandma's knitting: the role of identity processes in the transformation of cultural practices', *Social Psychology Quarterly* 77/2 (2014), pp. 150–65.

4 Fiona Hackney, 'Quiet activism and the new amateur: the power of home and hobby crafts', *Design and Culture* 5/2 (2013), pp. 169–93, p. 170.

5 Alla Myzelev, 'Whip your hobby into shape: knitting, feminism and construction of gender', *Textile: The Journal of Cloth and Culture* 7/2 (2009), pp. 148–63, p. 150.

6 Sarah Lewis-Hammond, 'The rise of mending: how Britain learned to repair clothes again', *Guardian*, 19 May 2014. Available at theguardian.com/lifeandstyle/2014/may/19/the-rise-of-mending-how-britain-learned-to-repair-clothes-again (accessed 6 October 2016).

7 For example: Huma Qureshi, 'From the high life to the good life: cutting one's cloth is back in fashion', *Observer*, 25 January 2009. Available at theguardian.com/business/2009/jan/25/cooking-sewing-hen-keeping-economising-credit-crunch (accessed 6 October 2016); Perri Lewis, 'Pride in the wool: the rise of knitting', *Guardian*, 6 July 2011. Available at theguardian.com/lifeandstyle/2011/jul/06/wool-rise-knitting (accessed 6 October 2016).

8 Data accessed via google.co.uk/trends/explore, using search terms 'knitting', 'sewing' and 'crochet', in the UK, across all categories, relating to web searches, on 28 April 2015.

9 National Endowment for the Arts, 'National Endowment for the Arts presents highlights from the 2012 Survey of Public Participation in the Arts' (26 September 2013). Available at arts.gov/news/2013/national-endowment-arts-presents-highlights-2012-survey-public-participation-arts (accessed 6 October 2016).

10 Craft & Hobby Association, *2012 State of the Craft Industry: Key Insights* (2012). Available at craftandhobby.org/eweb/docs/2012.State.of.the.Craft.Industy.Public.pdf (accessed 6 October 2016).

11 National NeedleArts Association, *The State of Specialty NeedleArts 2013: Market Summary USA* (2013). Available at tnna.org/resource/collection/386A6007-6C3F-4D15-A864-6D0DBD47FB40/TNNA-2013-Market-Summary-Final.pdf (accessed 6 October 2016).

12 Lewis-Hammond, 'The rise of mending'; UK Hand Knitting Association, 'About us' (2015). Available at ukhandknitting.com/about-us (accessed 6 October 2016).

13 Tom Fisher, Tim Cooper, Sophie Woodward, Alex Hiller and Helen Goworek, *Public Understanding of Sustainable Clothing* (London: DEFRA, 2008). Available at http://randd.defra.gov.uk/Default.aspx?Module= More& Location=None&ProjectID=15626 (accessed 6 October 2016).

14 Jonnet Middleton, 'Mending', in Kate Fletcher and Mathilda Tham (eds), *Routledge Handbook of Sustainability and Fashion* (Abingdon: Routledge, 2015), pp. 262–74, p. 265.

15 For more information, visit prickyourfinger.com.

16 For more information, visit diy-couture.co.uk.

17 For more information, visit tomofholland.com.

18 Susan Luckman, *Craft and the Creative Economy* (Basingstoke: Palgrave Macmillan, 2015), p. 24.

19 Joanne Turney, *The Culture of Knitting* (Oxford: Berg, 2009), p. 53.

20 Dennis Stevens, 'Validity is in the eye of the beholder: mapping craft communities of practice', in Maria Elena Buszek (ed.), *Extra/ordinary: Craft and Contemporary Art* (Durham: Duke University Press, 2011), pp. 43–58; Lewis, 'Pride in the wool'.

21 Stacey Kuznetsov and Eric Paulos, 'Rise of the expert amateur: DIY projects, communities, and cultures', conference paper, 6th Nordic Conference on Human–Computer Interaction (Reykjavik, 16–20 October 2010). Available at staceyk.org/hci/KuznetsovDIY.pdf (accessed 6 October 2016).

22 Jack Z. Bratich and Heidi M. Brush, 'Fabricating activism: craft-work, popular culture, gender', *Utopian Studies* 22/2 (2011), pp. 233–60, p. 242.

23 Jessica Bain, '"Darn right I'm a feminist ... sew what?" The politics of contemporary home dressmaking: sewing, slow fashion and feminism', *Women's Studies International Forum* 54 (2016), pp. 57–66, p. 57.

24 David Gauntlett, *Making Is Connecting* (Cambridge: Polity, 2011), p. 62.

25 Emma Shercliff, 'Hidden values in human inconsistencies: ways in which hand skills enable prized encounters between matter and thought', paper presented at TRIP: An International Symposium Exploring the Role and Relevance of Traditional 'Hand Skills' in Contemporary Textiles, and the Value and Status of Craft Process (Loughborough University, 16–17 November 2011), p. 17.

26 Christine Cyr Clisset's blog can be found at daughterfish.com, and her Thread Cult podcast at threadcult.com.

27 Betsy Greer, 'What is craftivism, anyway?', Craftivism (2015). Available at craftivism.com/what-is-craftivism-anyway (accessed 6 October 2016).

28 For more information, visit afghansforafghans.org and craftivist-collective. com.

29 Susan Karlin, 'Urban graffiti knitters are the new, cozier Christo and Jeanne-Claude', *Fast Company* (28 March 2011). Available at fastcompany. com/1742637/urban-graffiti-knitters-are-new-cozier-christo-and-jeanne-claude (accessed 6 October 2016); Lewis, 'Pride in the wool'.

30 David Revere McFadden, 'Knitting and lace: radical and subversive?', in David Revere McFadden, Jennifer Scanlen and Jennifer Steifle Edwards (eds), *Radical Lace and Subversive Knitting* (New York: Museum of Arts & Design, 2007), pp. 8–19, p. 8.

31 Eirlys Penn, 'Mending: the ancient art of making wHOLE', *Selvedge* 70 (May/June 2016), p. 46.

32 Stevens, 'Validity is in the eye of the beholder', p. 50.

33 Betsy Greer (ed.), *Craftivism: The Art and Craft of Activism* (Vancouver: Arsenal Pulp Press, 2014), p. 59.

34 Office for National Statistics, *Social Trends 27* (London: Stationery Office, 1997).

35 Rozsika Parker, *The Subversive Stitch: Embroidery and the Making of the Feminine* (London: I.B.Tauris, [1984] 2010).

36 Jo Turney, 'Here's one I made earlier: making and living with home craft in contemporary Britain', *Journal of Design History* 17/3 (2004), pp. 267–82, p. 267.

37 Luckman, *Craft and the Creative Economy*, p. 48.

38 Bratich and Brush, 'Fabricating activism', p. 241.

39 Bain, '"Darn right I'm a feminist ... Sew what?"'.

40 Middleton, 'Mending', p. 267.

41 Luckman, *Craft and the Creative Economy*, p. 32.

42 Top ten yarns accessed via ravelry.com/yarns/search#sort=projects &view=thumblist on 28 April 2015.

43 Ravelry, 'Community eye candy: 5 million!' (3 February 2015). Available at blog.ravelry.com/2015/02/03/community-eye-candy-5-million (accessed 6 October 2016).

44 Katie Allen, 'Quilty pleasures', *Bookseller*, 29 October 2010.

45 Kate Orton-Johnson, 'Knit, purl and upload: new technologies, digital mediations and the experience of leisure', *Leisure Studies* 33/3 (2014), pp. 305–21, p. 312.

46 Rhiannon Williams, 'How to kiss: the most Googled questions', *Telegraph*, 28 October 2014. Available at telegraph.co.uk/technology/google/ 11192191/How-to-kiss-the-most-Googled-questions.html (accessed 6 October 2016).

47 Stella Minahan and Julie Wolfram Cox, 'Stitch'nBitch: cyberfeminism, a third place and the new materiality', *Journal of Material Culture* 12/1 (2007), pp. 5–21, p. 8.

48 Middleton, 'Mending', p. 265.

49 Eirlys Penn, 'The big mend', Scrapiana (2016). Available at scrapiana. com/the-big-mend (accessed 6 May 2016).

50 Lewis-Hammond, 'The rise of mending'.

51 Read Laura Blackwell's blog at kathyimlost.co.uk.

52 For more information, visit bimbleandpimble.com/bpsewvember.

53 Lewis, 'Pride in the wool'.

54 Joy Spanabel Emery, *A History of the Paper Pattern Industry* (London: Bloomsbury, 2014).

55 Mookychick, 'Men who knit – part 3' (3 September 2014). Available at mookychick.co.uk/how-to/arts-and-crafts/men-who-knit-part-3.php (accessed 6 October 2016).

56 Tom West, 'What my knitting means to me', Not So Granny (20 August 2014). Available at notsogranny.com/2014/08/what-my-knitting-means-to-me-tom-west.html (accessed 10 August 2015).

57 Middleton, 'Mending', p. 266.

3

Identity, Connection and the Fashion Commons

At a university function a few years ago I was loitering in the vicinity of the tea urn when I bumped into an acquaintance. She complimented me on my dress, which I had recently made by copying a favourite piece from my wardrobe.

'Thanks,' I said. 'I made it myself.'

'Ah yes, I thought so,' she replied. 'Oh! But not in a bad way!'

This awkward response encapsulates much of the uncertainty that surrounds homemade clothes. Do these items look different from shop-bought items? Should they? And, more fundamentally, what does it mean to wear something you have made yourself? Before I can explore these complex questions, I need to start with the basics and gain an understanding of the broader fashion system. This system frames every aspect of our fashion experience – including homemade clothes.

Identity and Connection

As Janet Hethorn and Connie Ulasewicz propose in the introduction to their book *Sustainable Fashion: Why Now?*, fashion 'goes directly to who we are and how we connect to one another'.[1] Indeed: it is widely recognised that fashion plays a crucial role in terms of identity. But what exactly does this mean? Identity is a familiar concept, yet difficult to define – especially as the word has particular meanings for different academic disciplines. A sociological approach is most useful for the purpose of understanding fashion because it emphasises the link between the individual and society. As Kimberly Rogers and Lynn Smith-Lovin explain, 'Sociologists use the term "identity" to refer to the many meanings attached to a person, both by the self and others.'[2]

We gain these meanings from our roles in society, the groups to which we belong, and our personal characteristics.[3]

Of course, societies vary tremendously; taking a broad view of human history, there are countless examples of societies in which roles and affiliations are pretty much fixed according to factors such as gender, class, occupation, religion and race. In such societies a person's identity would be largely predestined according to the context into which they were born. Our contemporary Western society is much more fluid, meaning that we have greater choice over how to live. There are still forces shaping our opportunities: societal expectations relating to gender and race, for example, and the restrictions associated with poverty. Yet it is certainly the case that today, in countries such as the UK, people have complex identities, made up of multiple meanings and associations which evolve and change over time. Sociologist Anthony Giddens describes this evolving process as 'the reflexive project of the self'.[4]

One way in which a person creates their identity in this contemporary context is through their possessions. For most people, leisure and lifestyle have become more important than factors such as religion in creating a sense of identity. Thus, as sociologist Diana Crane explains, 'the consumption of cultural goods, such as fashionable clothing, performs an increasingly important role'.[5] Others in the field argue that our clothes are a particularly significant type of possession because of the close relationship they have with our bodies. Tim Dant, for example, identifies clothes as the objects which play the most intimate and constant role in our individual and social lives.[6] Dressing can, therefore, be seen as a practice of constructing identity through the materials of fashion.

The emphasis on construction, rather than reflection, of identity is important and requires us to consider some rather deep questions about the relationship between mind and body. Some philosophical perspectives consider the body to be a transient and undermining entity, separate from the true self deep within. Daniel Miller criticises this view, in which clothing is seen as a shallow, surface representation of the individual. He argues instead that self and surface are one and

therefore that clothing actively constructs a person's evolving identity.[7] Social psychologist Susan Kaiser takes a similar position in her discussion of dressing, which she describes as 'minding appearance':

> There is no 'essence' or 'true self' waiting to be discovered under the disguise of an appearance. Rather, minding appearance facilitates making the best possible approximation of who one is, and is in the process of becoming, in a given cultural moment.[8]

Identity construction is an ongoing process: our roles and affiliations are made and remade in everyday acts and interactions. As Sophie Woodward, whose doctoral research investigated the choices made by women about what to wear, explains, 'it is apparent that clothing does not simply reflect the self or identity. Instead, [...] clothing gives women a sense that they have a self and indeed that they can change it.'[9] It is important to note that this process of identity construction does not just take place when we buy new clothes or stand in front of the wardrobe wondering what to wear, but throughout the process of owning and disposing of our garments.

The process of identity construction relies on the meanings associated with our clothes. These meanings might relate to the style of the garment, in terms of its silhouette, detail or material, or to the designer or manufacturer, as communicated via (more or less visible) branding. Such meanings are not universal or fixed, however. As Miller describes, the symbolic meanings of all objects are highly variable, 'dependent upon the social positioning of the interpreter and the context of interpretation'.[10] This is particularly true within the contemporary fashion context; a single garment may be read in different ways by different viewers and in different contexts. Furthermore, a single outfit, or even a single item, can combine multiple – perhaps conflicting – meanings and messages. While this ambiguity can, at times, lead to a degree of confusion, it also means that clothes are particularly well suited to expressing and resolving the complexities and tensions of contemporary identity. Sociologist Fred Davis suggests that these tensions include 'youth versus

age, masculinity versus femininity, androgyny versus singularity, inclusiveness versus exclusiveness, work versus play, domesticity versus worldliness, revelation versus concealment, license versus restraint, and conformity versus rebellion'.[11] As Susan Kaiser puts it, clothing is 'good to think with' and can bring 'complex contradictions to the surface'.[12] As well as the meanings that are shared with others, it is important to note that we also attach personal meanings to our clothes, often based on memorable experiences. Such meanings may be deeply significant to the wearer, yet invisible to others.

Tim Dant explains that 'Wearing clothes is social in that what people wear is treated by those around them as being some sort of indicator of who they are.'[13] Clothes are vital to our self-presentation, helping us to communicate our identity to those around us. Even though the meanings associated with clothes are ambiguous and a wearer's intentions may be misread, research shows that our self-image is largely informed by external appraisals. Susan Kaiser describes three stages in this process: the way in which we imagine we appear to others; the way in which we imagine others to appraise this appearance; and a consequent inner feeling, such as pride or humiliation.[14] Therefore, the imagined gaze of others is ever present in our clothing decisions, connecting us with others in society.

We are connected, too, through the dynamic social processes of identification and differentiation. First identified by one of the grand-fathers of sociology, Georg Simmel, over a hundred years ago, identi-fication, or conformity, describes a need to belong and carries a sense of solidarity; differentiation, or individuality, describes a need to feel unique.[15] According to Kaiser, 'identification and differentiation are cultural principles or ideologies that are embedded deeply in a culture's collective consciousness'.[16] Because of their ubiquity and visibility, clothes play an important part in these processes. Kaiser explains that within contemporary society, most people conform to the style of a particular group, while expressing a degree of individuality through their selection of specific garments. As fashion journalist Maya Singer puts it, 'we all exist in dynamic relationship to our communities, and fashion is a medium for testing or strengthening those bonds'.[17] People vary

in their level of desired uniqueness according to various psychological and social factors. Interestingly, the need to conform is not constant, but varies throughout our lives. Furthermore, research shows that uniqueness is a self-correcting process – so when people start to feel too similar to others they find ways to reassert their individuality, and vice versa.[18]

Fashion, Well-Being and Social Norms

Bearing in mind these thoughts about identity construction and connecting with others, it is useful to consider the relationship between fashion and well-being. Does fashion satisfy any of the basic human needs described by development economist Manfred Max-Neef?[19] While clothing clearly meets the physical need for protection, I agree with Kate Fletcher and Lynda Grose that we primarily use fashion to meet our needs for identity and participation.[20] Writer Fredericke Winkler concurs, suggesting that 'fashion certainly has the potential to boost one's health. As a medium for endowing us with an identity and a method of interaction it has a positive effect on our spiritual and social state.'[21] I wonder whether fashion might also satisfy our needs for creation and leisure: the process of putting an outfit together can be a satisfyingly creative act, and the process of acquiring and selecting garments is, for many people, a pleasurable leisure activity.

There are further ways in which fashion gives us enjoyment – such as the tactile and embodied pleasures associated with clothing. Lynda Grose discusses 'simply feeling good in a well-fitting garment; and [...] the joy of touching something superbly well-crafted'.[22] This pleasure was certainly evident in the interviews I conducted with the Hereford knitters at the start of the project we undertook together. Each of them spoke about beautiful items of clothing in their wardrobes, and inadvertently demonstrated the tactile nature of knitwear by handling, stroking and folding each item as they talked about it. It has also been suggested that fashion satisfies our 'neophilia', or need for novelty,[23] though opinions differ as to whether this is a genuine human need or

a culturally acquired expectation. And, as Kate Fletcher points out, 'as we begin to accumulate more, we experience diminishing emotional returns of novelty and stimulation'.[24]

There is a flipside to this happy story: the many accounts which describe anxiety and embarrassment as being integral to experiences of fashion.[25] Reflecting on her observation of women getting dressed in the morning, Sophie Woodward describes how they often feel fashion to be a burden of expectation.[26] This anxiety derives in part from the uncertainty of contemporary fashion. In the past, sources of fashion authority instructed us clearly in how to dress. For example, during the restrictive 'class fashion' era of the nineteenth and early twentieth centuries, clothing expressed the social position of the wearer and stylistic rules were dictated by designers in Paris.[27] A broad range of styles is now on offer at any time and we receive contradictory information on what is 'in fashion'. Some people enjoy navigating this ever-shifting stylistic environment. Journalist Hadley Freeman explains that many people follow fashion 'because it's fun to feel part of a club and to talk in shared codes with other club members [...] The changeability is part of the thrill.'[28] Yet Woodward suggests that it is common for the uncertainty of trends to cause panic. The lack of clearly prescribed fashions frequently confuses, rather than solves, the problem of what to wear.[29]

Making the 'right' choices about what to wear is not just down to a keen awareness of the latest trends, for we experience social pressure that restricts our options. Appropriate choices are framed by social norms, which in turn are structured by wider factors such as gender, class, race, morality and sexuality.[30] Gender plays a particularly important role in shaping societal expectations. Joanne Entwistle describes the many ways in which women are culturally associated with dress and fashion; as she says, 'discourses on dress construct it as a "feminine" thing'.[31] On a similar note, Maura Banim, Eileen Green and Ali Guy argue that women 'are encouraged to aspire to the idealized body and the clothed image wrapped around it'.[32] Social norms tend to go unnoticed until they are transgressed, and even minor transgressions can cause a stir. For some people, this is desirable: dress is a highly effective means of

challenging restrictive stereotypes. Yet most of us, most of the time, are not looking to make a stand in this way, and therefore our choice of what to wear is not entirely open. Fleeting fashion trends must be balanced with entrenched social expectations and a judgement of the context to construct an outfit that does not stand out – or, perhaps, stands out to just the right degree.

In fact, a wide range of social and material factors affect our decisions about what to wear. In her writing on fashion theory, Efrat Tseëlon identifies three broad issues affecting clothing choices: 'the situation, the people present and the state of mind'.[33] Sociologist Colin Campbell discusses 'instrumental' considerations which play an important part in clothing decisions, including how well a garment fits and how comfortable it is to wear, and issues such as ease of cleaning.[34] A certain garment might seem to be the perfect choice in theory, yet be entirely unviable in material reality. As Banim, Green and Guy point out, clothes themselves exert agency over our clothing decisions. Garments which need to be clean, presentable and fit our bodies are often discovered to be crumpled, stained or no longer such a good fit; having selected an outfit, 'we then have to check that the chosen clothes are as we remember them and are "behaving themselves" that day'.[35]

After considering all this, I have to conclude that fashion can be simultaneously positive and negative in terms of well-being. The instability and ambiguity of fashion, which make it so able to express a changing identity, can also cause uncertainty and stress. According to Alison Clarke and Daniel Miller, this contradiction lies at the heart of modern life. They explain that while the decline of traditional societal structures has created the conditions for the plurality of contemporary fashion, 'You cannot have democratic liberty and equality without a concomitant sense of anxiety that is the precise result of that experience of freedom.'[36] It seems that we have to take the rough with the smooth: we can all benefit from the opportunity to construct identity and connect with others through fashion, but cannot eliminate the tensions associated with these processes.

The Fashion Commons

All of this theory has provided me with a useful basic understanding of fashion, but in order to move forward I need to return to the metaphor of fashion as common land that I introduced in Chapter 1. As a reminder: I see the fashion commons as comprising all of the garments – new, old, fashionable, unfashionable – in existence. (The size of this resource is astonishing: it is estimated that in the UK almost 6 billion items are hanging in our wardrobes.)[37] More conceptually, I see the commons as encompassing every style of dress there has ever been: the huge diversity of archetypal garment styles, shapes and details from different geographical areas and historical periods; fabric types and their associated construction methods; and the enormous variety of ways of wearing clothes, and their associated meanings, that make up the world's fashion and clothing cultures.

Susan Kaiser, writing about fashion and sustainability, suggests that 'metaphors suggest analogies that enable us to visualize and understand concepts that might otherwise be difficult to grasp'.[38] She explains that most metaphors for fashion are associated with industrial capitalism and reinforce the division between designer and wearer. For example, one metaphor proposes fashion as a pipeline. This sets up production and consumption as fundamentally separate activities and encourages the idea that materials can continually flow through the system, without limits. Kaiser argues that a sustainable fashion system requires circular and weblike metaphors, because existing models 'contribute to binary thinking [...] they ultimately limit our ability to envision new possibilities'.[39] I see the fashion commons as one such alternative metaphor, one that is particularly productive because it positions fashion as a life-sustaining or life-enhancing resource, shared among members of a group.[40] Furthermore, the metaphor places the focus squarely on wearers, rather than 'experts' such as designers, manufacturers, stylists or celebrities. In the process, it values the individual's embodied experience of wearing clothes and sidelines the obsession with image that defines much of contemporary fashion culture. While the concept of a commons is traditionally linked to land,

11. Imagining the fashion commons.

the principle is frequently extended to other physical resources, such as water and air, and intangible cultural resources – sometimes called the commons of the mind – such as open-source software and languages.[41] Although fashion could be logically placed into this intangible category, I like to think of it in terms of land. This brings hidden issues into focus and encourages me to consider ways in which we might safeguard this valuable shared resource.

To visualise the metaphor of fashion as common land, I imagine the diversity of the world's garments, styles and meanings distributed around a vast meadow, with wearers – all of us – moving around, selecting, combining and revitalising particular elements. Because fashion reflects preferences at a specific moment, areas of the meadow are accessed at different times and by different people. The way in which individuals move around the commons depends upon the degree to which they wish to stand out or conform. Activity is not evenly spread; some areas may have enduring appeal while others become popular for only a short time, until the 'erosion' of overexposure drives people away. Tim Dant describes how fashion 'acts as a living museum' and 'plays promiscuously with the past'; Pamela Church Gibson similarly

describes fashion as 'a storehouse of identity-kits, or surface parts'.[42] Thus, particularly fertile elements within the resource may return to favour time after time, renewed and layered with new meanings.

Enclosure

I believe that it is important to have an open fashion commons – that is, with all areas accessible – in order to give us the space to construct our identities and connect with others most effectively. By extending the metaphor of fashion as common land, I can look out for signs of enclosure: restrictions that limit access to an otherwise openly shared resource. Perhaps the most famous instances of enclosure were the Enclosure Acts of the eighteenth and nineteenth centuries which took the vast majority of common land in England into private ownership.[43] In an open fashion commons, we would have access to the full diversity of styles and ways of wearing them; enclosure would mean that these choices were restricted.

Christine Cox and Jennifer Jenkins, who specialise in intellectual property law, suggest that fashion is an open commons because it has minimal legal protections for its creative design; we are free to copy, recombine and transform existing design elements.[44] Despite this valid argument, I cannot help but feel that our access to this shared resource is actually rather restricted. The inherent dynamics of fashion are one form of constraint, as are the social norms that shape our dress. While we can challenge these norms by subverting the meanings within our clothing, these forces will never entirely disappear. I take this on board, but still wonder: is the fashion commons as open as it might be? Could there be aspects of the fashion system which impose 'external' restrictions on the freedom of wearers? I believe so: I feel that there are restrictions associated with the production of the clothes that fill our wardrobes. The vast majority of our garments are produced overseas – in China, Bangladesh or Turkey, for example – and most wearers have little experience or knowledge of how their clothes are made. Despite the current resurgence of sewing and knitting, folk fashion is still a relatively

peripheral area of activity. Thus, people are generally dependent on the clothing that is commercially available – and therefore the parts of the fashion commons that manufacturers choose to access.

This disconnect between production and use is a relatively recent phenomenon. In the first half of the twentieth century, making and mending were commonplace activities within the home. Fashion writer Colin McDowell describes the extent of domestic sewing expertise in 1930s Britain:

> Virtually every middle-class woman was a needlewoman of some level of skill [...] most were capable of taking a pattern – if not *Vogue*, then *Weldon's* or *Butterick* – and producing an acceptable cotton dress for summer or a woollen skirt for winter wear.[45]

Home sewing was just as widespread amongst working-class women at this time, though McDowell portrays their activities as rather less leisurely and aspirational, shaped instead by poverty and sheer necessity. After World War II, the picture shifted; cultural historian Christopher Breward describes how people had become much more accustomed to standardisation and were more receptive to mass-produced clothes.[46] As Margarethe Szeless explains, 'The motivation for home-dressmaking gradually transformed from an economical necessity during the 1950s to a creative recreational activity during the course of the 1960s.'[47] Leisure participation was initially high: one report claimed that in the USA in the 1960s there were 40 million home sewers, each averaging 27 garments per year, and 80 per cent of teenage girls made clothes for themselves.[48] Domestic dressmaking began to decline in popularity from the 1980s onwards, however; as women increasingly worked outside the home, they had less time and inclination for sewing.[49]

Knitting in the home was similarly prevalent in the early twentieth century. The drive to produce 'comforts' for the troops during World War I led to a revival of hand knitting, and women employed their skills to knit fashionable items for themselves after the war ended. World War II saw activity increase once again. Women knitted for both troops and family, as Sandy Black writes: 'Home knitting for the family

became crucial in eking out the ration of clothing coupons. These went much further in buying wool yarns than they did in buying clothes or even fabric.'[50] Knitting activity has long been influenced by the fashionableness of knitwear. Black describes the 1950s as 'the heyday of fashionable knitting' but suggests that homemade knitwear began to appear outdated in the 1960s, due to the craft's association with austerity.[51] Knitting enjoyed a return to popularity in the 1980s, but many laid down their needles in the minimalist 1990s, when sportswear, performance fabrics and fleece – impossible to knit at home – became popular.[52] Overall, then, the making of clothes shifted from an integral element of domestic life to a relatively marginal leisure pursuit during the twentieth century. Despite the resurgence of knitting and sewing in the early twenty-first century, textile-related making remains a distant and unfamiliar concept for many people.

We might be largely dependent on commercially produced clothes nowadays, but does that really mean that our choice is restricted? Many people would argue that we are able to pick from a very broad range of clothing options. Conventional economic thinking sees capitalism as creating choice, and today's fashion is much more diverse and plural than in the past. Nevertheless, just because the clothing we are

12. Homogeneous clothes in homogeneous shops.

offered on the high street is sufficiently diverse to cause confusion and anxiety, it does not mean that the fashion commons is as open as it could be. In fact, I would argue that although the contemporary fashion system is thought to offer an array of options, it is actually deceptively homogeneous. I strongly relate to the experience of a woman described by Sophie Woodward: 'each shop she goes into seems to present so many choices, yet these apparent choices mask a startling sameness in what she can buy'.[53] Although none of the Hereford knitters described the situation in such stark terms, they did describe frustrating searches for specific styles. Anne, for example, related her experience:

There is so much choice and I could spend an absolute fortune and I could find lots and lots of things I like. [But] I suppose I do feel constrained sometimes. What happens is, I think I'd like a so-and-so, and I have an image in my head, and it's just not available. So you search from shop to shop to shop to shop thinking, I've got this image in my head, and you never can find quite what you want.

The restriction is exacerbated when other factors are taken into account. Wearers unwilling to purchase clothing that they consider to be low quality, such as Hereford knitter Margaret, find their choices to be further limited:

I think, now, clothing is so cheap. I can't believe the thinness of the fabrics. When I was with Mum last, I took her to Marks & Spencer's as a treat, and both of us couldn't believe it. It's just so shoddy, so thin, so … stuff that won't last anything. I mean, I wouldn't even bother to go into a lot of shops, because I think it's just cheap tat that's not really interesting.

Writing about young women's experiences of fashion, Pamela Abbott and Francesca Sapsford describe how options are limited for individuals whose bodies do not conform to the standardised size ranges of high-street shops.[54] Anne went on to talk in detail about how size and fit restrict the choice of clothing available to her:

I find knitwear is easier to buy in the mainstream shops for my size, but if I want something like dresses or blouses or things, there's a lot of shops I couldn't go in, I wouldn't be able to get into them. I can't just go in any shop, you know, and get something. I find the last two or three years there've been quite a lot of fashions around which have a nod to the 1950s, '60s fashions, which I quite like. But they're in shops like New Look and places like that, which just don't really go big enough. They do have a bigger department, but that's not the same styles. I do like things that are a bit shaped, curved at the waist. In the bigger shops, it's just all very straight up and down, which I don't really like.

Alex – a woman in her sixties and another of the Hereford knitters – discussed the same topic:

There's a lot of disappointment. Mainly to do with fit. And I don't know whether that's because of my age, or my shape. I think women's shape does change throughout their lives. I mean, I've noticed from my own personal experience, my shape has changed. What is fashionable isn't cut to suit my figure. It's mainly in the waist and the hips. Tops are okay, but trousers are very difficult. And it's … do they want to sell clothes to my age group? I think, is it my fault for trying to wear something which is unsuitable for me, or is it their fault for only cutting for one shape?

Industrialisation and Restriction

Ben Fine and Ellen Leopold write about 'systems of provision': the unique economic and social processes which affect the production and consumption of different types of goods. They argue that the means by which clothing is produced affect not only the characteristics of the garments themselves, but also the workings of the entire fashion system.[55] The industrialisation of clothing depends on the standardisation of products and manufacturing methods; therefore,

it would seem that this relative homogeneity – and lack of choice in terms of style and fit – is an inevitable result of mass production and economies of scale. Fashion is thought to be defined by fast-paced change, but, as writer Kurt Andersen argues, the fashion industry is so vast that it actually requires predictability.[56] Adam Briggs confirms that despite the apparent speed of fast fashion, 'the design specification of a manufacturer's range still has to be relatively stable in order to be financially viable'.[57] This issue is heightened by the structure of the fashion industry. In the UK, clothing retail is dominated by a small number of powerful companies, with over a third of all clothing items sold by just three retailers: Primark, Asda and Marks & Spencer.[58]

My argument is that the designers, manufacturers and retailers who produce our clothing prescribe which areas of the fashion commons are available to us, and therefore restrict our access to it. Many would refute this claim, arguing that in order for retailers to sell their wares, they must anticipate what people will want to wear and provide it at a price point appropriate to their customers; therefore, these customers are ultimately in control of fashion. While I disagree, I do not want to fall into the trap of viewing consumers as gullible and passive individuals who are entirely controlled by a manipulative industry. As Elizabeth Wilson reminds us, 'this kind of explanation assumes that changes in fashion are foisted upon us, especially on women'.[59] On balance, I prefer historian Regina Lee Blaszczyk's suggestion that fashion is a collective activity, involving complex flows of information and influence between businesses, groups and individuals.[60] Essentially, I am proposing that those who produce our clothes restrict our use of the fashion commons because they make many choices about what is available and, as dependent wearers without an independent means of production, most people can only choose from the options provided. Naomi Klein makes a similar point in her book *No Logo*:

> media and retail companies have inflated to such bloated proportions that simple decisions about what items to stock in a store [...] now have enormous consequences: those who make these choices have the power to reengineer the cultural landscape.[61]

The dominating force of the fashion industry does not just affect the type of clothes that are available to purchase; perhaps more importantly, it actively sidelines other ways of acquiring clothes and experiencing fashion. As Kate Fletcher explains:

> Especially since the 1960s, a new hierarchy of fashion provision, driven by top designers and brands, has helped to displace nearly all other experiences of fashion. Shared public expectations of creating fashion are largely forgotten, with solutions now framed entirely within the shopping mall. Choices that don't fit into this paradigm are made to appear undesirable, impractical, or too expensive.[62]

While secondhand, tailor-made and homemade clothes do offer diverse alternatives, they are all marginal options compared to the mainstream culture of ready-to-wear. The system works effectively to prevent such options from gaining ground: as Kate Fletcher and Lynda Grose argue, homogeneous products mystify the practice of making clothes and keep consumers dependent.[63] Even people who are able to make their own clothes sometimes worry about the viability of their creations, wondering whether the aesthetic decisions they have made, and the quality of the finish they have achieved, will pass muster in comparison with shop-bought items. The fashion media, meanwhile, reinforce the dominance of commercial retailers because of their dependence on advertising revenue. As Hadley Freeman explains, 'The only negative words you'll ever see in a fashion magazine are ones used for styles from (ew!) last season.'[64] This has significant knock-on effects for the association between fashion and consumption, and therefore sustainability. As Joanne Finkelstein observes, 'if we are relying upon the properties of procured goods for our sense of identity, then we are compelled to procure again and again'.[65]

Enclosure and Well-Being

Now that I have explored the idea of enclosure of the fashion commons, I would like to consider the impact of this enclosure on well-being. It is

important to concede that it has had some positive effects on our lives. Mass production has made clothing easily accessible and removed the drudgery of making and mending clothes from the long list of women's domestic tasks. Before affordable ready-made clothes became the norm, these activities were, effectively, compulsory chores and thus could be a source of great resentment. Colin McDowell notes that during World War II 'darning and patching [...] were laborious, time-consuming and boring pastimes, far too difficult to be seen as a leisure pursuit by most women'.[66] Another argument is that fashion enclosure serves the collective cultural interests of the population by offering an array of clothes and thus enabling more people to participate in fashion freely and inexpensively. Even the restriction that I have identified could be seen as beneficial, given that – as well-being researcher Beverley Searle describes – overwhelming choice can result in 'paralysis rather than liberation, with consequential misery rather than satisfaction'.[67]

Despite these potential benefits, there are indications that enclosure has created many negative effects in terms of well-being. Some anxiety is inherent in contemporary fashion, but I think that this restriction tips the balance, heightening the negative aspects while compromising our ability to access the positives. Sewing blogger Jenny Rushmore offers a firsthand perspective of the frustration it causes. She describes the 'grinding and dispiriting' experience of 'trudging up and down the high street, reaching to the back of the rack, and attempting to jam yourself into things you don't even really like'.[68] From a more conceptual position, I would argue that in order to express and resolve our identities, we need a diversity of options from which to draw. We need space to move around the commons, to identify with and differentiate ourselves from others, and to make gaps and juxtapositions between styles. The restriction of access to the full fashion commons therefore curtails our ability to satisfy our human needs. While too much choice can indeed be overwhelming, Searle goes on to point out that a 'fallacy of choice' – being told you have open choice, when in fact your options are limited – can undermine well-being.[69]

A further issue is that a restricted commons affects future fashion innovation. The creation of new fashions depends on fragments of

previous styles being revisited and remixed; a constrained commons means that we have less and less to play with. The impact of homogenised fast fashion can already be seen in the racks of identikit jerseywear in British charity shops. In the sphere of folk music, song collector Alan Lomax saw 'musical diversity as akin to biodiversity; every song style that disappeared was potentially as serious a tragedy as the loss of a species'.[70] I propose the same argument in terms of fashion: the less diverse our fashion culture, the less vibrant, rewarding and satisfying it becomes.

All of this stuff, all of this sameness, sometimes gets me down. I feel a genuine sense of outrage that the identikit shops which dominate our high streets have come to control our wardrobes. These corporate forces have not only monopolised the clothes that we wear but also affected our ideas of what we can do ourselves. This idea depresses me enormously. It was this indignation that got me started thinking about enclosure: a vague memory of the Enclosure Acts left over from high-school history lessons was the best comparison I could find to describe the loss and injustice I felt. But my outlook on life is generally optimistic, and so I soon remember that the power to challenge this monopoly is in my – our – hands. Clothes are an incredibly accessible type of possession; the techniques used to make them are basically the same, whether working at home or in a factory. And, as Kate Fletcher argues, 'action, not watching, or looking, [is] a powerful fashion currency'.[71] By picking up needle and thread and making things ourselves, we can regain our access to the fashion commons, and we can wander at will.

Notes

1 Janet Hethorn and Connie Ulasewicz (eds), *Sustainable Fashion: Why Now? A Conversation About Issues, Practices, and Possibilities* (New York: Fairchild, 2008), p. xix.
2 Kimberly B. Rogers and Lynn Smith-Lovin, 'Action, interaction, and groups', in George Ritzer (ed.), *The Wiley-Blackwell Companion to Sociology* (Oxford: Blackwell, 2011), pp. 121–38, p. 121.

3 Peter J. Burke and Jan E. Stets, *Identity Theory* (Oxford: Oxford University Press, 2009).

4 Anthony Giddens, *Modernity and Self-Identity: Self and Society in the Late Modern Age* (Stanford: Stanford University Press, 1991), p. 5.

5 Diana Crane, *Fashion and its Social Agendas: Class, Gender and Identity in Clothing* (Chicago: University of Chicago Press, 2000), p. 11.

6 Tim Dant, *Material Culture in the Social World: Values, Activities, Lifestyles* (Buckingham: Open University Press, 1999).

7 Daniel Miller, *Stuff* (Cambridge: Polity, 2009).

8 Susan B. Kaiser, 'Minding appearances', in Joanne Entwistle and Elizabeth Wilson (eds), *Body Dressing* (Oxford: Berg, 2001), pp. 79–102, p. 90.

9 Sophie Woodward, *Why Women Wear What They Wear* (Oxford: Berg, 2007), p. 157.

10 Daniel Miller, *Material Culture and Mass Consumption* (Oxford: Blackwell, 1987), p. 106.

11 Fred Davis, *Fashion, Culture, and Identity* (Chicago: University of Chicago Press, 1992), p. 18.

12 Kaiser, 'Minding appearances', p. 84.

13 Dant, *Material Culture in the Social World*, p. 107.

14 Susan B. Kaiser, *The Social Psychology of Clothing: Symbolic Appearances in Context*, revised 2nd edn (New York: Fairchild, 1997).

15 Georg Simmel, 'Fashion', *International Quarterly* 10 (1904), pp. 130–55.

16 Kaiser, *The Social Psychology of Clothing*, p. 471.

17 Maya Singer, 'Hear us roar: finding feminism in fashion', *Vogue* (5 September 2014). Available at vogue.com/13268564/finding-feminism-in-fashion (accessed 6 October 2016).

18 Charles R. Snyder and Harold L. Fromkin, *Uniqueness* (New York: Plenum, 1980).

19 Manfred Max-Neef, 'Development and human needs', in Paul Ekins and Manfred Max-Neef (eds), *Real-Life Economics: Understanding Wealth Creation* (London: Routledge, 1992), pp. 197–213.

20 Kate Fletcher and Lynda Grose, 'Fashion that helps us flourish', conference paper, Changing the Change: Design, Visions, Proposals and Tools (Turin, 10–12 July 2008).

21 Fredericke Winkler, 'Fashion is bad for your health', *J'N'C* 1/12 (2012), pp. 59–63, p. 59.

22 Lynda Grose, 'Future visions: making the links', conference paper, Towards Sustainability in the Fashion and Textile Industry, Copenhagen, 26–27 April 2011, p. 5.

23 René König, *The Restless Image: A Sociology of Fashion* (London: Allen and Unwin, 1973).

24 Kate Fletcher, 'In the hands of the user: the Local Wisdom Project and the search for an alternative fashion system', *Journal of Design Strategies* 7 (2015), pp. 10–17, p. 12. Available at http://sds.parsons.edu/designdialogues/?post_type=article&p=630 (accessed 6 October 2016).

25 Efrat Tseëlon, *The Masque of Femininity: The Presentation of Woman in Everyday Life* (London: Sage, 1995); Alison Clarke and Daniel Miller, 'Fashion and anxiety', *Fashion Theory* 6/2 (2002), pp. 191–213; Woodward, *Why Women Wear What They Wear*.

26 Ibid.

27 Crane, *Fashion and its Social Agendas*.

28 Hadley Freeman, 'Why do people bother keeping up with fashion?', *Guardian*, 13 November 2011. Available at theguardian.com/lifeandstyle/2011/nov/13/people-bother-keeping-up-fashion (accessed 6 October 2016).

29 Woodward, *Why Women Wear What They Wear*.

30 Kim Sawchuk, 'A tale of inscription/fashion statements', in Arthur Kroker and Marilouise Kroker (eds), *Body Invaders: Sexuality and the Postmodern Condition* (Basingstoke: Macmillan Education, 1988), pp. 61–77.

31 Joanne Entwistle, *The Fashioned Body: Fashion, Dress, and Modern Social Theory* (Cambridge: Polity, 2000), p. 21.

32 Maura Banim, Eileen Green and Ali Guy, 'Introduction', in Ali Guy, Eileen Green and Maura Banim (eds), *Through the Wardrobe: Women's Relationships with Their Clothes* (Oxford: Berg, 2001), pp. 1–17, p. 6.

33 Tseëlon, *The Masque of Femininity*, p. 55.

34 Colin Campbell, 'The meaning of objects and the meaning of actions', *Journal of Material Culture* 1/1 (1996), pp. 93–105.

35 Banim, Green and Guy, 'Introduction', p. 4.

36 Clarke and Miller, 'Fashion and anxiety', p. 211.

37 Faye Gracey and David Moon, *Valuing Our Clothes: The Evidence Base* (Waste & Resources Action Programme, 2012). Available at wrap.org.uk/sites/files/wrap/10.7.12 VOC- FINAL.pdf (accessed 6 October 2016).

38 Susan B. Kaiser, 'Mixing metaphors in the fiber, textile and apparel complex: moving toward a more sustainable fashion', in Janet Hethorn and Connie Ulasewicz (eds), *Sustainable Fashion: Why Now? A Conversation About Issues, Practices, and Possibilities* (New York: Fairchild, 2008), pp. 139–64, p. 140.

39 Ibid., p. 143.

40 Justin Kenrick, 'Commons thinking', in Arran Stibbe (ed.), *The Handbook of Sustainability Literacy* (Totnes: Green Books, 2009), pp. 51–7.

41 Silvia Federici, 'Feminism and the politics of the commons', *The Commoner* (2011). Available at commoner.org.uk/wp-content/uploads/2011/01/federici-feminism-and-the-politics-of-commons.pdf (accessed 6 October 2016).

42 Dant, *Material Culture in the Social World*, p. 93; Pamela Church Gibson, 'Redressing the balance: patriarchy, postmodernism and feminism', in Stella Bruzzi and Pamela Church Gibson (eds), *Fashion Cultures: Theories, Explorations and Analysis* (Abingdon: Routledge, 2000), pp. 349–62, p. 356.

43 J. M. Neeson, *Commoners: Common Right, Enclosure and Social Change in England, 1700–1820* (Cambridge: Cambridge University Press, 1993).

44 Christine Cox and Jennifer Jenkins, 'Between the seams, a fertile commons: an overview of the relationship between fashion and intellectual property', conference paper, Ready to Share: Fashion and the Ownership of Creativity (USC Annenberg School for Communication and Journalism, Los Angeles, 29 January 2005). Available at learcenter.org/pdf/RTSJenkinsCox.pdf (accessed 6 October 2016).

45 Colin McDowell, *Forties Fashion and the New Look* (London: Bloomsbury, 1997), p. 28.

46 Christopher Breward, *Fashion* (Oxford: Oxford University Press, 2003).

47 Margarethe Szeless, 'Burda fashions – a wish that doesn't have to be wishful thinking: home-dressmaking in Austria 1950–1970', *Cultural Studies* 16/6 (2002), pp. 848–62, p. 853.

48 Joy Spanabel Emery, *A History of the Paper Pattern Industry* (London: Bloomsbury, 2014), p. 178.

49 Ibid.

50 Sandy Black, *Knitting: Fashion, Industry, Craft* (London: V&A Publishing, 2012), pp. 137–8.

51 Ibid., p. 144.

52 Ibid.

53 Woodward, *Why Women Wear What They Wear*, p. 122.

54 Pamela Abbott and Francesca Sapsford, 'Young women and their wardrobes', in Guy, Green and Banim, *Through the Wardrobe*, pp. 21–38.

55 Ben Fine and Ellen Leopold, *The World of Consumption* (London: Routledge, 1993).

56 Kurt Andersen, 'You say you want a devolution?', *Vanity Fair (USA)*, January 2012. Available at vanityfair.com/style/2012/01/prisoners-of-style-201201 (accessed 6 October 2016).

57 Adam Briggs, 'Response' [to Chapter 3], in Christopher Breward and Caroline Evans (eds), *Fashion and Modernity* (Oxford: Berg, 2005), pp. 79–81, p. 81.

58 Andrea Felsted, 'Asda overtakes Marks and Spencer in clothing market', *Financial Times*, 14 August 2014. Available at ft.com/cms/s/0/ 4d90a934-23cc-11e4-be13-00144feabdc0.html (accessed 28 September 2015).

59 Elizabeth Wilson, *Adorned in Dreams: Fashion and Modernity* (Berkeley: University of California Press, 1987), p. 49.

60 Regina Lee Blaszczyk, 'Rethinking fashion', in Regina Lee Blaszczyk (ed.), *Producing Fashion: Commerce, Culture, and Consumers* (Philadelphia: University of Pennsylvania Press, 2008), pp. 1–18.

61 Naomi Klein, *No Logo: Taking Aim at the Brand Bullies* (London: Flamingo, 2000), p. 165.

62 Fletcher, 'In the hands of the user'.

63 Fletcher and Grose, 'Fashion that helps us flourish', p. 5.

64 Hadley Freeman, 'Flares are ridiculous. Pity the desperate designers who bring them back into fashion', *Guardian*, 19 January 2015. Available at theguardian.com/fashion/2015/jan/19/flares-designers-fashion (accessed 6 October 2016).

65 Joanne Finkelstein, *The Fashioned Self* (Cambridge: Polity, 1991), p. 145.

66 McDowell, *Forties Fashion and the New Look*, p. 98.

67 Beverley A. Searle, *Well-Being: In Search of a Good Life?* (Bristol: Policy Press, 2008), p. 29.

68 Jenny Rushmore, 'Sewing my clothes is an escape from fashion's dictates. I no longer hate my body', *Guardian*, 3 August 2015. Available at theguardian.com/commentisfree/2015/aug/03/sewing-clothes-escape-fashion-dictates-no-longer-hate-my-body (accessed 6 October 2016).

69 Searle, *Well-Being,* p. 29.

70 John Szwed, *The Man Who Recorded the World* (London: Arrow Books, 2010), p. 390.

71 Kate Fletcher, *Craft of Use: Post-Growth Fashion* (Abingdon: Routledge, 2016), p. 185.

4

Why DIY?

The Experience of Making and Wearing Homemade

In 1932, frustration was growing amongst the people of Manchester. Rambling was a popular leisure activity for the working class, but the vast majority of the nearby Peak District was privately owned and there were very few open footpaths. A mass trespass of the highest peak in the area, Kinder Scout, was organised to demand the right to roam. The trespass led to several arrests but prompted a huge wave of public sympathy and ultimately had a great impact, influencing the creation of Britain's National Parks in 1949 and still inspiring activists today.[1]

I like to think of people making their own clothes as somewhat like the Kinder trespassers: claiming the right to roam through the fashion commons by physically taking action. Yet taking action is not as simple as grabbing some materials, throwing an item together and adding it to the wardrobe. When we wear our homemade clothes in a world dominated by mass-produced items, the conflicting meanings associated with folk fashion come to the fore. The twenty-first-century resurgence of making has contributed to a positive perception of homemade clothes; today, the practice of sewing or knitting your own items to wear is seen in some spheres as creative, anarchic and youthful. Yet conversations with makers highlight various negative factors which complicate the folk fashion experience.

The Making Process

Before I consider how it feels to wear a homemade item, I would first like to have a good look at the experience of making – and especially

the various benefits that makers derive from this activity. The social aspects of making are rightly celebrated as an important motivation for taking up a craft. The vital online and offline networks which make up folk fashion culture are testament to the value of finding like-minded peers with whom to share interests, ideas and challenges. Making does not just help us to meet new people but can provide a valuable point of common interest with family members. Textile crafts can also provide a means of connecting with those who are absent. In her interview Rachael Matthews explained that she has met many new knitters who are motivated by the death of a family member who knitted for them or taught them to knit as a child; re-engaging with the practice provides a means of emotional connection.

Another benefit of making relates to the internal conversation taking place between head, hands and material. Makers often find themselves becoming absorbed in the process of making, losing awareness of the outside world. Textile artist Abigail Doan suggests: 'We can lose ourselves in the patterns and textures created, and this for me is extremely therapeutic and restorative. It creates a one-to-one relationship that makes everything else simply fade away.'[2] Interviewee Tom van Deijnen described his experience of knitting in a similar way: 'I do find it meditative. If I'm on a roll, I find it really calming and soothing. You know, if you're in the flow, suddenly it's an hour later.' In fact, makers often refer to the concept of 'flow'. Psychologist Mihály Csíkszentmihályi uses the term to describe total absorption in an activity, losing a sense of time, place and self-consciousness.[3] Wendy Parkins suggests that the experience of making in a flow state can 'free the knitter from the constraints of time in everyday life'; this can be particularly beneficial, considering the busy lives that many people lead.[4] Comments about making that I gathered at the drop-in knitting tent activity (introduced in Chapter 1) show how important this can be. One reads: 'It looks good, it feels good, it takes forever ... antidote to our too speedy society.' Another describes 'Leisure time for craft – resolution to make space.'

My conversations with makers have revealed that there are two quite different modes of making, both of which offer opportunities for flow. One is rhythmic and repetitive, carried out without a

great deal of conscious attention, while the other requires focused concentration. The rhythmic mode often relates to hand knitting and hand stitching – at least, once people are past the tricky early stages of learning. An ongoing research project, Stitchlinks, is seeking to provide evidence for anecdotal claims of the therapeutic benefits of this type of making and to understand its physical effects. The project has found that these repetitive movements enhance the release of serotonin.[5] Comments gathered at the drop-in knitting activity

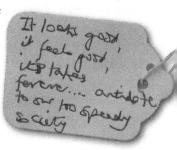

13. Knitting tent tag #21.

frequently include words such as 'relaxing', 'therapeutic', 'peaceful', 'contented' and 'soothing'. This mode of making has also been linked to mindfulness and meditation. One of the Hereford knitters, Alex, described how hand knitting allows her to empty her mind, yet work through problems:

> It frees the mind to just wander, and think about things. Not necessarily deep thinking, but just things pass through your mind, and sometimes you can ponder on something that might be bothering you. You sort of take it out and have a little look at it now and again, without solving it, but you know, it helps.

Rosie Martin suggested that sewing a garment with a machine offers a different experience to this rhythmic and repetitive activity – though no less absorbing:

> I do think of sewing as toil – it's hard! You have to spread out, you have to think, you have to do maths, you have to cut right. You have to be alone – sometimes I have to turn music or podcasts off, because I can't concentrate.

Knitting also involves this focused mode of activity from time to time. Tricky procedures, such as picking up the stitches for a collar or fixing

a mistake, demand concentration and generally require a quiet space with plenty of light. While many people enjoy getting lost in their craft for an extended period, if necessary both of these modes of making can be broken up into short bursts of activity. In her interview, Laura Blackwell described taking up sewing after the birth of her daughter, because she found that the activity lent itself well to the brief periods of time she had available. Similarly, knitters often carry mobile projects to make the most of short gaps in a busy day.

Materials and Skills

When making, the body works with materials to construct an object, and this interaction offers further rewards. Emma Shercliff observes that 'Playing with pattern, shape, colour and materials is pleasing perceptually, emotionally and cognitively.'[6] Rachel Moseley agrees that makers find joy in the 'design, construction, texture and colour' of homemade garments.[7] There is great tactile pleasure to be derived from engaging with materials. Jeweller and writer Bruce Metcalf suggests that people who take to a craft experience 'a powerful intuitive response to the labour of manipulating a particular craft material'.[8] When I asked the Hereford knitting group why they enjoyed knitting, several responded by simply raising the needles and yarn in their hands.

Another satisfaction associated with making is the opportunity to build, to create something that did not previously exist. Julia, a member of the Hereford knitting group, spoke about the joy of seeing an item gradually take shape: 'It's creating something, isn't it? I think it is just having these balls of wool and the needles and then ... eventually you end up with something, it's lovely.' Various writers have commented on the significance of this experience. Anthropologist Ellen Dissanayake, for example, discusses the sheer enjoyment of bringing something new into existence, and having 'an indisputable effect on the world'.[9] Rozsika Parker describes how an embroiderer 'holds in her hands a coherent object which exists both outside in the world and inside her head' and explains that this has a great positive impact on the sense

of self.[10] Community architect Christopher Alexander involved local people in the design and construction of their own dwellings and writes eloquently of the effect of this experience. His observations could equally apply to folk fashion:

> They have made themselves solid in the world, have shaped the world as they have shaped themselves [...] They, they themselves, have created their own lives, not in that half-conscious, underground, interior way that we all do, but manifestly, out there on their own land: they are alive; they breathe the breath of their own houses ...[11]

The mending experience is slightly different, though no less satisfying: rather than bringing something new into the world, we are altering and reshaping the things around us.

The joy of creating a physical item is not just about the immediate experience of building and finishing it; it is also about producing something that can provide a valuable lasting mark of effort. As many feminist writers over the years have pointed out, women frequently find their time to be filled by domestic tasks, such as cooking, washing and tidying, which leave no permanent evidence. In contrast, craft offers an opportunity to leave a mark, as Hereford knitter Kiki observed: 'Something to do with leaving something behind. You know, continuity. Something nice about leaving something behind that you have made.' Researchers Despina Tzanidaki and Frances Reynolds point out that makers can gain a similarly satisfying, yet less materially evident, feeling of 'handing down' when they teach craft skills and traditions to a younger generation.[12]

Working with the inherent challenges of making offers yet another source of pleasure. Matthew Crawford, in his bestselling book *The Case for Working with Your Hands*, discusses the satisfaction of working within objective standards, such as – for makers working with hard materials – those provided by a spirit level or set square.[13] Similarly, Peter Dormer suggests that crafts offer clear criteria for success or failure, and that these certainties provide comfort in an uncertain world.[14] Sewing and knitting are full of objective standards: getting a

collar straight and symmetrical; matching stripes at a seam; knitting a fabric with its stitches configured exactly as intended. Folk fashion makers gain satisfaction from coming up against, and successfully dealing with, these challenges – or, as woodworker Peter Korn puts it, 'the engaged pursuit of quality'.[15] Laura Blackwell explained that she enjoys the challenge presented by a man's shirt:

> I really love making men's shirts because they've got loads of bits to them, loads of variables. And you know what you're supposed to end up with at the end. You can tell the difference between a good one and a bad one at a glance.

Making also offers the satisfaction of working with your hands and body in a skilled manner, because craft offers a rare outlet for what Howard Gardner identifies as bodily kinaesthetic intelligence.[16] Sewing and knitting require familiarity with stitches and the fine hand movements required to make them, meaning that bodily knowledge is as important as, or more important than, visual and cognitive knowledge. For some people this is a deep-seated need. As Laura described, 'Physically making something with your hands, I love it. Always have done. And if I don't do it for a few days, I get a bit irritable.' Indeed, learning how to work with your hands effectively can be incredibly satisfying. As Korn explains, 'There is a deep centeredness in trusting one's hands, mind, and imagination to work as a single, well-tuned instrument.'[17]

Furthermore, crafts such as sewing and knitting offer the opportunity to develop skills over a lifetime. Laura pointed out that her practice of sharing finished projects on Instagram helps her to see her own progression. Kate Orton-Johnson agrees that digital space offers a valuable opportunity to build an archive of projects and thus create a 'digital record of skill, expertise and knowledge'.[18] Rosie Martin also mentioned the importance of personal growth, pointing out that the satisfaction of making is 'not just producing the one item, but the lifelong satisfaction of having a hobby that you can just keep growing steadily in the background: it's a constant in your life, an ongoing project'. Finally,

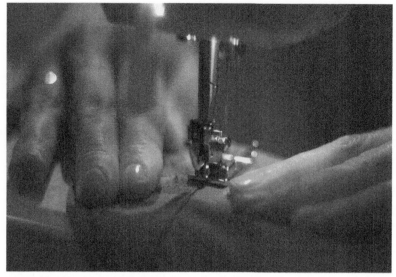

14. The tactile skill of sewing.

making offers valuable opportunities for creative expression; a recent survey of American knitters and crocheters found this to be the most common reason for engaging in craft.[19]

Making and Well-Being

Returning to Manfred Max-Neef's list of human needs, it is apparent that the process of making – like fashion – helps to satisfy our need for participation, as well as providing a source of leisure and creation.[20] As I will discuss in more detail, it also satisfies our need for identity. Thus, making can provide an important contribution to well-being. This corresponds with the research being carried out by Stitchlinks; though the project is primarily concerned with the benefits of knitting and stitching for people with health problems, it has found that the 'possible physiological, neurological, psychological, behavioural and social changes' brought about by such activities are applicable to everyone.[21]

Other studies have similarly found that art and craft participation is directly linked to positive well-being. A report published by Voluntary Arts England found that 'regular participation in creative activities has benefited people physically, mentally, emotionally and socially'.[22]

In *Making is Connecting*, David Gauntlett explores the relationship between making and happiness. He identifies many of the benefits outlined above and emphasises the importance of having something to work towards, quoting writer Richard Layard's aphorism, 'Prod any happy person and you will find a project.'[23] Psychologist Sonja Lyubomirsky and her colleagues describe the value of activities which are structured around goals, such as craft projects, and they explain that the act of choosing to do an activity increases its positive impact. This indicates why we can get such satisfaction out of practices such as making and mending which were standard household activities for many people, and even regarded as drudgery, in the past.[24] Gauntlett also highlights the value of sharing and collaboration. He emphasises the fact that social connections, such as those created through making, are crucial for a healthy society:

> having friendly social connections and communication, and working together with people on shared projects, is not merely pleasant-but-optional 'icing on the cake' of individual lives, but is absolutely essential both for personal well-being and for a healthy, secure, trustworthy society.[25]

Although it is clear that the process of making offers many benefits, it is important to acknowledge that some people experience barriers to participation in craft. For example, one comment gathered at the drop-in knitting activity indicated that the participant used to make a lot of clothes, but is now unable to, due to various infirmities. Other problems relate to the time required for making. When researching quilting in the USA, Marybeth Stalp found that many women did not have much leisure time and felt a stigma about pursuing hobbies alongside paid work and caring for their families.[26] This stigma clashes with the maker's urge to lavish time on projects in the pursuit of quality – or, for some,

quantity. Even those who are able to make can experience frustrations. My conversations with knitters over the years have indicated that many are unhappy with the patterns that are available, and have a desire for more freedom and creative input. Furthermore, I have found makers to be sometimes dissatisfied with the things that they have made, which can affect their enjoyment of the making process.

The Finished Garment

Research into amateur craft has raised thought-provoking questions about the relationship between the process of making and the outcomes it creates. In his study of a diverse range of makers, researcher Andrew Jackson found that 'the possession or use of the final artifact was the least important part of the activity'.[27] Sociologist Marybeth Stalp identified a similar attitude amongst amateur quilters.[28] In his writing on amateur craft, Stephen Knott likewise argues that 'the experience of time [...] is more important than the end result'.[29] While I agree that the process of making is both complex and valuable, and for some people the main motivation for engaging in craft, my research has uncovered a rather different situation in the world of folk fashion. For the vast majority of people making their own clothes, the outcome of their making – and the ability to make use of that outcome – is significant. The anticipation of, and desire for, the finished item provides the initial motivation for many new makers; this interest remains highly relevant for people at all levels of experience. The output is the goal of the making project, the finishing line which is slowly worked towards. A garment is intended for use, and wearing a homemade garment legitimates the activity of making it. This comment by Hereford knitter Margaret epitomises the importance of the finished item as a goal: 'There's definitely a desire to make something for me. That's the impulse, the drive, is to make something. I would like the garment, that's the big motivation.'

When a maker is choosing what to make and thinking ahead to the goal of their finished garment, economic considerations are never far away. Home making certainly was the cheaper option in the past,

and journalist Huma Qureshi proposes that it is still a means of saving money today.[30] Some people do manage this – for example, by repairing and remaking items in their wardrobe, or by purchasing materials particularly cheaply. Carol, a home sewer who enjoys working with vintage fabrics and patterns, described picking up inexpensive materials from car-boot sales and charity shops. Hereford knitter Alex similarly takes pride in knitting herself a bargain, describing a Fair Isle jumper she had knitted herself for just £8. This possibility depends on the price of the materials you choose to buy, however. It is fair to say that in today's era of inexpensive high-street fashion, you could usually buy a finished item for less than the raw materials – especially as many makers feel that they should complement their investment of time in making with an investment in quality materials. Yet this equation is not as simple as it might seem; all garments are not created equal. Just because you could buy a dress for less than it might cost you to make one yourself, does not mean that you would actually want the one you could buy for that price! If you compare the price of the item you genuinely desire – taking quality, fibre, fit and finish into account – then homemade can, once again, be the pleasingly inexpensive option. Interviewee Christine Cyr Clisset, who was first motivated to sew by the garments she saw in upmarket boutiques, explained that she still thinks in the same way: 'I'll go into a boutique and see a silk shirt for $200. I'm like, I'm not going to spend that much money on that, I'm going to make my own. I can make something just as nice.'

Through making, we can also create clothes that are fitted to our exact specifications. It is worth noting that for people whose bodies do not conform to the standard norm, this can be particularly valuable. Jenny Rushmore describes the impact of learning to make her own clothes after struggling to find items to fit her on the high street:

> As my skills grew, I started making clothes that actually fitted me well for the first time in my life, and my body image started shifting in parallel. As I shrugged off set clothes sizes and started making garments that precisely fit my dimensions, the feeling of abnormality and exclusion began to lift.[31]

Furthermore, we can create garments in the colour, fabric and style that we want to wear. This opportunity was key in the promotion of dressmaking to women as an aspirational leisure activity during the 1950s and 1960s. Margarethe Szeless quotes a sewing machine advertisement from *Burda* magazine in 1956: 'Those who can sew are better off! Modern and successful women, who know how to sew, can easily keep up with fashion trends.'[32] The ability to make our own aesthetic choices can also, of course, help us to *avoid* oversaturated fashion trends. Hereford knitter Margaret spoke about not finding the clothes she wanted in the shops, and reflected: 'I must start making ... I think that's the conclusion I've come to, just start trying to make things up. I suppose what I'm wanting is just something that looks a little bit different, a bit more individual.'

'Turning Out'

Many makers manage to create good-quality, well-fitting and unique garments which they are proud to wear. The many sewers and knitters who showcase their successful projects via Instagram and other platforms for the annual 'Me Made May' challenge are testament to the amazing work being produced within the folk fashion community.[33] Yet from my own experience and conversations with others I know that folk fashion projects frequently do not 'turn out' as hoped. As Stephen Knott points out, external observers should not judge the value of amateur craft by its outcomes.[34] Yet, to understand the lived experience of folk fashion makers, it is important to acknowledge that people are sometimes disappointed by their completed projects. Roaming through the fashion commons is somewhat dangerous: we might be free to create garments of whatever style we wish, but we also have to take responsibility for their successful execution. In some cases, a maker is initially happy with the outcome of a project but later looks back with a more critical eye, as Laura described:

I think the thing that you can't recognise when you start making stuff is, is it any good? You're just really pleased with yourself that you

made a thing with a neck hole and two armholes – you've already won! And then you get a bit further on and look back at the old things and think, they weren't that good.

In many cases the disappointment is more immediate; these pieces may never be worn. Comments from the drop-in knitting activity about homemade clothes encapsulate the issues that can be encountered. One person wrote: 'Often disappointed: they never quite match up to how I imagined and hoped them to turn out!' Another suggested: 'Cheap and nice idea but takes well long and ends up looking shit if your sewing skills are anything like mine.' At the start of the reknitting project Kiki described the majority of her attempts to knit garments for herself as 'unwearable'. This comment, made in response to a *Guardian* article by Sarah Ditum about homemade clothes, strikes a similar tone:

> It's when you get two uneven sleeves and you can't get the shoulders right for love nor money that you realise you've walked out of your high street relationship too soon. [...] Knitting can be therapeutic so long as you don't expect what you produce to be wearable.[35]

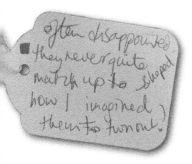

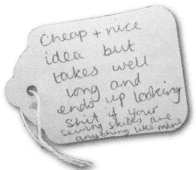

15. Knitting tent tag #44. 16. Knitting tent tag #14.

These comments indicate the difficulty of achieving a high-quality fit and finish, and highlight the skills that are involved in creating a 'successful' garment. Jo Turney suggests that 'the notion that knitting is "easy" [is] fundamental to its revival'. Yet, as she points out, the skills

required to construct a knitted garment are considerable.[36] Reflecting on her early sewing projects, Laura felt she had encountered multiple challenges, including fabric choice, fit and finish – perhaps influenced by books encouraging new sewers to try quick projects, such as making a skirt in an afternoon. Even those with well-developed skills encounter occasional problems. Tom, one of the most expert knitters I know, explained that he, too, has projects which sit unworn in the wardrobe. Some issues are down to style rather than skill. As Rosie described, sometimes you may finish a garment and then discover that it simply does not suit you. She distinguishes these 'personal fails' – which someone else would enjoy wearing – from 'actual fails'. Whatever the case, it is often only when the item is complete that the maker discovers whether their efforts have been successful. This can be incredibly frustrating, as Hereford knitter Anne indicated:

> I always have this thing about, you buy the wool you like, and you buy the pattern, and then when it's made up, it doesn't seem to sit right, or look right, or it's not the right shape for you or something. You spend all that time and money, and then it just looks a bit of a dog's dinner at the end of it!

Another comment from the *Guardian* article identifies this issue as a significant disadvantage of making your own clothes: 'I know you don't get the same warm glow of satisfaction, but there's a lot to be said for trying something on that someone else has made, before you buy it.'[37]

The Maker's Gaze

While these concerns about finished items are relatively pragmatic, I feel that there are often more internal processes at work which affect our feelings about clothes we have made ourselves. One such factor links to the experience of building an item from nothing: seeing the pieces appear and become combined into the finished article, in your hands. Having worked so closely with the garment during this process – and

taken care along the way – there is a tendency to become hypercritical of the completed item. Rosie spoke about this issue amongst sewers:

> Learners can get so stressed out. They're looking through the magnifying glass at what they've done. And I'm like, if you tried something on in Topshop, stood ten feet back from the mirror and looked at it, you wouldn't be looking at whether their stitches were straight. You'd be thinking, Do I like the colour? Do I like how it hangs generally? Do I like how it makes me feel?

I remember a chat relating to this topic with a hand knitter at one of my workshops a few years ago. She observed that when she has knitted a garment, she still perceives it as separate sections, each bearing the emotional scars of any problems which might have occurred during construction. Other people, who do not have access to these stories, accept the garment as they find it and see it as a whole. It is interesting to note that the memories of these problems and the tendency to examine your own work 'through the magnifying glass' fade over time. The maker becomes distanced from the experience of making and gains perspective on the item itself – thus seeing it more like the Topshop garment, ten feet back, than an artefact of her or his own creation, still jangling with mistakes and regrets. Hereford knitter Kiki spoke about this shift: 'That's what I expect, really, when I make something, I often don't like it. And then I put it away and I come back and I look at it and I say, Oh that's nice (laughs), as if it's someone else who made it.'

Another issue affecting our satisfaction with completed projects is the delay between an item being conceived in the maker's head, and becoming a coherent object existing in the world. It can hover in the imagination for a long time – weeks, months, even years – while being planned and constructed. When the garment is finally complete, the maker has to adapt to the way that it took shape, and come to terms with the fact that this is often somewhat different to the way they imagined. In my experience, makers tend to interpret that difference as a lack of skill on their part. But, as Rachael Matthews explained, it is an inherent element of the craft process:

When you're making, you've got your thought, you've got your hands, and those two things can do the best that they can, but it's actually happening, and I call that bit God. Because that's the bit that you're not really in control of, however skilled you are.

I recently followed a series of Twitter posts by Turner Prize-winning artist Grayson Perry as he built, decorated and glazed one of his signature large-scale ceramic vases. On Day 41, he posted a picture of the finished artefact, just out of the kiln after glazing. The comment accompanying this picture revealed the need for even such an eminent and experienced artist to come to terms with the gap between the pot he anticipated and the pot as it turned out: 'I have to adjust to [the] reality of it now after imagining how it would look all this time.'[38]

Finally, I would like to think about the 'success' of clothes made for others: partners, friends, children and grandchildren. In a survey of American knitters and crocheters, making for others was the second most common reason for engaging in craft.[39] In many cases, homemade items are gratefully received and successfully pass into wear; the recipients are pleased with their unique and thoughtfully produced garments. Yet non-makers do not always appreciate the effort involved. As Laura described, 'If you spend a week knitting a pair of socks, that's quite a big deal to you, but it's just a pair of socks to them.' Furthermore, recipients – particularly children – might actively reject their homemade gifts. Christine Cyr Clisset related her experience: 'I think, as a parent, you can't have the expectation that even your one-year-old will want to wear what you've made. I just made my daughter a few really cute dresses, and she will have nothing to do with them.'

It is not just small children who turn their noses up at homemade items. In an amusingly scathing article, Germaine Greer bemoans the burden of 'hideous' homemade gifts, arguing that 'to foist clumsily knitted goods on loved ones is to drive them to acts of hypocrisy that carry ineradicable guilt'.[40] I certainly know people who indiscriminately shower the people around them with their creations. Still, it seems to me that makers are generally aware of the perils of making for others and aim to put in the time and effort only for those who will appreciate what

17. A positive experience of making for others: the wedding dress I made for my friend Lauren.

they can produce. A useful strategy is to invite the recipient to choose the pattern and materials – although there is often a lingering concern that they might just be being polite, and not truly like, or intend to wear, the finished result.

Identity Construction and Folk Fashion

How do making practices and homemade garments relate to identity? Identities are based on positions in social structures; in contemporary society, these positions are increasingly based on our personal interests and chosen leisure pursuits. As Anthony Giddens explains, 'The more post-traditional the settings in which an individual moves, the more lifestyle concerns the very core of self-identity, its making and remaking.'[41] Taking up knitting or sewing as a hobby allows recognition

as 'a maker'. Joyce Starr Johnson and Laurel Wilson say that the adoption of this identity connects makers with wider networks, and creates a recognisable role – independent of other relationships and responsibilities – within the circle of family and friends.[42] While the activity of making establishes an identity, the items produced render that identity both tangible and visible; wearing them creates a resonance between making and use. In her research, Marybeth Stalp found that 'quilts establish through fabric the identity of women as quilters'.[43] Similarly, Johnson and Wilson explain that homemade objects are manifestations of the meaningful experience of making. They argue that these 'items which convey creativity and the mastery of skills, and which mark time, are particularly effective in defining the self'.[44] When makers share their completed homemade garments online – as with other instances of 'personal style blogging' – they are engaged in a further process of identity construction and creative self-presentation.[45]

It is clear, then, that making and wearing homemade clothes can be a highly effective means of constructing identity. The identity that can be constructed depends on the meanings – both personal and shared – associated with these practices and objects. Homemade items are likely to carry deeper personal meanings than purchased garments, because of the time and effort involved in their creation. I like Stalp's suggestion that a homemade item becomes a 'bookmark' of the period during which it was made.[46] Writing about people who have built their own houses, Roni Brown argues that the activity 'brings meaning to everyday life by the simple fact that the presence of the home prompts the re-telling of this, most compelling, creative experience'.[47] Similarly, folk fashion makers enjoy dwelling on the personal meanings of their garments by telling others about the items they have made, whether online or in person. Hereford knitter Kiki described doing so: 'I like wearing the gloves, I feel very pleased, I show everybody (laughs). You'd think I was 12 years old, look, I knitted these!'

Of course, the making experience can create negative personal meanings as well as positive ones. A knitter once told me about her current project, a cardigan which had come out disastrously wrong on the first attempt and so she was subsequently reknitting it. Looking

ahead to the time when it would finally be finished, she said that she did not know whether she would wear it, as she thought she might still harbour feelings of resentment towards the troublesome garment.

Shared Meanings of the Homemade

Alongside personal meanings, there are shared meanings associated with the practices and artefacts of folk fashion. Shared meanings of clothes are multiple, movable and potentially ambiguous; I argue that this ambiguity is heightened in the case of homemade clothes. This is partly because homemade clothes do not have the markers which help us to quickly understand the objects around us, as Sarah Ditum explains:

> When brands and prices are markers of identity and value, anything that's been made for the sake of love and craftsmanship is infuriatingly tricky to place – that, I think, is the logic behind the snotty jibes at 'nana sweaters'. It doesn't matter how beautiful a homemade object is: for most of us, what we buy is an extension of who we are, and wearing something without a price tag comes off like a shifty refusal to state your business.[48]

The meanings associated with commerce are replaced by the meanings of homemade, and these are, indeed, difficult to place. The comments gathered at the drop-in knitting activity help me to examine this issue in more detail. I asked participants to share their feelings about wearing homemade clothes; within this context – where knitting was generally viewed as a desirable, creative activity – the majority of the responses revealed a romantic perspective. Emotions such as 'happy' and 'proud' were mentioned frequently, along with comments describing the garments as 'made with love', 'quality', 'comfortable', 'original' and 'satisfying'. These responses correspond with the positive meanings of folk fashion that have emerged with the resurgence of knitting and sewing. In fact, the responses paint a picture of homemade

garments as indiscriminately better than mass-produced alternatives. This ties in with the contemporary notion that 'crafted' objects made through skilled handwork – from bread and beer to handbags and interiors – are more desirable, and luxurious, than mainstream options. Of course, this attitude to the homemade conflicts with the fact that makers are often disappointed with projects that do not turn out as expected. Though I cannot be sure, my suspicion is that the writers of many of these comments have limited experience of trying to make wearable items for themselves: their ideas seem aspirational, rather than reflective. Whatever the truth, these comments demonstrate that homemade items are often seen in an eminently positive way.

This romantic attitude is countered by a stigma that, for some, lingers around the homemade. I asked the Hereford knitting group what they felt other people thought about knitting and knitters. While some of the group were positive, mentioning the recent revival, others felt that people see knitting as old-fashioned and boring. This suggests that the established meaning of the craft as a low-status activity still has currency. Moreover, the products of this making – the homemade garments themselves – seem to carry an added set of outdated but enduring associations. For example, we still have a collective tendency to subconsciously link homemade clothes with poverty, despite the economics of folk fashion today being very different to that of the past. Moreover, people on low incomes (as the population more generally) are far more likely to purchase inexpensive high-street garments than to sew or knit items for themselves. Susan Luckman agrees that there is an enduring association between the homemade and poverty, which she traces back to the Depression in the 1930s and the postwar desire for shiny new mass-produced goods.[49] This association is especially prevalent in terms of mended clothing, as Alison Gwilt explains: 'In dress and costume history, wearing repaired clothing was typically a signifier of financial hardship, particularly when the repair was visible. This notion has continued to influence contemporary thinking about repair.'[50]

Our collective attitude to homemade clothes is informed by personal experiences. While some people have happy memories, many have

anecdotes about the embarrassment of wearing homemade items in childhood. At the drop-in knitting activity, one response to my prompt regarding homemade clothes simply noted 'memories of the awful dresses my mum knitted for me!'; another mentioned 'nightmares' of a homemade seersucker suit. Of course, some of these apparently dreadful items may have not turned out as hoped. Yet I have a feeling that the embarrassment often associated with homemade clothes is not just about their fit and finish, or their association with poverty, but also about their association with the home and the family. After all, in the process of growing into independent adults, we must loosen our ties with the family. Homemade clothes, with all their embedded effort and love, manifest the connection between the individual and the home and thus pull against this emergent independence. This story by Ingrid Murnane about a pair of homemade gloves encapsulates the issue:

> You might think that I would be grateful for this lovely handcrafted pair of gloves, uniquely made just for me. You would be wrong. I remember whingeing that they were the wrong colour, they didn't fit right and they were just not cool! Being eleven, I wanted to have something the same as all my school friends, namely machine-knit ones from Marks and Spencer; not embarrassing ones knit by my Mum and Nan.[51]

Bearing all of this in mind, it is unsurprising to conclude that folk fashion practices and artefacts might be perceived differently in different contexts. Within folk fashion communities, and amongst those who recognise the skill, creativity and contemporary cachet of crafts such as sewing and knitting, they are seen in a positive light. But in the wider world the established perceptions stubbornly remain. While on one hand we might see homemade items as embodying the luxury of leisure time, on the other we are aware that amateur and domestic time is chronically undervalued. If we are not attracted by the outcome of the time spent – if a project fails to turn out well, for whatever reason – then the whole activity can seem like a misguided folly, despite the many benefits associated with the process of making. Thus, the process

of constructing identity through making and the homemade is likely to be rather ambivalent.

It is worth noting that it may be possible to overcome this ambivalence by wearing homemade items in a way that highlights their positive associations. Various fashion theory texts discuss this idea in relation to secondhand clothes, which have a similar mix of meanings: poverty and lack of sophistication versus post-consumerist, stylish thrift. For example, Nicky Gregson and Louise Crewe describe middle-class people wearing secondhand items in combination with new items in order to present them in a positive sense, explaining that 'the certainties of one unlock the potentials of the other, safely, in a framed, controlled juxtaposition of meaning'.[52] Despite any efforts we might make, though, the message we intend to create through our clothes is often not picked up by the viewer. Our personal perceptions may be outvoted by the crowd – as in this cautionary tale captured at the knitting tent: 'I wore a hat I made in Textiles once and was socially shunned from thereonafter.'

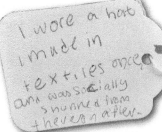

I wore a hat I made in textiles once and was socially shunned thereon after.

18. Knitting tent tag #10.

The Homemade 'Look'

The question of the meanings associated with the homemade is predicated on the assumption that the people around us – these 'others' whose gaze we are anticipating when we dress – are even able to recognise homemade items, as opposed to mass-produced and shop-bought garments. I discussed this issue with the Hereford knitting group; the consensus was that makers would recognise homemade garments, but those outside folk fashion communities would be unlikely to identify them as such. For those who are interested or informed enough to notice the difference – or a potentially larger group of people who instinctively sense that *something* is different about a homemade

item, even if they are not sure what – it is interesting to consider what the hallmarks of the homemade would be. In many cases, this is down to finish, time and expertise: you will rarely find a cast-off edge on a mass-produced jumper, or a hand-stitched hem on a shop-bought dress, because these techniques are too labour intensive to be used in factories. However, these lines are rather blurry. High-street shops sell chunky hand-knitted accessories, and there are many mass-produced clothes with a distressed finish, designed to mimic a mended aesthetic.

Blurring the lines in the other direction are those folk fashion makers who aim to make clothes which look like those in the shops. The motivation to make is frequently related to a desire for a specific commercially produced item, and ambiguity of origin is often seen as a positive attribute of homemade clothes. For example, Alla Myzelev describes a designer of hand-knitting patterns for whom 'the success of the garment is contingent on [...] if it was ever confused with a store-bought item'.[53] Christine Cyr Clisset made a similar point:

> You want to make stuff that is chic, and beautiful, and you don't necessarily want people to know that it was homemade – though you're excited to tell people that you made it yourself when they compliment you on it.

Rosie Martin described this ambiguity being celebrated within the sewing blogging community:

> If you post a picture of something and someone says it looks shop-bought, it looks high street – they always mean in a good way. Because they're like, wow, it's truly camouflaged, that looks 'real'. So it's definitely used as a term of praise: I'd never know that was homemade.

I think there are two elements at work here. Firstly, there is the situation where folk fashion makers are aiming to produce styles of clothing which they wear regularly – such as jeans, jerseywear and sportswear. All of these styles are strongly associated with mass production: that is, the manufacturing techniques which give them their distinctive look

are those of the factory, rather than the domestic studio, and thus there is no tradition of their being produced in the home. If you manage to create the right look successfully, the garment will look authentic – 'real', as Rosie said – and, therefore, mass-produced and shop-bought.

Yet I think the desire to produce items which look shop-bought generally involves a different distinction: that of 'professional' over 'homemade'. In this instance, 'professional' seems to mean consistent, neat and skilled, and meeting all of the objective criteria posed by the challenge of making. It is fair enough that people have these expectations of professionally produced clothes – after all, such items go through rounds of quality control before they reach the consumer. And, of course, it is understandable that makers aspire to these criteria for their own projects. Great satisfaction can be derived from doing a good job. Moreover, if we are to enjoy wearing them, clothes need to function well: to accommodate a moving body and withstand the stresses and strains of wear and washing. I find it unfortunate, though, that 'homemade' is set up as the binary opposite of 'professional': inconsistent, messy and unskilled. As Stephen Knott explains, this negative portrayal of domestic activity dates back to the nineteenth century: 'artisans, craftsmen and artists used the word amateur pejoratively to denote lack of commitment, poor skill and ineptitude [...] expertise, skill and excellence were tied to monetary remuneration within a "profession"'.[54] Despite the expertise of many amateur makers, this perception persists today. Christine Cyr Clisset suggested, 'you don't want [an item] to look "homemade", like it was just patched together, basically'. Fellow interviewee Carol made a similar distinction, comparing her recent projects with earlier, slightly cruder items: 'I'm more than happy to come out in things I've made now, but at one time I wondered if they looked a bit too homemade.'

Although I am arguing that it is unfair that 'homemade' is automatically taken to mean, as one comment from the knitting tent put it, 'wonky and somehow a bit crap', I readily acknowledge that many homemade items are, indeed, somewhat 'imperfect'. It is interesting to consider why this imperfection should bother us so much in clothing, when in many situations we have an inbuilt desire for it.

As David Gauntlett points out, 'roughly made and non-professional things embody a kind of celebration of humanity's imperfections – the very fact that we are *not* machines'.[55] I agree that we value a rustic, imperfect look in many contexts, but argue that few people find this look to be desirable in dress. A minority of makers manage to frame their imperfections in a positive light. For example, Jessica Bain quotes sewing blogger Zoe Edwards, who wrote compellingly about her acceptance of imperfection:

> I am far more forgiving of the homemade-y looking elements of my clothes because they exhibit the truth that it is possible to avoid mass-manufactured clothing. That badly applied bias binding or concealed zip reminds me that I'm contributing, in some small way, to the debate about our culture's sustainability. Not only do I forgive the signs that put my clothes into the homemade/handmade category, but I guess I've learnt to almost embrace them.[56]

From a similar perspective, Jonnet Middleton proposes that 'the crudest mends can ooze kudos from their sheer daring or joviality'.[57] In fact, this issue is paramount in the new mending movement. As Eirlys Penn explains, at the monthly mending socials she runs, attendees discuss 'whether we want our repairs to be visible – conspicuous even – or not and what wearing something with an evident repair says to others'.[58] Some people have embraced imperfection, then. But I do not think most people currently have the desire, or the chutzpah, to carry off conspicuous irregularities and mistakes. I suspect that the common distaste for flaws is partly down to the dominance of mass-produced clothes in contemporary culture. The standardised finish of these garments has raised the bar in terms of our expectations – even though shop-bought items sometimes disappoint in terms of quality. The more fundamental reason may be that clothes are such a significant and intimate type of possession, so closely linked with identity. We are, perhaps, loath to associate the self so closely with imperfection, especially when mistakes and irregularities are the result of our own actions.

Uniqueness and Validation

When I asked participants at the knitting tent to share their feelings about wearing homemade clothes, many of the positive responses mentioned uniqueness, originality and individuality. Even Hereford knitter Alex, who describes herself as being quite conservative in her personal style, made a similar comment: 'You feel pleased, because it's yours. I mean, it really is yours because you've made it. And you're unlikely to meet anybody else wearing it.' Homemade items are indeed unique; even when using a kit or pattern, each individual's personal production methods, along with mistakes and intentional alterations, create a one-off item. Some makers go out of their way to accentuate this uniqueness through the use of unconventional materials or styles, as Rosie Martin described: 'Definitely, for the earlier years of sewing I was like, why would I make anything that looks shop-bought? I want to make stuff that doesn't exist anywhere else.'

We all have a desire for uniqueness, and fashion is a potent means of expressing this desire, but it is tempered by the need to belong. This belonging can be observed in folk fashion culture. I have noted sewers, in particular, connecting around specific patterns from indie designers: complimenting each other on an 'excellent Granville' or 'fabulous Coco'. And although the uniqueness of the homemade is seen as a positive by many people, it also underlies many negative experiences. In the anecdote about the homemade gloves shared earlier, the gloves are rejected for being too different; the wearer wanted to look the same as her friends. As Susan Luckman points out, 'the last thing that children becoming "tweens" wish to do is to stand out from their peers, especially in handmade clothing'.[59] Visibly mended items carry the same risk. This is important, for as Mihály Csíkszentmihályi and Eugene Rochberg-Halton explain in their writing on material culture, if our possessions are too unusual they cease to connect us with those around us:

> Originality is often thought to mean not being influenced in any way
> – not imitating others. But if originality becomes an ultimate goal,

and one consistently pursues it, one loses the most valuable means of growing as a person – the possibility of imitation, the process that is so essential to the development of the self in the first place.[60]

Of course, we vary in our level of desired uniqueness according to various psychological and social factors. We might want to stand out, to bring attention to ourselves or to challenge others' expectations. But even Rosie, who clearly has a taste for outlandish dressing, could see the dangers of taking this too far, suggesting that 'you can completely lose touch. It's like going off-grid, isn't it? It could all be very wonderful – or you could just become so removed from other humans that you forget what normal humans are like.'

Homemade clothes are particularly unique, or 'original', in that they represent solely the intentions of the maker. Shop-bought items, in contrast, have been 'validated' by a chain of professionals: trend forecasters, designers, buyers, merchandisers, retailers, stylists and journalists. If the steps that lead to a garment being produced are considered as a series of decisions, the decisions behind a ready-made item have been made by a community of experts. This provides reassurance that the item is desirable and appropriate, within social norms. Conversely, a one-off homemade garment represents, and displays, the decisions of a single person. A maker might be using a professionally designed pattern, but the decisions are still ultimately their own. As Peter Korn puts it, homemade items 'embody questions I asked and the answers at which I arrived during their creation'.[61] Therefore, folk fashion garments have the potential to be unwittingly transgressive of social norms; it is easy, as Rosie says, to lose touch.

To sum up these differences between shop-bought and homemade clothes, I will borrow the concept of 'the workmanship of certainty' and 'the workmanship of risk' from craft writer David Pye:

> The essential idea is that the quality of the result is continually at risk during the process of making; and so I shall call this kind of workmanship 'The workmanship of risk' [...] With the workmanship of risk we may contrast the workmanship of certainty, always to be

found in quantity production [...] In workmanship of this sort the quality of the result is exactly predetermined before a single saleable thing is made.[62]

I see commercially produced, shop-bought clothes as representing the workmanship of certainty – in terms of manufacture, as Pye describes, but also in terms of style. The chain of validation provides confirmation and approval. In contrast, homemade clothes represent the workmanship of risk. Not only is a maker usually producing just the one garment – meaning that they are learning, adjusting and correcting as they proceed – but they are also making unilateral decisions in terms of style. While this has the potential to be an incredibly satisfying process, the risk continues when they wear the garment; they have much less assurance that it will be positively received in the outside world, compared to a shop-bought alternative.

If all this is sounding rather bleak and you are looking suspiciously at the homemade items hanging in your wardrobe, take heart. There are alternative sources of validation, and many of those that I spoke to use these sources in order to gather feedback on – and therefore gain confidence in – their projects. Carol described showing off her completed garments at a sewing club she attends, and feeling more confident about wearing them after receiving compliments from her peers. Similarly, Laura spoke about gaining confidence from positive comments made by other sewers after sharing her homemade items on Instagram: 'I really need that. If you're the sort of person who needs a pat on the back (laughs), Instagram's really great.' Another alternative source of validation could be the objective standards and pursuit of quality involved in the challenge of making.

Well-Being and Wandering

Returning to the theme of well-being, I feel that wearing homemade has the potential to provide an ideal source of personal satisfaction. It joins the practice of making – which satisfies needs in its own right – with

the practice of wearing. Indeed, there is evidence that for some people, wearing homemade clothes is a wonderfully fulfilling experience. I have met many people who are successful in making garments for themselves to wear, and do so with pride. One tag from the knitting tent links homemade clothes with a sense of empowerment and well-being: 'Something unique, personal, empowering and healthy – because it's for my body, not somebody else's shape or image.' Indeed, making challenges the conventional emphasis on image as the essence of fashion and instead values what Wendy Parkins and Geoffrey Craig, in their book *Slow Living*, describe as 'the senses of proximity'.[63] Yet anxiety dominates many people's relationships with clothing, and for some people homemade clothes can exacerbate this anxiety. Although those around us might not even recognise our clothes as homemade – suggesting that any concerns about negative associations may be unfounded – our self-image is based on our *imagining* of how others appraise our appearance. Taking a holistic view, I have to say that the experience of making and wearing homemade clothes is, once again, rather ambivalent in terms of well-being.

One way of insulating ourselves from the negative associations of the homemade is to make styles that suit making by hand: cases where 'homemadeness', or at least 'handmadeness', is seen as an advantage rather than a drawback. Hereford knitter Alex described hand-knitted garments as occupying their own territory, which sits apart from mass-produced clothing: 'I think hand-knitted garments … to my mind, have a category of their own. It's not

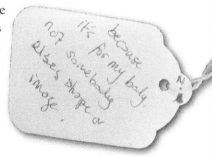

19. Knitting tent tag #35.

trying to be what you can buy. That's why I do the colourwork, and the Arans, and look for the old pattern books.' The items mentioned by Alex are traditional designs, which have always been associated with hand knitting. I think of these styles as being 'safe spaces' for the homemade, carrying a sense of cultural 'rightness'. In a similar way, haute couture provides a safe haven for home sewers to aspire to: these

ultra-luxurious garments are defined by their use of hand stitching, rather than machine sewing. In this cultural bubble, the handmade represents the very utmost in quality; and, as Claire Schaeffer describes, 'many of the techniques used in couture workrooms can be duplicated at home'.[64]

Returning to my metaphor, these safe spaces could be described as approved footpaths within the fashion commons. Such footpaths are valuable: they offer genuine personal benefits to makers and include wonderful textile traditions that provide great satisfaction. Yet I cannot help but feel frustrated. I would like to think that folk fashion makers could wander across the full expanse of the fashion commons, without constantly comparing their garments to shop-bought alternatives. Furthermore, if we stick to the footpaths, we limit the radical potential of folk fashion and allow the prevailing structure of the fashion industry to continue unabated.

Notes

1 Kinder Visitor Centre Group, 'Kinder mass trespass' (undated). Available at kindertrespass.com (accessed 10 May 2016).

2 Abigail Doan, quoted in Amy DuFault, 'Using your hands to soothe the brain: part 2', *Ecosalon* (19 January 2011). Available at ecosalon.com/using-your-hands-to-soothe-the-brain-part-2 (accessed 6 October 2016).

3 Mihály Csíkszentmihályi, *Flow: The Psychology of Optimal Experience* (New York: HarperCollins, 1990).

4 Wendy Parkins, 'Celebrity knitting and the temporality of postmodernity', *Fashion Theory* 8/4 (2004), pp. 425–42, p. 435.

5 Stitchlinks, 'Guide to Our Theories So Far' (April 2008). Available at stitchlinks.com/pdfsNewSite/research/Our%20theories%20so%20far%20New_%20unshuffled%20watermarked_4.pdf (accessed 11 August 2015).

6 Emma Shercliff, 'A poetics of waste: evaluating time and effort spent sewing', *Making Futures* 1 (2009), pp. 186–97, p. 189. Available at mfarchive.plymouthart.ac.uk/journalvol1/papers/emma-shercliff.pdf (accessed 6 October 2016).

7 Rachel Moseley, 'Respectability sewn up: dressmaking and film star style in the fifties and sixties', *European Journal of Cultural Studies* 4/4 (2001), pp. 473–90, p. 486.

8 Bruce Metcalf, 'Craft and art, culture and biology', in Peter Dormer (ed.), *The Culture of Craft: Status and Future* (Manchester: Manchester University Press, 1997), pp. 67–82, p. 76.

9 Ellen Dissanayake, 'The pleasure and meaning of making', *American Craft* 55/2 (1995), pp. 40–5, p. 45.

10 Rozsika Parker, *The Subversive Stitch: Embroidery and the Making of the Feminine* (London: I.B.Tauris, [1984] 2010), p. xx.

11 Christopher Alexander, *The Production of Houses* (Oxford: Oxford University Press, 1985), p. 322.

12 Despina Tzanidaki and Frances Reynolds, 'Exploring the meanings of making traditional arts and crafts among older women in Crete, using interpretative phenomenological analysis', *British Journal of Occupational Therapy* 74/8 (2011), pp. 375–82.

13 Matthew Crawford, *The Case for Working with Your Hands: Or Why Office Work Is Bad for Us and Fixing Things Feels Good* (London: Penguin, 2009).

14 Peter Dormer, 'The ideal world of Vermeer's little lacemaker', in John Thackara (ed.), *Design After Modernism* (London: Thames & Hudson, 1988), pp. 135–44.

15 Peter Korn, *Why We Make Things and Why It Matters: The Education of a Craftsman* (London: Square Peg, 2015), p. 12.

16 Howard Gardner, *Intelligence Reframed: Multiple Intelligences for the 21st Century* (New York: Basic Books, 1999).

17 Korn, *Why We Make Things and Why It Matters*, p. 53.

18 Kate Orton-Johnson, 'Knit, purl and upload: new technologies, digital mediations and the experience of leisure', *Leisure Studies* 33/3 (2014), pp. 305–21, p. 317.

19 Craft Yarn Council, 'Crocheters and knitters of all ages are an active and creative group' (2014). Available at craftyarncouncil.com/sites/default/files/press/D586_ResearchOneSheet_1.pdf (accessed 6 October 2016).

20 Manfred Max-Neef, 'Development and human needs', in Paul Ekins and Manfred Max-Neef (eds), *Real-Life Economics: Understanding Wealth Creation* (London: Routledge, 1992), pp. 197–213.

21 Stitchlinks, 'Where are we now?'. Available at stitchlinks.com/research. html (accessed 6 October 2016).

22 Paul Devlin, *Restoring the Balance: The Effect of Arts Participation on Wellbeing and Health* (Newcastle upon Tyne: Voluntary Arts England, 2010), p. 10.

23 Richard Layard, *Happiness: Lessons from a New Science*, 2nd edn (London: Penguin, 2011), p. 73.

24 Sonja Lyubomirsky, Kennon M. Sheldon and David Schkade, 'Pursuing happiness: the architecture of sustainable change', *Review of General Psychology* 9/2 (2005), pp. 111–31.

25 David Gauntlett, *Making Is Connecting* (Cambridge: Polity, 2011), p. 161.

26 Marybeth C. Stalp, *Quilting: The Fabric of Everyday Life* (Oxford: Berg, 2008).

27 Andrew Jackson, 'Constructing at home: understanding the experience of the amateur maker', *Design and Culture* 2/1 (2010), pp. 5–26, p. 12.

28 Stalp, *Quilting*.

29 Stephen Knott, *Amateur Craft: History and Theory* (London: Bloomsbury, 2015), p. 89.

30 Huma Qureshi, 'From the high life to the good life: cutting one's cloth is back in fashion', *Observer*, 25 January 2009. Available at theguardian.com/ business/2009/jan/25/cooking-sewing-hen-keeping-economising-credit-crunch (accessed 6 October 2016).

31 Jenny Rushmore, 'Sewing my clothes is an escape from fashion's dictates. I no longer hate my body', *Guardian*, 3 August 2015. Available at theguardian.com/commentisfree/2015/aug/03/sewing-clothes-escape-fashion-dictates-no-longer-hate-my-body (accessed 6 October 2016).

32 Margarethe Szeless, 'Burda fashions – a wish that doesn't have to be wishful thinking: home-dressmaking in Austria 1950–1970', *Cultural Studies* 16/6 (2002), pp. 848–62, p. 851.

33 More information at So Zo … What Do You Know?, sozowhatdoyouknow. blogspot.co.uk/p/about-me-made-may.html.

34 Knott, *Amateur Craft*.

35 Comment in thread below Sarah Ditum, 'Knitting offers welcome relief from fashion lust', *Guardian*, 22 February 2012. Available at theguardian. com/commentisfree/2012/feb/22/knitting-fashion-lust (accessed 6 October 2016).

36 Jo Turney, 'Fashion's victim', *Crafts* 222 (January/February 2010), pp. 46–9, p. 48.

37 Comment in thread below Ditum, 'Knitting offers welcome relief from fashion lust'.

38 Grayson Perry (@Alan_Measles), 'Day 41, another view, I have to adjust to reality of it now after imagining how it would look all this time', Twitter (19 February 2015). Available at twitter.com/Alan_Measles/status/568390597653999616 (accessed 6 October 2016).

39 Craft Yarn Council, 'Crocheters and knitters of all ages are an active and creative group'.

40 Germaine Greer, 'Who says knitting is easy? One of my bedsocks is bigger than the other', *Guardian*, 13 December 2009. Available at theguardian.com/artanddesign/2009/dec/13/germaine-greer-knitting-cultural-olympiad (accessed 6 October 2016).

41 Anthony Giddens, *Modernity and Self-Identity: Self and Society in the Late Modern Age* (Stanford: Stanford University Press, 1991), p. 81.

42 Joyce Starr Johnson and Laurel E. Wilson, '"It says you really care": motivational factors of contemporary female handcrafters', *Clothing & Textiles Research Journal* 23/2 (2005), pp. 115–30.

43 Stalp, *Quilting*, p. 112.

44 Johnson and Wilson, '"It says you really care"', p. 124.

45 Rosie Findlay, 'O HAI GUYZ: between personal style bloggers, their readers, and modern fashion', PhD thesis, University of Sydney, 2014.

46 Stalp, *Quilting*.

47 Roni Brown, 'Designing differently: the self-build home', *Journal of Design History* 21/4 (2008), pp. 359–70, p. 368.

48 Ditum, 'Knitting offers welcome relief from fashion lust'.

49 Susan Luckman, *Locating Cultural Work: The Politics and Poetics of Rural, Regional and Remote Creativity* (Basingstoke: Palgrave Macmillan, 2012).

50 Alison Gwilt, 'Fashion and sustainability: repairing the clothes we wear', in Alison Gwilt (ed.), *Fashion Design for Living* (Abingdon: Routledge, 2015), pp. 61–77, p. 70.

51 Ingrid Murnane, 'Just an instruction leaflet?', Knit on the Net (2008). Link no longer working.

52 Nicky Gregson and Louise Crewe, *Second-Hand Cultures* (Oxford: Berg, 2003), p. 8.

53 Alla Myzelev, 'Whip your hobby into shape: knitting, feminism and construction of gender', *Textile: The Journal of Cloth and Culture* 7/2 (2009), pp. 148–63, p. 158.

54 Knott, *Amateur Craft*, p. xiv.

55 Gauntlett, *Making Is Connecting*, p. 218, original emphasis.

56 Jessica Bain, '"Darn right I'm a feminist ...sew what?" The politics of contemporary home dressmaking: sewing, slow fashion and feminism', *Women's Studies International Forum* 54 (2016), pp. 57–66, p. 57. Zoe Edwards, 'Thoughts on forgiveness', *So, Zo ... What Do You Know?* (20 June 2010). Available at sozowhatdoyouknow.blogspot.co.uk/2010/06/thoughts -on-forgiveness.html (accessed 10 May 2016).

57 Jonnet Middleton, 'Mending', in Kate Fletcher and Mathilda Tham (eds), *Routledge Handbook of Sustainability and Fashion* (Abingdon: Routledge, 2015), pp. 262–74, p. 265.

58 Eirlys Penn, 'The big mend's 4th birthday', *Scrapiana* (26 April 2016). Available at scrapiana.com/2016/04/26/big-mends-4th-birthday (accessed 6 May 2016).

59 Susan Luckman, *Craft and the Creative Economy* (Basingstoke: Palgrave Macmillan, 2015), p. x.

60 Mihály Csíkszentmihályi and Eugene Rochberg-Halton, *The Meaning of Things: Domestic Symbols and the Self* (Cambridge: Cambridge University Press, 1981), p. 190.

61 Korn, *Why We Make Things and Why It Matters*, p. 63.

62 David Pye, *The Nature and Art of Workmanship* (Cambridge: Cambridge University Press, 1968), p. 4.

63 Wendy Parkins and Geoffrey Craig, *Slow Living* (Oxford: Berg, 2006), p. 92.

64 Claire B. Schaeffer, *Couture Sewing Techniques* (Newton: Taunton Press, 2007), p. 7.

5

Reknitting

An Experimental Folk Fashion Practice

How might we gain confidence as folk fashion makers and start to operate more freely across the full expanse of the fashion commons? I think we need to challenge the conventions of making and allow our practices to spill out of the established norm. To inspire this change, I like to look to another land-related movement: the Diggers of the seventeenth century. Instead of obediently abiding by the laws governing access to land, this group occupied and cultivated an area as a way of symbolically demonstrating their view that everyone should have the freedom to dig the land and grow food.[1] A contemporary version of this attitude can be found in the guerrilla gardening movement. This activity involves 'the illicit cultivation of someone else's land', whether a handful of flowers tended on a roadside verge or the conversion of derelict urban plots to unofficial community gardens.[2] Like their historical forebears, guerrilla gardeners demonstrate their disregard for the enclosure of land by practical action: they dig, rather than merely roam. How might we dig the fashion commons? One strategy is to remake existing garments: tinkering with the shop-bought pieces in our wardrobes. By tinkering, we challenge the professionalisation of fashion and claim ownership of our clothes in unequivocally material terms.

Remaking and Reknitting

I use the term 'remaking' to refer to alteration processes which renew and transform garments. For example, a dress might be restyled: reinvigorated with a new hemline and sleeve shape. An item might

equally be converted into a different type of garment: trousers might become a skirt, or provide fabric to make an item for a child. While remaking can broadly be seen as an act of repair, I see it as going beyond what is generally thought of as mending. It is useful to borrow Richard Sennett's ideas of static and dynamic repair: a static repair restores an item to its previous state, while a dynamic repair changes the item's form or function.[3] I see mending as the former, and remaking as the latter. (A similar discussion – of conservative repair versus creative transformation – can be found in Christopher Alexander's writing about the evolution of buildings.)[4] Of course, the line between these two categories is rather blurry. Tom van Deijnen's Visible Mending Programme, for example, repositions mending as a dynamic, transformative and celebratory act rather than a static, restorative and somewhat apologetic one.[5]

I am especially interested in remaking because I see it as a radical type of folk fashion. Although making has many positive attributes in terms of individual well-being and sustainability, I am always concerned that the conventional mode of activity – where new items are created, one after another – inadvertently mirrors the linear production–consumption model of the mainstream fashion industry. Of course, the conditions under which the items are produced are very different. Yet I wonder whether we tend to treat the finished garments in much the same way as shop-bought pieces: to be kept or discarded, but not usually altered. Remaking frames making as a continuous process that takes place time after time, rather than a one-off event. It allows us to extend the useful life of our garments and quietly challenges conventional consumption practices.

Of course, this idea is nothing new. Ben Fine and Ellen Leopold explain that in the eighteenth century it was common for dresses to be remade time after time, in order to make the most of valuable fabric.[6] This practice continued into the era of the sewing pattern. According to Nancy Page Fernandez, in the nineteenth century home dressmakers used paper pattern pieces to help them restyle outdated garments.[7] When resources were scarce during World War II the remaking of clothing became a necessity, as Margaret Murray and Jane Koster explained in 1946:

The most fashionable indoor sport for women these days is cunningly contriving old bits and pieces of this frock and that into a stunning model that hits every one in the eye, and makes the wearer the envy of all beholders.[8]

Today the restyling of sewn garments is enjoying a resurgence, with support available via books, workshops and online resources. Dedicated blogs and books are inspiring folk fashion makers across the world to consider remaking, rather than always producing new items, and to see this as an exciting and accessible creative process.

In terms of knitted garments, the vast majority of remaking activity seems to be restricted to transformative processes which use felting, cutting and sewing; various resources provide tutorials for turning unwanted jumpers into quirky fashion and home accessories using such techniques.[9] An alternative approach is to use knitting to rework knitted garments – that is, to use techniques which utilise a knitter's existing skills and knowledge, and engage with the structure of the knitted fabric instead of treating it as a continuous sheet. There are plenty of precedents for this approach. For example, Michael Pearson describes how traditional gansey sleeves are knitted down from the shoulder, 'to enable one to repair any worn parts by simply pulling back past the hole and knitting back down again to the cuff'.[10] Annemor Sundbø, the custodian of an amazing collection of homemade Norwegian garments, describes stockings she has found which 'illustrate the practice of knitting new heels and toes on old stocking legs […] stocking legs may be 100 years older than the feet'.[11] In 1944 Agnes Miall advised readers:

Never throw away a hand-knitted or crocheted garment because it is worn in places, out-of-date in style, or you happen to feel tired of it. It may be hopeless as an article of dress, but it is a storehouse of good wool, which even if it has not all the qualities of new wool, can be used again to make a fresh item which costs you nothing.[12]

A series of knitting books published by Odhams Press in the 1940s include numerous examples of reknitting, with sorrowful 'before' and

glamorous 'after' photographs.[13] At one of the early Hereford knitting group sessions, Alex shared a childhood memory of her aunt reknitting sections of her uncle's jumpers:

> When it got really ratty, the polo neck would get all stretched and horrible. She would redo the cuffs and she'd unpick the polo neck, and reknit a new polo neck for him to keep him snug in the winter.

In recent years, as new clothes have become cheaper and more accessible, these practices have largely disappeared. Although some people do still reknit today – instructions for unravelling and reclaiming yarn can readily be found online – the activity seems to be marginal within the knitting community. While darning is enjoying a surge in popularity amongst the 'new menders', I have seldom heard of anyone using their knitting skills to rework existing knitted items. It seems that the tacit knowledge of how to unravel, alter, replace and reknit has largely been lost.

Developing Reknitting Techniques

Motivated by ideas about remaking, I set up an experimental reknitting project for my PhD research. I aimed to develop, test and communicate methods of reknitting existing garments, to be used and adapted by knitters to remake garments from their own wardrobes. In doing so, I rediscovered old reknitting techniques and also developed new approaches, appropriate to the mass-produced garments in our wardrobes today. Instructions from the 1940s focus solely on hand-knitted items; now, we wear many more industrially produced knitted garments, which I very much wanted to include in my scope. Because every existing knitted garment is different, it would be impossible to produce conventional, 'closed' patterns for reknitting. Instead, I aimed to create flexible methods that could be adapted by a knitter to suit the particularities of their item.

I use 'reknitting' to refer to techniques which use knit-based skills and knowledge and exploit the knitted structure's capability for

reconfiguration, treating each loop as a unit, or a building block. Knitted fabric is built up from row after row of interlinked loops, and these loops can be retrospectively configured, or – as I tend to say – 'tinkered with'. There is huge potential in this simple idea. Rows can be unravelled, to deconstruct the fabric gradually, and reknitted; the vertical columns of loops can be unmeshed ('laddered') and reformed; and new loops can be picked up within a fabric to create integrally joined pieces. In order to define the scope of my project, I needed to establish some rules. I chose to include crochet as an alternative to knitting, but included only those sewing processes that engage directly with the knitted structure, such as grafting (stitching that seamlessly joins two knitted fabrics) and Swiss darning (stitching that duplicates the knitted structure).

I started the project by researching existing knowledge about reknitting, digging through my collection of knitting books and taking a couple of enjoyable visits to the excellent Knitting Reference Library at Winchester School of Art. I found that many books provided advice on reworking garments. In the earlier books (up to around 1950) these garments were assumed to be old hand-knits, requiring repair or rejuvenation. In the more recent books the advice was intended to assist with newly knitted items, fixing problems of fit. I also gathered information on processes – such as inserting pockets or cutting a cardigan opening – that can be carried out after the main garment has been constructed. Though intended to be used in the course of making new items, they could equally be applied to existing garments. I term these 'afterthought' techniques, taking inspiration from Elizabeth Zimmermann. This influential knitting teacher and designer encouraged an experimental approach through her books and US television series, and promoted the 'afterthought pocket' and 'afterthought buttonhole'.[14]

It was great to find all this relevant material, but I was keen to look at the potential for other reknitting techniques, beyond those which had previously been documented. I already had one technique in mind: an alteration process that I had developed a few years earlier, which I call 'stitch-hacking'. Stitch-hacking involves the laddering and reconfiguration of stitches in an existing knitted fabric. It is based on a straightforward repair technique, used in a new context: to change

a fabric to a new design rather than repairing it back to its former structure. I have used this process to insert text-based designs into found knitted garments to explore ideas of ownership and authorship.[15]

I started to brainstorm further ideas for reknitting, and – after many iterations – combined these ideas with the information from the knitting books into a master diagram showing a spectrum of reknitting techniques, or 'treatments'. The treatments are grouped according to the way in which the original garment is altered: without opening the fabric, opening the fabric horizontally, or cutting it vertically or diagonally. The spectrum also shows the steps involved in each treatment, with many of the steps being common to several treatments. It is important to note that in this process I was aiming to show what could technically

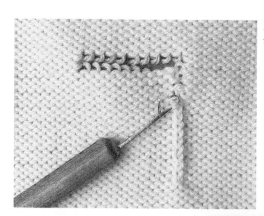

20. The stitch-hacking technique.

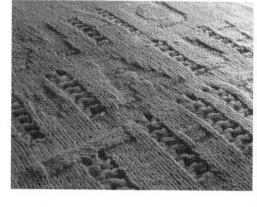

21. 'Who Made This?' (detail), stitch-hacked found cardigan by Amy Twigger Holroyd, 2009.

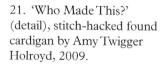

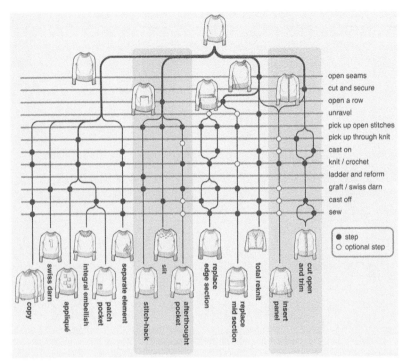

open seams
cut and secure
open a row
unravel
pick up open stitches
pick up through knit
cast on
knit / crochet
ladder and reform
graft / swiss darn
cast off
sew

● step
○ optional step

copy
swiss darn
appliqué
integral embellish
patch pocket
separate element
stitch-hack
slit
afterthought pocket
replace edge section
replace mid section
total reknit
insert panel
cut open and trim

22. The spectrum of reknitting treatments.

be done with an existing item of knitwear, not just alterations that I, personally, fancied trying out. Furthermore, the spectrum shows only the technical principle of each treatment; each one is highly flexible in terms of scale, aesthetic and finish.

Soon, it was time for me to test the treatments with some willing volunteers: the Hereford knitting group. By physically exploring the techniques together, we were able to identify previously unforeseen problems and possibilities. I carried out my own personal exploration, too, creating step-by-step instructions for various treatments and trying out five interventions on a sample garment. All of these experiments informed the resources I was developing to communicate the possibilities of reknitting, which I gathered together in a dedicated section on my website.[16]

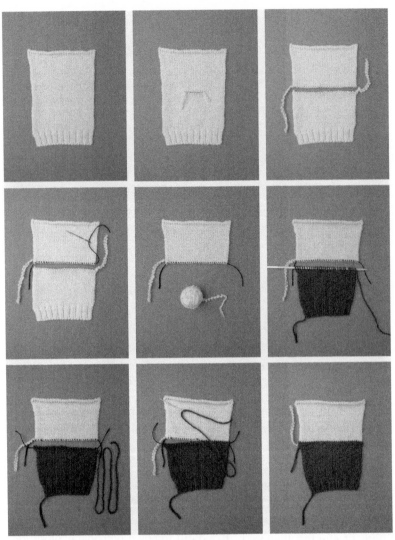

23. Step-by-step instructions for 'replace edge section' reknitting treatment.

The entire process of developing the reknitting techniques was an exciting and complex challenge, but two aspects stood out as being of particular interest. The first is the question of changing gauge. As

I have mentioned, I wanted the reknitting treatments to apply to any knitted garment in the wardrobe, not just chunky hand-knits. Many industrially produced garments are much finer gauge than we would ever want to hand knit. Therefore, I had to figure out a way to move from an existing fabric with a large number of small stitches to a new fabric with fewer, bigger stitches. This apparently simple task ballooned into a fascinating technical challenge and creative design opportunity, combining mathematical and aesthetic considerations.[17] The second aspect relates to the theme of openness. Because each reknitting treatment is extremely flexible, I wanted to offer knitters as many options as possible. Yet this would not be achieved by offering every variation of a technique or process. Not only were many of these variations difficult to knit or aesthetically displeasing, but I realised that too many options – especially when using an unfamiliar technique – can be overwhelming and ultimately stifle the ability to act. In the end I came to see that open activity occupies a point somewhere between the prescription of a conventional knitting pattern and unsupported, endless choice.

The Reknitting Projects

As the workshops progressed, the knitters moved from sampling to working on their own individual reknitting projects.

Alex decided to rework a hand-knitted cardigan that she had made herself. Although she had enjoyed wearing it for a while, she now felt it was boring and did not reflect her identity. The garment was still in good condition and she felt it was too good to discard; it had, therefore, become a problematic item in her wardrobe. Alex was concerned about the effort involved in reworking, saying that she did not want 'the cure to be worse than the disease'. She decided to replace the trims in a contrast colour and add striped patch pockets, feeling this would be fashionable, give the garment definition, and balance effort with reward. Alex was delighted with her finished project and began wearing it straight away in conjunction with complementary items in her wardrobe.

24. Alex's reknitting project, with samples.

Anne chose to renew a favourite Fair Isle jumper belonging to her daughter. She initially described the replacement of the damaged cuffs and welt as a 'repair', rather than 'design', task. Having had the idea to knit multicoloured, rather than plain, trims, however, the project became more exciting. Anne tried out various ways of working the trims, and we were amazed to find some 4-ply yarns in my studio that provided an excellent colour match for the original fabric. By experimenting with needle size, she was able to match the gauge of the original rib. She then repaired a few holes in the main body by knitting small patches onto the fabric. Both Anne and her daughter were pleased with the finished outcome, feeling that the jumper had been given a new lease of life.

Catherine bought the cardigan that she chose to rework in a charity shop, attracted by its colour and luxurious yarn. Yet the item was 'rather sad' in its current state: it had no buttons and was much too large for her to wear. Catherine chose to shorten the sleeves of her cardigan to

25. Anne's reknitting project (detail).

26. Catherine's reknitting project (detail).

solve the size problem, and used a scarf as inspiration for the colours of the new trim. It was difficult for her to pick up the stitches of the extremely fine knit, but she developed a successful method of doing so as the work progressed. Catherine used the spare fabric from the sleeves to create a patch pocket with trim and added vintage Bakelite buttons. A few weeks after completing the project, she reported that she had worn her reworked cardigan to a friend's wedding, and 'almost constantly since'.

Julia chose to alter a fine-gauge lambswool jumper from her wardrobe. Although she liked the colour, it had not been worn for some time. She had the idea to use the 'cut open and trim' treatment to 'cardiganise' the jumper and decided to add an afterthought pocket to match the button band trim, in order to make the whole intervention look intentional. Like Catherine, Julia based her colour palette on a

27. Julia's reknitting project, with inspiration.

scarf from her wardrobe that she particularly liked. She encountered problems in the execution of the treatments, which required her to redo several time-consuming processes. At first, she seemed to have mixed feelings about the outcome but, a few months later, reported that she had been wearing her new cardigan and felt very happy with it.

Kiki decided to reknit a well-worn cardigan, with disintegrating cuffs and patched elbows. She chose to reknit the sleeves and, because she liked the idea of adding brighter colours to the dark background, knitted patterned samples in a number of colour combinations. Although the worn yarn was very weak, Kiki was able to salvage a reasonable amount to use in the new sections. She used photocopies to mock up the design, and then planned out the colour pattern and shaping using a grid system. Together, we adapted a picot edging to create a delicate scalloped finish that complemented the main trim. Although she had

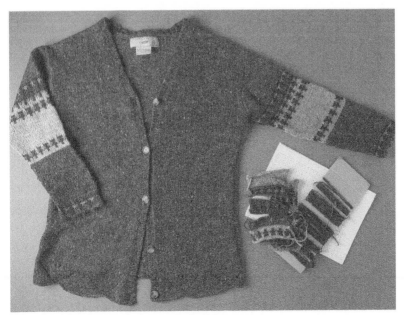

28. Kiki's reknitting project, with samples.

been unsure about the design whilst knitting it, Kiki felt that the project 'came together' at the end, and was satisfied with the outcome.

Margaret regenerated a woollen cardigan which she had knitted for herself over a decade before. It was riddled with moth damage and had a huge hole at each elbow. She had felt unable to throw the garment out because it was strongly linked to happy memories. When looking through her stash for yarn to use for the project, Margaret unexpectedly discovered a small sample of Fair Isle knitting she had made some years before, which became a starting point for the replacement sleeves. Aided by a book of Fair Isle patterns, she created the design as she went along, describing this playful process as 'liberating'. She then darned the small holes in the body of the garment and stitch-hacked her initials into the back. Margaret was pleased with her renewed garment and wore it as soon as it was finished.

29. Margaret's reknitting project (detail).

Experiencing Reknitting

Each of the Hereford knitters had expressed interest in the idea of transforming existing items of knitwear by volunteering to take part in the research. They were intrigued by the prospect of this transformation, but were generally unsure about what reknitting would involve, or what it might look like. Kiki, for example, said, 'I can't see it, I can't visualise, I can't imagine what you would do. I'm not very imaginative in that way.' Alex said that she did not know of any techniques that would successfully enhance a garment:

> My experience of altering things, or dressing them up, is limited but … they always involved changing the buttons or putting lace on it or something like that. And it just never looked right. It was never good enough that you'd want to wear it. It was a lot of effort, and the result was unsatisfactory.

Despite these misgivings, the knitters quickly embraced the potential of reknitting. When I shared the spectrum diagram with them at the first workshop, they responded positively to the suggestions it offered. As the project progressed, they proved to be game for the unexpected challenges presented by each of their garments. Because reknitting is, essentially, a type of repair, it cannot be fully planned in advance; it is a deeply contingent and open-ended activity. As Tim Dant observes in relation to repair, 'Often the nature of the task is only imprecisely specified in advance and its actual demands only emerge as the work progresses.'[18] Indeed, the knitters made discoveries about their garments as they worked with them. Julia, for example, found that the fabric of her jumper was slightly 'squint', which caused problems when she cut it open.

Interestingly, I observed a flexibility amongst the knitters in terms of the exact aesthetic of the outcome they produced. I found this surprising because when we had discussed the idea of reknitting at the start of the project, they had talked about needing to know how the finished item would look before choosing to invest time and effort

in reworking it. On the other hand, perhaps this could have been predicted: makers are used to their projects turning out differently from what is anticipated. In many cases this is a negative experience, but it seems that in this instance it helped the knitters to be relaxed and open-minded. Catherine said she liked the process of the garment growing and changing, as did Kiki, who suggested that this approach made her more creative. Alex, too, became comfortable with the contingency associated with reknitting: 'It doesn't have to be an immediate success. You've got to allow for, not exactly failure, but for things to turn out in a surprising way. Because you don't know.'

Following the project, the knitters reflected on their transformed garments. As the individual stories show, they were pleased with them and considered their alterations to have improved the original items. Margaret felt positive about the activity of reknitting more generally:

> It's been really quite exciting, what you can do with existing garments that you've got. Just to turn them into something really original, which I think is fantastic. It's quite a liberating thing. You feel like you can go in and alter and put back together. It's a really nice thing to do.

Julia described feeling proud of having achieved a complex task: 'I'm impressed with the way it all works, the construction of it. I think that's really clever. And I'm quite pleased that I've been able to do it.' Catherine, meanwhile, felt positive about having been able to transform an unworn item and return it to wear: 'It does feel good – noble … perhaps, sounds too pompous – to reinvigorate a rather sad garment.' Alex made a similar point: 'I feel, sort of, justified that I've been able to turn it into something I want. And I shall feel self-righteous when I wear it!' Julia reported that the experience of trying new techniques during the workshops would make her more confident in her knitting more generally: 'We've done things I wouldn't have attempted before. And things I haven't done yet, because I've thought they're beyond me … I do feel now, I can have a go.'

We continued to meet as a group after the scheduled sessions were completed. Several of the knitters brought along further items of

knitwear that they wanted to rework; others mentioned various projects that they had in mind. Catherine, for example, described having 'a large pile of knits waiting for new futures'. Alex explained that she was starting to see reknitting as an extension of her knitting practice:

> I think I've realised that knitting the garment is not the end of the journey. Whereas before, when you knitted something, you either wore it out, or got tired of it, gave it to charity. But it's no longer the end of the journey, it can always become something else. I may not think of that extended life at the time I'm knitting it, but it will always be in my mind when the time comes: either it's gone out of fashion, or I've got tired of it. There's another option there.

Margaret alluded to this anticipation of an extended life when discussing her reknitted cardigan. She recognised that the new sleeves would last longer than the worn fabric of the body, and suggested that she might end up reknitting the rest of the garment at some point.[19] Overall, I would say that together we succeeded in reframing knitting as a cyclical, rather than linear, process which can be flexibly employed to extend the life of garments in the wardrobe.

Openness and Reknitting

Returning to the theme of openness, reknitting can be seen as a process of 'opening' items which appear to be finished, complete and whole. This concept has been discussed in other spheres. In their work on packaging re-use, for example, Tom Fisher and Janet Shipton discuss 'open' and 'closed' objects; they describe open objects as being open to modification.[20] Many within the maker movement are also concerned with openness: frustrated by sealed electronic units and proprietary tools, they protest, 'If you can't open it, you don't own it.'[21] In that context, openness is primarily limited by physical restrictions. In contrast, the knitted structure is inherently open and tinkerable, and alteration activity is primarily restricted by human, rather than physical, factors. Therefore,

in my research I was particularly interested in the way garments are perceived: whether we feel that we are able to alter an item of knitwear (seeing it as open) or feel we cannot do anything to it (seeing it as closed). This corresponds to an idea proposed by Jonnet Middleton, building on the work of anthropologist Tim Ingold. She suggests that we can approach a garment either as a finished and fixed 'object', or as an unfinished and transformable 'sample of material'.[22] I also wanted to discover whether these perceptions can be challenged, and whether some actions are perceived as more possible than others. When reworking knitted garments, we are operating at two levels: accessing and altering the fabric itself, and reshaping the garment as a whole. I will deal with the fabric issues first, which are much more straightforward and relate to the common deconstruction processes of unravelling, laddering and cutting.

Unravelling – the deconstruction of a knitted fabric, row by row – directly reverses the formation of the loops involved in knitting, and the yarn remains in its original state, as a continuous strand. Knitters unravel and reknit their work in order to correct mistakes; this might be a small section of a single panel, or an entire garment which has not turned out as desired. Hence, unravelling can be seen as an integral element of knitting practice. Although unravelling is sometimes associated with disappointment, it does not seem to involve a great deal of anxiety. The process offers the satisfying opportunity to start afresh, as Julia described: 'I'm known as a backwards knitter. I'm always pulling stuff out and doing it again. I can't bear to be defeated by some balls of wool, and I can't bear waste.' Another operation used in the reknitting techniques is laddering. This occurs accidentally when a stitch is dropped, and for some people is a worrying experience, as Anne suggested: 'I'm always scared, if you drop a stitch or something, I'm always scared it's going to run right down to the bottom.' Still, most knitters know how to repair a ladder and are able to use this technique as an alternative means of correcting mistakes.

In contrast to both of these actions, which are seen as relatively safe, knitters are generally wary of cutting their knitting. If I mention the word 'cut' to knitters, the response is usually a sharp intake of breath and a look of panic. More than once I have heard 'sacrilege' muttered

in response. This horror is understandable; when a knitted fabric is cut, the structure of intermeshed loops is disrupted and it cannot be unravelled into a continuous thread. Cutting cannot be reversed, as unravelling or laddering can; therefore, I see it as a more savage means of opening a fabric. Cutting is often used in the creation of Nordic and Fair Isle knitwear, however. Garments are knitted as tubes and then 'steeked' – cut open to create sleeve and front openings. Nevertheless, it is still approached with caution. Even Alex, an experienced and confident knitter, said that she had never dared to use this technique.

Interestingly, I found it was quite possible to support knitters to overcome their horror of cutting by playing around with knitted fabric. Early in the project, I encouraged the group to take apart several mass-produced knitted garments. Their conversation revealed a shared assumption that any unsecured knitted fabric – whether open stitches not held on a needle, or a cut edge – would immediately disintegrate. The knitters were amazed to find that this was not the case. The nature of the knitted structure is such that ladders need manipulation to 'run', and a fabric cut vertically does not tend to come apart without vigorous handling. By playing with knitted fabrics, the knitters discovered qualities that they had not previously perceived and developed a deeper understanding of the knitted structure; this changed their attitude to alteration at the fabric level.

Opening Knitted Garments

I will now turn to the more complicated issues which emerge when thinking about altering knitted garments, and consider what we perceive to be possible in this regard. As I have explained, reknitting is no longer a common practice. Although we may have a vague cultural memory of items being unravelled and reworked, the lack of current activity indicates that the idea does not occur to most people, beyond fixing problems that arise during the making process.

When I started the research, I was particularly interested in the issue of origin: I wanted to see whether the knitters were more

inclined to alter homemade garments over shop-bought items. Kate Fletcher suggests that the ready-made garments supplied by mass production are 'presented to us as complete or "closed", with an almost untouchable or sacrosanct status'.[23] Design writer Stuart Walker adopts a similar position, describing ready-made products as predefined and inviolable, 'presented to us as a fait accompli'.[24] To some extent, this seemed to be the case: when the Hereford knitters talked about selecting items for reknitting, it was clear that they were less confident about tackling fine-gauge knitwear, all of which would be mass-produced, and therefore shop-bought. I realised, however, that this concern primarily related to their ability to achieve a satisfactory result when working with the tiny stitches, and to execute the calculations that would be required, rather than the origin of the item. In fact, after the projects were completed, Catherine said that she would be more inclined to work on fine-gauge, mass-produced items than hand-knitted garments, feeling that she would be more able to achieve a successful result.

I found it surprising that the origin of a garment did not seem to be an issue, and I wonder whether the group's willingness to tackle shop-bought items might have been supported by my encouragement and the sample garment I produced. If they were working more independently, I suspect that many knitters would, indeed, be reticent to alter shop-bought pieces. When a homemade garment is altered, there are fewer mysteries to be uncovered; the methods of construction are familiar. As Walker points out, 'if we had a hand in its creation, we would be more able to effect a repair because we would already have an understanding of the object – what it is made from, how it is made and how it works'.[25] Although the basic structure of hand-knitted and machine-knitted fabric is the same, knitters are less familiar with the construction techniques of mass-produced items and the sense of risk is therefore heightened. This may affect their assessment of whether they can achieve a positive result.

Another issue emerged from my conversations with knitters, also relating to the question of origin. In her interview at the start of the project, Julia spoke in detail about her experiences of unravelling

homemade garments which had not turned out successfully. As she described two garments that were 'waiting for an unpick', I sensed that she was visualising the balls of yarn which could be extracted from these unsatisfactory items. Because she had made the garments, she perceived them differently to the way another knitter would; she also thought about them differently to shop-bought items. This supports my idea that makers perceive things they have made as separate sections, while others see the garment as a whole. When a knitter has made an item, he or she retains the memory of its previous states: as balled yarn, as work in progress and as separate panels before sewing up. Reknitting requires the knitter to treat each stitch as a building block. To do so, the stitches must be recognised, and it seems that it is easier to recognise stitches if you originally formed them.

Condition and wholeness

While origin may play a part in our willingness to alter a garment, the project suggested that condition is, in fact, a much more important factor. All of the garments selected for reworking by the Hereford knitting group had one or more identifiable problems, which they intended to address by reknitting. Some of these problems were physical, such as holes or other damage. Some related to fit – not a problem with the garment in isolation, but rather in combination with the intended wearer. Other issues were purely subjective, such as the cardigan which Alex felt to be too boring to wear. Whatever the issue, the problems were apparent to the knitters and made the garments seem open and suitable for alteration. At one workshop, as an exercise, I asked the knitters to help me redesign a plain red cashmere jumper. The jumper was in perfect condition, and I did not identify any problem with it. Although we generated a range of ideas, towards the end of the activity Anne explained that she was having trouble: 'See, I do find it difficult to just look at that jumper, all nice and complete … I just think it's a very nice jumper.' The other knitters agreed, suggesting that the wholeness of the garment made it difficult for them to imagine

making changes to it. It seems that the perfect condition of the item meant that it was perceived as closed, in comparison to a damaged garment, which is open and invites action. Drawing on the writing of German philosopher Martin Heidegger, Steven Jackson argues that when objects cease to function as expected, they catch our attention and reveal previously unanticipated possibilities. As he points out, 'It is therefore precisely in moments of breakdown that we learn to see and engage our technologies in new and sometimes surprising ways.'[26] While all knitted garments have the capacity to be altered, it is when they become damaged and the structure starts to degrade that this property becomes more obvious.

Interestingly, an appetite for wholeness also popped up during the process of reknitting. The conversations between the knitters revealed a crucial issue: whether their alterations would look intentional and purposeful. During the early stages of the projects, several of them expressed concern that their additions might look 'stuck on', added just for the sake of it. These concerns were addressed by using the repetition of design elements to 'tie everything together', making the original garment and the new additions part of a new whole. This repetition involved the use of matching or toning colours, the use of a new trim at multiple points on the garment, the re-use of the original yarn and the matching of new and old trims. When the knitters reflected on their projects, positive comments mentioned the alterations looking 'like it's part of what it's supposed to be' and 'interwoven', and the altered garment being 'like a whole' and 'hanging together'. Comments made by Alex about her project revealed the desire to preserve the 'essence' of her garment, which could be seen as another aspect of wholeness:

At the end of the day, I do like the cardigan although I haven't worn it. I don't want to mess it about too much, and spoil the essence of what it is. It would be mad to cut it in the middle and start putting Fair Isle bands and things in it, because it would lose the being as the thing I like.

Reknitting and Well-Being

How might this experimental practice of reknitting relate to well-being? This question can be considered in terms of both making and wearing. Reknitting is simply a different type of knitting activity: remaking existing pieces rather than creating new ones. Therefore, many of the rewards associated with the process of making, such as the social aspects of the activity, the exercising of bodily kinaesthetic intelligence and the opportunity to 'leave your mark', are still relevant. Furthermore, the economic benefit of making at home comes back into play when mending or reworking existing items: a valued piece could be returned to wear for the cost of a small amount of new material. In some ways, however, the experience of reknitting is different from conventional knitting. This is partly practical. In my experience, the activity requires a larger proportion of the 'concentrating' mode of making, and this might make it less attractive to those who prefer the rhythmic repetition of forming stitches to the intense challenges of design and pattern calculation. More conceptually, repair offers a different relationship with the things around us: it involves tinkering with our possessions, rather than bringing new ones into being. That does not mean it is not satisfying, of course. In fact, I would say that this activity has the potential to deliver an equal, if not greater, sense of agency, as it gives us the chance to reshape the world around us.

What about the experience of wearing reknitted garments? In reknitting – and repair more generally – the garment is present during the design process. In conventional making, where new items are created from scratch, the fact that you cannot try on a garment before you have knitted it is acknowledged to be a drawback. In this project, the knitters benefited from trying on and manipulating their items whilst designing and making. This helped them to have an idea of how the finished piece would look and feel, which in turn, I believe, helped them to be satisfied with the result.

I have said that homemade clothes could provide an ideal way to meet our needs for identity and participation, because they connect the practices of making and wearing. In principle, reknitting brings those

practices closer together by applying the knitter's making practice to the clothes already within the wardrobe. When we reknit, we are able to mould our identity *within* a single garment, adding new meanings associated with the practice of making. Alex felt that her original cardigan did not reflect her current identity, but by updating it to correspond with current fashions, she was able to change the meaning that she perceived in it. Margaret was keen to maintain the personal meanings associated with her cardigan, which reminded her of a particular period of her life. By replacing the sleeves, she preserved these meanings and added new feelings of achievement and creativity. But homemade clothes are also subject to shared meanings. While making and mending can be seen in a positive light, they can likewise be associated with the stigma of poverty and 'making do' – even though such attitudes do not reflect the economic realities of contemporary life. In this project we seemed to be able to position reknitting – a type of repair – as a positive and creative act. The satisfaction of contributing to the evolution of a garment was given prominence, and shared within the group.

Reknitting provides the opportunity for knitters to use hand knitting to rework mass-produced garments, and therefore to mix two cultures of making within a single item. This transgression of boundaries is potentially risky. If the 'amateur' homemade is juxtaposed with the 'professional' finish of manufacture, it may be perceived more negatively. Yet, thinking back to the knitters' discussion of 'wholeness', it would seem that the new and old sections of the garments were perceived to have merged, producing a new type of garment: neither handmade nor shop-bought. In his discussion of the repair of buildings, Christopher Alexander makes a similar point:

When we repair something in this new sense, we assume that we are going to transform it, that new wholes will be born, that, indeed, the entire whole which is being repaired will become a different whole as the result of the repair.[27]

On one hand, the items in this new, marginal space could be seen as even more vulnerable to negative meanings than purely homemade

items. On the other, they could be items for which a collective meaning has not yet been developed. Certainly, within the micro fashion culture of the Hereford knitting group, the reknitted garments were perceived as embodying positive meanings which contributed to a positive wearing experience.

Supporting Reknitting

There is definitely scope for wider participation in reknitting. After all, there are estimated to be several million hand knitters in the UK and many millions more across the world. From this experiment, I believe that a significant minority – those who welcome more complex knitting challenges, and the opportunity to feel more creative – could be interested in extending their practices to embrace this activity. As Chantel Carr and Chris Gibson point out, their existing skills equip them well for the challenge of reworking:

> Across diverse maker cultures are people *already equipped* with the sensibilities and disposition to conceive of things-at-hand as only ever temporary gatherings of matter and idea, which can disperse and be reassembled elsewhere in new combinations.[28]

I am excited by the prospect of greater engagement with reknitting because I see it as a radical type of folk fashion which can disrupt our conventional wardrobe habits and turn making into a cyclical process – thus keeping garments in use for longer. It allows us to stray far from the sanctioned footpaths of the fashion commons and thereby effectively challenge the enclosure associated with mass production and the professionalisation of making. Like the Diggers and the guerrilla gardeners, we are getting stuck in, physically intervening in the garments already in existence.

The fact that millions of knitters are not already reknitting away happily suggests that there is a need for support to nurture a folk fashion culture of reworking. This practice requires a quite different approach

from the normal, expected procedure of following a pattern. The structure of the reknitting project provided a permissive environment which supported this new mode of activity, as Alex described:

> Well, that's been the thing about these workshops, and the space between them, is … I'm getting permission by being here. To play around with things, and it's not wasteful to spend time doing things and pulling them back. It's a freedom that you have, but you don't know you've got.

This 'permission' also relates to the outcomes of reknitting; the knitters gained confidence in their projects by working within a supportive group – using their peers as an alternative source of validation. In order to foster a sense of shared practice and gradually build tacit knowledge in individuals and communities, the supportive space provided by the project would have to be built on a larger scale. Things get exciting when we start to dig together.

Notes

1　Tom Hazeldine, 'Foreword', in Andrew Hopton (ed.), *Gerrard Winstanley: A Common Treasury* (London: Verso, 2011), pp. vii–xix.

2　Richard Reynolds, *On Guerrilla Gardening: A Handbook for Gardening Without Boundaries* (London: Bloomsbury, 2008), p. 16.

3　Richard Sennett, *The Craftsman* (London: Penguin, 2008), p. 200.

4　Christopher Alexander, *The Timeless Way of Building* (New York: Oxford University Press, 1979).

5　More information on Tom van Deijnen's Visible Mending Programme can be found at tomofholland.com.

6　Ben Fine and Ellen Leopold, *The World of Consumption* (London: Routledge, 1993).

7　Nancy Page Fernandez, 'Innovations for home dressmaking and the popularization of stylish dress', *Journal of American Culture* 17/3 (1994), pp. 23–33.

8 Margaret Murray and Jane Koster, *Complete Home Knitting Illustrated* (London: Odhams Press, 1946), p. 229.

9 For example: Anna-Stina Lindén Ivarsson, Katarina Brieditis and Katarina Evans, *Second-Time Cool: The Art of Chopping Up a Sweater* (Toronto: Annick Press, 2005); Stefanie Girard, *Sweater Surgery: How to Make New Things with Old Sweaters* (Beverly: Quarry Books, 2008).

10 Michael R. R. Pearson, *Traditional Knitting of the British Isles: The Fisher Gansey Patterns of North East England* (Newcastle: Esteem Press, 1980), p. 13.

11 Annemor Sundbø, *Everyday Knitting: Treasures from a Ragpile* (Norway: Torridal Tweed, 2000), pp. 136–7.

12 Agnes Miall, *Economy Knitting and Patchwork* (London: John Gifford, 1944), pp. 74–5.

13 For example: Murray and Koster, *Complete Home Knitting Illustrated*.

14 Elizabeth Zimmermann, *Knitting Without Tears* (New York: Fireside, 1971).

15 Details of my stitch-hacked garments can be found at keepandshare.co.uk/making/stitch-hacking.

16 The reknitting resource is now available at reknitrevolution.org.

17 Visit the reknitting resource, reknitrevolution.org, for more information on changing gauge. Full discussion in Amy Twigger Holroyd, 'Folk fashion: amateur re-knitting as a strategy for sustainability', PhD thesis, Birmingham City University, 2013. Available at bit.ly/folk-fashion (accessed 7 October 2016).

18 Tim Dant, 'The work of repair: gesture, emotion and sensual knowledge', *Sociological Research Online* 15/3 (2010), p. 7. Available at socresonline.org.uk/15/3/7.html (accessed 6 October 2016).

19 Readers familiar with the classic British TV series *Only Fools and Horses* will note the similarity of Margaret's suggestion to Trigger's broom, which had 17 new heads and 14 new handles in its lifetime. Classicists might alternatively be reminded of the ship of Theseus, which had all of its planks replaced. The question of whether the cardigan, broom or ship remains the same object has fascinated philosophers for centuries.

20 Tom Fisher and Janet Shipton, *Designing for Re-Use: The Life of Consumer Packaging* (London: Earthscan, 2010).

21 Mister Jalopy, 'Owner's manifesto', Make (2005). Link no longer working.

22 Jonnet Middleton, 'Mending', in Kate Fletcher and Mathilda Tham (eds), *Routledge Handbook of Sustainability and Fashion* (Abingdon: Routledge, 2015), pp. 262–74, p. 270.

23 Kate Fletcher, *Sustainable Fashion and Textiles* (London: Earthscan, 2008), p. 187.

24 Stuart Walker, *Sustainable by Design: Explorations in Theory and Practice* (London: Earthscan, 2006), p. 54.

25 Ibid., p. 57.

26 Steven J. Jackson, 'Rethinking repair', in Tarleton Gillespie, Pablo J. Boczkowski and Kirsten A. Foot (eds), *Media Technologies: Essays on Communication, Materiality, and Society* (Cambridge, MA: MIT Press, 2014), pp. 221–40, p. 230.

27 Alexander, *The Timeless Way of Building*, p. 485.

28 Chantel Carr and Chris Gibson, 'Geographies of making: rethinking materials and skills for volatile futures', *Progress in Human Geography* 40/3 (2016), pp. 297–315, p. 305, original emphasis.

6

Patterns, Design and Creativity

The magic of sweater design is that there is no magic. There is just common sense, a knowledge of how the human body is put together, an understanding of the way knitted fabric gives and stretches and pulls, and easy fourth-grade arithmetic. Nothing more. Nothing complicated.[1]

Can this statement – part of the introduction to Maggie Righetti's *Sweater Design in Plain English* – really be true? I love her positive attitude, encouraging knitters to break free from pre-designed patterns and explore their creative ideas. Designing for yourself is an excellent way to roam free across the varied terrain of the fashion commons. On the other hand, I know from bitter experience how difficult it can be to turn an idea into knitted reality, and – even more – to come up with a convincing and original idea in the first place.

Using Patterns

Textile practices such as knitting and sewing are blessed with a rich diversity of shared designs which makers have used, adapted, reinvented and contributed to over generations. Many such designs are linked with particular regional communities, such as the intricate two-colour geometric glove designs which emerged in the Scottish town of Sanquhar in the late eighteenth century. Traditionally, these patterns would have been passed on orally from generation to generation. Alison McGavin, a Sanquhar knitter interviewed in 1955, suggested that 'there are some bits you can't do unless you've seen them done'.[2] Since the nineteenth century, however, it has

increasingly been common practice to document garment instructions in an accessible form through patterns. An explosion of hand-knitting books provided patterns for items such as caps, shawls, baby clothes, mittens, stockings and blankets when the craft became a respectable hobby for middle-class women in the 1830s.[3] Sewing patterns have a similarly long history: the same decade saw the first of many clothing-related books and periodicals for women containing patterns in some form being published. These books were followed by the first paper patterns a couple of decades later.[4]

Over time, patterns have varied in the amount of detail offered. The first sewing patterns for domestic use provided scant information, assuming a significant amount of knowledge on the part of the maker.[5] The same is true of early knitting patterns.[6] Patterns also vary in terms of complexity, from basic options for beginners to 'couture' projects requiring a high level of skill. In their most common format, sewing patterns combine full-size shaped pattern pieces with step-by-step guidance, while knitting patterns provide instructions in the form of written, and sometimes graphically represented, code. These resources are invaluable in guiding makers through what is – even

30. The differing languages of sewing and knitting patterns.

for a simple garment – a relatively complicated construction process, providing a highly effective means of communicating instructions from one person to another and recording procedures for future reference.

Despite their ubiquity, patterns are not without problems. For example, in her interview Rosie Martin spoke about novice sewers being afraid of patterns and not knowing how to approach them. As Rachael Matthews explained, this is also the case with knitting: 'Most people that haven't used a pattern ever before, they're terrified of it, because it's all in code. They just look at it, freak out, and say that's not for me.' Even experienced makers can sometimes have difficulty deciphering pattern instructions – whether due to a temporary lack of the lateral thinking skills required on the part of the user, or unclear coding by the pattern writer. I have heard many stories about poor-quality knitting patterns, such as projects published with sections of the instructions missing and jumpers with neckholes insufficient to stretch over a head. I have also heard both knitters and sewers criticise the fit of some patterns, describing them as sloppy, shapeless or drafted only for a specific figure. Makers sometimes complain about a lack of clear visual information; seductively styled photographs often fail to communicate the true shape of a finished item. Despite the massive choice of patterns now available, some people struggle to find styles that they want to wear – perhaps because their tastes are not being catered for, or because they are unaware of the full diversity of designs on offer. In a way, this is another form of enclosure: it could be argued that patterns are as restrictive to the commons as the ready-made clothes available in the shops. A further problem can be identifying patterns which are suitable for your skill level, as Hereford knitter Kiki described:

I try and find a pattern that's not too difficult, which is difficult in itself (laughs). Especially when you ask the person in the shop and they say it's a relatively easy one, and then you get home and you haven't a clue.

Patterns and Creativity

I am interested in the connection between folk fashion and creativity, partly because creation is one of the human needs identified by Manfred Max-Neef in his work on well-being.[7] But what does creativity mean? As David Gauntlett explains, many definitions of this concept discuss world-changing inventions and focus entirely on outcomes, rather than the process of creation; something must be *completely* new, and be acclaimed as such by others in the field, to be deemed creative.[8] These perspectives overlap with the established values of art, which venerate originality and also promote the notion of the individual genius.[9] In contrast, the culture of craft has long been based on sharing, with activities such as knitting, quilting and embroidery drawing on a rich resource of traditional designs and an ethos of communal evolution.[10] Thus, this culture – and especially the use of patterns and instructions within it – is often stigmatised as uncreative. Artist Pen Dalton writes disparagingly of patterns, describing them as having a standardising and restrictive effect on craft practice.[11] Sociologist Kevin Wehr is even more dismissive, suggesting that instructions 'can lessen the purity of a DIY endeavor. This can verge towards a "DIY-lite" where a project is done in a "color-by-numbers" manner.'[12] With these attitudes in mind, it is unsurprising that many people who make their own clothes do not consider it to be a creative process – as Rosie Martin explained:

> People who sew often don't see themselves as creative. They see it as something you can do if you're not a creative person, because that recipe is already there, the sewing pattern ... so all you're doing is following instructions.

This way of thinking seems to be pretty widespread. It has its benefits: if making clothes is thought to be uncreative, then the activity arguably becomes more accessible, as people do not have to identify as 'artistic' or 'creative' in order to get involved. Yet in many ways this perspective downplays the value of folk fashion and contributes to the long-standing hierarchy of fine art over craft.

Recognising the shortcomings of established definitions of creativity for amateur making, Gauntlett offers an alternative perspective. He suggests that 'creativity is about breaking new ground, but internally: the sense of going somewhere, doing something that you've not done before'.[13] He places importance on the process of making, explaining that it should arouse feelings of joy and requires only that the output be novel in its immediate context – thus valuing the maker's own sphere of activity. Using this definition, much folk fashion making could be characterised as creative. In my experience, the majority of knitters and sewers like to challenge themselves by trying new things – and therefore 'breaking new ground' – with each project. Furthermore, as Kathryn Harriman explains, the individual variations on established patterns made by makers contribute to the continuous evolution of designs and techniques.[14] Taking this more inclusive view, the act of choosing a pattern and materials can be seen as an opportunity for creativity. Rozsika Parker describes how women choose embroidery patterns which have particular meaning for them as individuals,[15] while interviewee Rosie Martin pointed out that in selecting fabric for their garments, makers 'bring themselves' to the patterns they use.

Deviating from Patterns

Even when taking a positive position on patterns, it is important to acknowledge that there may be makers who wish to operate more freely. My research has highlighted the fact that some people wish to deviate from pre-designed patterns but lack the confidence to do so. Laura Blackwell, for example, said in her interview that when she started sewing she was 'über-faithful' to the pattern. Hereford knitter Anne described herself as 'a slave' to a knitting pattern she was using. This lack of confidence seems to be a particular issue for knitters, and I think the tone of many knitting resources has a role to play. As Ferne Geller Cone describes:

One area of fashion that for years has dangled its devotees on puppet strings is handknitting. […] The puppet strings are labelled *always*

and *never* [...] Thinking in such absolute terms produces copycat knitters who blindly follow someone else's dictates.[16]

The complex format of the written knitting pattern further contributes to this problem. Maggie Whiting explains that when presented with 'lengthy, row by row written instructions [...] even many experienced knitters often [have] no idea how to adapt patterns to suit themselves'.[17]

Despite these barriers, I have found that makers often do start to adapt patterns as they gain experience and confidence. In many cases, patterns themselves support a degree of adaptation. Dressmaking patterns have long been designed – as Marcia McLean describes – 'so that the sewer could choose various options and features, giving her a role to play in the design of the garment'.[18] Similarly, knitting patterns usually include multiple sizes and sometimes a number of style variations. And makers frequently venture beyond the options provided by the pattern. Margarethe Szeless suggests the term 'unorthodox home dressmaking' to describe the way in which home sewers exceed these boundaries,[19] and the same practice is now described in the sewing world as 'pattern-hacking'. A widespread 'unorthodox' approach employed by knitters is the use of a different yarn to that specified in the pattern. More experienced knitters might even use a yarn of a different weight or a different stitch, or vary the design, as Hereford knitter Alex described:

> I look at things and think, I really like that, but I would make the neck lower, and I'll make the sleeves shorter, and I'll make the body longer ... I'll take this idea, I'll take 90 per cent of this pattern, and I'll just do the bits that I want, so that I know I'll wear it and be comfortable in it.

In her interview, Carol described altering vintage sewing patterns to fit her body shape and subsequently using that pattern in a variety of ways. Laura Blackwell said that she now has the confidence to mix and match patterns, for example combining the sleeve of one design with the body of another. When I spoke with Christine Cyr Clisset, she, too, reported adapting patterns:

I always want to tweak it a little bit, or change it. For instance, I had this weird funky pattern from the 80s for a wrap dress. I really liked the top, so I ended up adapting the pattern so I could just make it into a blouse.

Online platforms are now making it possible for makers to share their adaptations with others, fuelling further activity. As Rachel Kinnard explains, the BurdaStyle website – like knitting website Ravelry – provides a platform for user-generated variations on commercially produced patterns: 'This extensive catalog serves as a library as well as a source of inspiration for members' own versions, and also represents a genuine alternative to the popular image of the "designer as genius".'[20] Other pattern companies actively encourage users to hack their designs, sharing and rewarding inventive adaptations. By Hand London, for example, ran a 'Pattern Hackathon', where they invited customers to 'show off [their] favourite hacks, hybrids and lovechildren'.[21]

Designing for Yourself

While many makers derive great satisfaction from using patterns, whether adapting them or following them faithfully, there are plenty of people who have the desire to work without commercial patterns and instead design their own projects. In some cases, this is because they cannot find patterns for what they want to make; in others it is because they are keen to feel a greater sense of creativity in their making practices. I used to run a weekend workshop in calculating knitting patterns, and at the start of every course I would ask the participants why they had come along. One woman memorably responded that she wanted to knit 'off-piste' – a statement that others in the group heartily agreed with. At an early session with the Hereford knitters, Julia said that she did not like using patterns simply because 'I don't like being told what to do'. Although I have met many makers who share this desire to design, I think most would agree that it is a rather intimidating challenge. As Alex commented at the beginning of the reknitting project: 'It's a scary

thing to be creative, when you've got nobody anywhere giving you a nod that you're on the right line.'

What does design mean? Influential design thinker Herbert Simon argues, 'Everyone designs who devises courses of action aimed at changing existing situations into preferred ones.'[22] Victor Papanek takes a similar line, saying that 'The planning and patterning of any act toward a desired, foreseeable end constitutes the design process.'[23] Despite these impressively inclusive definitions – open in their understanding of what is being designed, and who is able to design – it is fair to say that design, as Philip Pacey suggests, is commonly thought of as 'a modern activity practised more or less exclusively by a professional elite'.[24] The consequence of this is that design carried out by amateurs is generally seen as either non-existent or crude and incompetent, a perspective that corresponds with the more general denigration of the homemade. This is unfair and inaccurate, of course. While *some* clothing designed by amateurs is indeed rather crude, there is nothing to say that an amateur cannot come up with just as elegant a design as any professional.

When considering this issue, it is worth remembering that designing for yourself is quite a different task to designing for industrial production. When I studied fashion design at university I was training for a role in which I would design collections of garments aimed at target markets and based on a standard range of sizes. I would be considering both forthcoming trends and a particular method of manufacture, and the garments I designed would go through several rounds of testing and refinement before production. In contrast, when I am designing for myself I am creating individual garments, taking into account my current preferences as a maker and as a wearer, and catering for my own unique body shape. While I might produce some samples along the way, I am essentially creating a one-off piece and cannot be sure it has turned out as hoped until the very end of the process. Therefore, while the skills required by the professional fashion designer and the amateur folk fashion maker might overlap, they are certainly not identical. Bearing this in mind helps us to see the activity of designing for ourselves as its own unique challenge.

I enjoy gathering tales which demonstrate the design abilities of amateur makers. Oenone Cave, for example, describes the women who made traditional smocks in England during the nineteenth century:

> The countrywoman, with her usual ingenuity, contrived when embroidering the smock to combine stitch, design and fabric in perfect harmony to make the finished product serve efficiently the use for which it was intended, allowing it to be essentially practical yet strikingly decorative at the same time.[25]

Kate Davies describes similarly impressive skills in a blog post about the vibrant culture of domestic needlework on the Estonian island of Muhu, explaining that 'Without the pressures of external commercial markets, the women of Muhu simply competed *among themselves* to produce domestic textiles of ever-more glorious variety, ornament and colour.'[26]

Of course, these success stories do not mean that design is easy. In contrast, I would say that it is rather tricky, requiring the development of a creative vision alongside the practical knowledge of how to execute it. Of these two complementary sets of skills, the practical ones are arguably more accessible. Knitters can attend a workshop such as mine to learn how to calculate patterns, use a book or – for the more maths-literate and adventurous – figure it out themselves. Similarly, sewers can attend classes or use books to learn to draft patterns, or develop alternative strategies, such as the one described by Christine:

> I'm really interested in geometric patterns, and how you can make clothing out of geometric shapes. A lot of the clothing that I do for myself will be based on triangles or on squares – and how you can make those fit together and make cool clothing out of them.

Another alternative strategy is to work without patterns altogether, through the practice of freehand dressmaking,[27] which is also enticingly described as the 'rock of eye' method.[28]

While there is much more that could be said about the amazing technical processes of creating patterns and garments, I would like to

focus on the other set of skills I mentioned: those required to develop a creative vision for a garment. In my experience, this is the area that most excites, but also most mystifies, folk fashion makers. In order to understand the processes involved in developing a design, and to think about ways in which amateurs might go about them, I will return to the reknitting project involving the Hereford knitting group. Because every existing item of knitwear is different, every reknit involves individual creative decisions. Therefore, an important part of the project was supporting the knitters to design for themselves. They all had a desire to be 'more creative' in their making but were not sure how to go about this. By examining their experiences, lessons can be learned about the challenge of folk fashion design, and ways in which it can be supported.

Finding Inspiration and Choosing Colours

It seems to me that those new to design have two contrasting problems when it comes to inspiration: they are either totally stumped and unsure how to gather the inspiration to kickstart a project, or they are overwhelmed with ideas, so much so that they try to combine too many concepts within a single garment. With the aim of navigating between these potential pitfalls, I set the Hereford knitting group the task of creating a personal inspiration resource. My idea was that this resource could be drawn upon for specific projects, with just one or two items selected on each occasion. I was delighted when the knitters arrived at the next workshop buzzing with excitement and ready to share a wide range of materials. Interestingly, most of this inspiration had been gleaned within their homes, and much of it had emotional significance. Some items had even been saved with the intention of a future creative application. Kiki, for example, described having gone through the whole house, starting in the attic. She brought in an amazing selection of textiles, including weaving and crochet samples made by her mother that she had saved for years. As she explained: 'I have drawers full of things saved for one day, you might know what to do with them ... so, a mixture of nostalgia and hope for the future!' By going through the

31. Sharing inspiration at the start of the reknitting project.

process of gathering inspiration and reflecting on it, the knitters made discoveries about their own tastes, which they linked to identity. Julia, for example, said: 'I've come down to what I know is me.' Margaret was prompted to think about how long-standing her personal preferences had proved themselves to be: 'I can pick out colours now that I know I liked when I was eight. You're just drawn to the same things, always.'

I know from the workshops I have run in the past that colour can be an area of both excitement and concern when people are designing for themselves. Claire Montgomerie has observed the same phenomenon:

> While working in a yarn shop, I witnessed the mesmerizing effect a rainbow of yarn can have on a customer's senses [...] However, most knitters are nervous about acting on this innate love of yarn and colour, fearing they are not creative enough or won't live up to the fantastic potential.[29]

When I talked to the Hereford knitters about this topic, Alex described being concerned about colour 'rules': 'I get hidebound by what I've seen and what I've been told. I'm trying to break out of it.' Kiki, too, was unsure about whether such rules should supersede her own ideas: 'Somebody once told me that all greens go together. I'm thinking, What? It's a matter of opinion, isn't it?' I encouraged the group to take an experimental approach to colour and not worry about any rules they might perceive. This approach is echoed by Maggie Righetti, who says: 'Go ahead, dive in, have fun, play with color, break the "rules", and use colors that sing songs of joy to you, even if only your ears can hear them.'[30] At one of the early workshops we tried out an exercise to introduce this approach, using fabric swatches to closely match the tones in an image or textile. The knitters enjoyed the tactile and visual nature of this process and found it helped them to come up with pleasing new combinations. This task was of use when they came to work on their individual reknitting projects, with several selecting items from their personal resources to inform their final colour choices.

Trying Things Out

Another design-related activity that I have found folk fashion makers tend to avoid is the process of trying out ideas before settling on a final design. In fact, they are not in the habit of sampling at all. Although knitting patterns sternly instruct the knitter to knit a tension square to check their gauge before embarking on a garment, most do not bother. When I talked to the Hereford knitting group about this issue, Julia commented: 'It seems like wasting time, because you've got the wool, and you want to end up with your garment. You just want to get on with it.' Kiki explained her reluctance to sample: 'Sometimes for me, it's anxiety-driven. It's … I'm not sure if I can do this; if I can do it fast enough, perhaps it'll work. You want to get to the end to check if you've done it.'

Sewers using patterns could, if they wished, produce a sample garment to check the shape and try out particular techniques before

cutting into their proper fabric. Laura Blackwell said that she only does so if she is planning to use an expensive fabric – because, as she explained, she hates making the same thing twice, and has limited time. Making without sampling is perfectly understandable when following a trustworthy pattern or creating a garment of a familiar type. It is a far more risky business to use the same approach when making a garment to your own design. Not only is sampling, for me, one of the most enjoyable parts of the design process, it is invaluable for identifying and addressing problems at an early stage. So why do many folk fashion makers not sample when designing for themselves? Perhaps because, as Alex suggested, 'There's no culture of playing with wool, unless you're trying to do fancy odd things. There's no culture for ordinary knitters of playing around.'

During the reknitting project, the knitters produced samples of various types and used them to visualise how their intervention would look on the garment. In fact, it was notable how quickly it became second nature for them to experiment. Transcripts of the design discussions show frequent mentions: 'you'd have to sample it'; 'I'd have to try it out'; 'I'll have to do a bit more experimenting'; 'I need to do more swatches'. Several of the knitters later described knitting samples for other projects. Kiki, for example, started to experiment with Fair Isle patterns. (These experiments quickly developed into some beautiful garments; I am pleased to report that she has truly left the 'discouraging' era of her knitting career behind her!) Thus, their attitudes to sampling had changed significantly as a result of the project, as Alex described:

It's one of these things you're told that you can't believe until you've done it. Everybody has to do it for themselves to understand what you get out of it, you can't be told. Certainly I feel, now, that doing any samples or trying out wool is not a waste of time because it adds to a benefit of what you're eventually going to do.

She went on to explain: 'I would have thought that was beyond me before, that was something that designers did.' These comments reveal a shift in what Alex felt she was 'allowed' to do as a folk fashion maker,

and an important blurring of the lines between professional and amateur activity. I see this as yet another potent way of challenging enclosure: stepping beyond the established role of the 'home sewer' or 'home knitter'.

Design Considerations

As I have described, designing for yourself is a rather particular challenge, which involves the balancing of multiple considerations. During the reknitting project I was able to observe the Hereford knitters developing designs which took into account the specifics of their selected garments, alongside their personal making and wearing preferences. Each of the garments chosen for reworking had an identifiable problem. This problem initiated the design process and informed the alterations that were up for consideration. As the knitters developed their designs, they thought about the structure, gauge and colour of the item and were sensitive to issues of wholeness and intentionality; they were keen for the finished item to 'hang together' as one coherent piece.

In terms of their wearing preferences, each knitter was thinking primarily about whether any proposed alteration would suit them and correspond with their identity. Hence, much of the conversation involved assessment: 'would I wear that?' In this comment Julia was considering options in relation to her personal style:

> If I did something simple like that, I know I would be prepared to wear it. I like the frills, but I don't think I'd wear them. It's not me, I'm not frilly. I like them, I think they look lovely, but they're not what I'd wear.

At the same time the knitters were thinking about their preferences as makers, considering the scale and complexity of various options and choosing one which felt right for them. In some cases, options were felt to be too complex. Kiki, for example, simplified the plan for her garment to make it more manageable. For some of the knitters, time

was the critical factor. Margaret said she was not being too ambitious because she had little time available to complete the project. She did, however, take the opportunity to use new techniques which appealed to her: 'I might stitch-hack my initials, because I'd love to just do a bit'; 'I quite fancy the idea of knitting down, because I've not done that before.' In the early stages of the design process, Julia considered two possible projects, comparing them in terms of effort and reward: 'I think that one would be easier. But this one, I think I'd be more pleased with the result. I'd feel I'd achieved a bit more with this one.'

I was impressed by the way in which the knitters were able to balance these multiple factors and come up with successful designs which they were happy to wear. They each developed a vision for their item and formulated a workable design which was flexible enough to embrace the contingencies of the existing garments. In the process, the knitters created their own patterns, which took different forms: conventional row-by-row written notes, graphically represented stitch-by-stitch diagrams and even a general plan held only in the knitter's memory. During the project, I observed them grow in confidence and begin to trust their own instincts about aspects of design such as colour, balance and silhouette. After the project finished, they were excited by the prospect of continuing to design and make. Catherine – who had previously been a professional artist – reported that the experience had allowed her to reclaim an important aspect of her identity: 'This is the bit that is me and the bit that has felt "asleep" for a hundred years – reawakened, excited and raring to go.'

Tacit Knowledge and Peer Support

It is important to note that this ability to design did not emerge from nowhere; it was aided by the knitters' tacit knowledge of knitting and the support of the group. Tacit knowledge is sometimes described as 'personal know-how' and contrasted with formal or explicit knowledge, which can be expressed and transmitted via language. I observed the knitters drawing on their tacit knowledge

of knitting throughout the design process, and I believe that this was crucial to their ability to design. They used this understanding to inform their initial ideas, consider technical issues, anticipate how a proposed alteration would look, and evaluate the complexity of a proposed alteration. It is particularly interesting to note that this tacit knowledge, which enabled the knitters to design, had been gained primarily through the use of knitting patterns. In the introduction to her book which aims to support knitters in designing and calculating their own garments, Barbara Walker writes: 'Those who blindly follow commercial knitting directions may never have given themselves time to understand garment construction, so they remain always at the same level of untutored helplessness.'[31] I disagree; this project shows that when knitters use patterns, they build up a stock of transferable tacit knowledge. While knitters may *feel* rather helpless, in a supportive space they are able to apply this tacit knowledge and use it successfully to design garments for themselves. This process is not restricted to knitters. Rosie Martin mentioned the value of tacit knowledge, gained through using patterns, for sewers: 'By making more and more different patterns, they're building up their repertoire and skills. It's almost like you can build this pile of what you know by stacking up your pattern envelopes.'

Along with tacit knowledge, I would also identify peer support as being crucial to the design process. During the project, the knitters worked collaboratively, discussing their projects in pairs and small groups. They helped each other by making suggestions, sharing expertise and giving encouragement. I see this as 'dialogic' design: a conversational equivalent of drawing. While, like many other designers, I draw and redraw to explore and fine-tune my ideas, the knitters' ideas developed through discussion, evolving and becoming clearer with each iteration. When they reflected on the experience, they felt these conversations and the support of the others in the group had been particularly important. This comment from Anne summarised the collective view: 'I don't know that I'd be very good on my own, sat at home, trying to come up with something. So I love the collaboration bit of it, chatting about it, the exchanging of ideas.' Kiki made a similar

point: 'I need to feed off other people, I think, to get ideas, and then to gain confidence in my ideas, I suppose.'

Kiki touches on something really important here: the importance of peer support for gaining confidence in our own creative ideas. Because homemade clothes are marginal in contemporary culture, wearers often lack confidence in the items they have made. It is rather risky to wander off the footpath, to make clothes without the sanctioning influence of professional manufacture. This risk is increased when working without even a professionally designed knitting pattern for support. By making alongside other people, the knitters benefited from an alternative source of sanctioning. Essentially, we took 'the homemade' from the private space of the home into a more social and supportive environment. When we dress we anticipate the gaze of others and imagine their appraisals of our clothing choices. The consideration of the gaze of others is essentially a concern for the opinions of the community. In this project, the knitters were able to get the nod from a number of trusted peers throughout the design and making process.

Creative Appropriation

When designing, we often take inspiration from existing garments, and many people are motivated to engage in making for the first time by a desire to recreate a particular item. This desire is core to the notion of the fashion commons. Fashion can be seen as 'a storehouse of identity-kits, or surface parts';[32] as designers we revisit, recombine and remix these elements to create contemporary fashions, layered with new meanings. Yet when we do, the complex issue of copying arises. In my workshops on calculating patterns, I encouraged participants to use existing garments as a starting point for their own designs. These items can be tried on and measured, and hence represent a valuable design resource. Garments can even be considered as a type of pattern, because they contain embedded information about their own form and construction. In many cases the workshop participants were using measurements or construction details to inform quite a different

project, but sometimes they wanted to create a new garment closely based on a pre-existing item. In this situation I was often asked, rather hesitantly, whether this was 'allowed'.

In response I would point out, first of all, that it is common practice in the fashion industry to use existing garments as a basis for new designs. There are minimal legal protections for fashion design, and a few minor changes are generally considered sufficient to avoid legal challenge. Of course, designers – both professional and amateur – may still have moral qualms, and I would encourage everyone to avoid creating direct copies of other people's designs, for their own creative satisfaction and peace of mind. Still, as Rosie Martin points out in a blog post on this topic: 'There is a qualitative difference between mass market imitation and the individual hobbyist.'[33] I agree; a high-street shop – or any commercial enterprise, in fact – lazily copying someone else's design, for profit, is quite different to an individual maker spending time and effort trying to recreate an item for their own private use. The individual maker will be translating the idea to suit their own wearing and making preferences, using their own materials and making methods. Furthermore, they will often be working from an impression of something they have seen, rather than a physical item. Rachael Matthews described knitters in this situation: 'They caught an image somewhere, and it's gone into the mind and it's swirled about a bit. It's blurred ... they're trying to capture those colours, and that shape.' In most cases, therefore, the maker will end up producing something rather different from the original inspiration, whether they intended to or not. In fact, I would be very surprised if any folk fashion project did manage to produce an exact replica. For me, this process is not copying, but creative appropriation – an activity which connects us with others and allows us to revive and recombine elements from the fashion commons in a new cultural context.

Satisfying Needs

Might the ability to make more creative decisions amplify the benefits of making and, in particular, more intensely satisfy the human need

for creation? I believe this is the case – but only for makers who have a desire for this experience. Many people are strongly attracted by the relaxing mode of making and find that following patterns is the best way of accessing this form of relaxation – choosing, as others have in the past, 'to eliminate […] the time consuming and anxiety-ridden process of drafting original designs'.[34] Nevertheless, for those people who are searching for a greater sense of creativity, the experience of designing can deliver great satisfaction. During the reknitting workshops, Margaret talked about the joy of taking her garment 'somewhere else' through the creation of an original design, rather than – as she often felt when adapting existing patterns – 'ending up with a mish-mash of what it should have been'. Making contributes to identity construction; if makers consider producing their own designs to be more creative than the 'conventional' practice of using patterns – as the Hereford knitters did – then, by engaging in this activity, they strengthen this positive sense of identity.

On the other hand, the various satisfactions associated with design can be compromised if folk fashion makers fall into the trap of expecting a project to turn out exactly right on the very first attempt. Designing and making clothes is a tricky process. To get the most out of the experience, makers need to realise that problems are not mistakes, but rather an integral part of this process. Even with a decade's experience of designing and making knitwear, I expect to take a few attempts to get a garment exactly right – especially if I am trying to create an unfamiliar garment shape or working with a new yarn. In my experience, amateur designers give themselves only one chance for success and tend to beat themselves up if their project does not turn out as desired. Rachael Matthews talked about the importance of being willing to make mistakes:

> It's really hard, because how many times have we all knitted something and gone – oh shit, done it wrong, just unravel it. It's so valuable that we're not frightened of doing that. Because it's so easy to be precious, isn't it?

Supporting Folk Fashion Design

Although some makers designing for themselves are able to work independently, many are unsure how to apply their tacit knowledge and translate their initial ideas into coherent projects. This presents an exciting challenge for professional designers and folk fashion facilitators: to help to create a sense of permission, by which amateur makers feel they are 'allowed' to experiment and make creative decisions – to 'do what designers do'. A key interface between facilitators and makers is, of course, the pattern. As Stephen Knott explains, patterns 'set the parameters of what [can] be achieved and the type of practice that [unfolds]'.[35] Although the format of predesigned patterns often presents a barrier to adaptation, elements can be included which support more open use. For example, as Rosie Martin explained, the inclusion of technical drawings within sewing patterns encourages alteration and hacking:

> I've only recently realised how inspiring technical drawings are to people. They're like, yes, I like that line, I like how that's cut … they just need the master plan. It's completely stripped down and presenting possibility. It's complete bottom-up inspiration in a way: where could I go from here?

Technical drawings, along with visual stitch patterns, are similarly useful for knitters, who may feel hemmed in by the complex language of the written pattern.

Folk fashion facilitators can also support amateur designers by giving advice and encouraging them to use their own inspiration and feelings about colour and composition. But, as Rachael Matthews explained, it is important to recognise that adaptation and design require experience, confidence and tacit knowledge. She suggested that makers should not be pushed too far or too fast:

> That thing of giving someone permission to do something, you can get that really wrong. You could actually be really freaking them out,

because inside they're saying, I couldn't possibly do that! I can't imagine what she's saying!

As we discussed this further, Rachael described how she gets round this problem:

> I probably say things like – in all the time that you've got working with this yarn and these needles and following the pattern up the front and the back, you've got plenty of time to think about how you would decrease the stitches on the sleeves. And you can always do those decreases and unravel it, and try it again.

As Rachael indicates, much of this advice is about encouraging people to make mistakes, to be prepared to go back and redo elements of their project if necessary, and not to feel that they have failed by doing so.

A sense of permission can also be created through the provision of supportive structures, or what David Gauntlett describes as 'platforms for creativity':

> 'Platforms for creativity' can refer to anything that is designed to foster the creativity of people, or to encourage creative conversations, as part of everyday life or within a more particular context. Platforms for creativity can be events, spaces, environments or tools. [...] These platforms, whatever their size or type, are about offering people opportunities to creatively express themselves and to – perhaps, ultimately – transform their worlds.[36]

It is widely acknowledged that creativity thrives within restrictions: a completely blank page can be daunting for even the most experienced designer. These platforms for creativity, therefore, frame activity and set open tasks that makers can choose to engage with. A well-designed platform will take people far beyond what they thought they could do. Platforms might take the form of challenges, such as a pattern hackathon promoted by an indie pattern company or an open brief set by a blogger, with responses shared on Instagram. Something as simple

32. Trousers made using Hackney Lights print by Ruth Esme Mitchell, from *Print, Make, Wear* by Melanie Bowles and the People's Print.

as a craft group can be a valuable platform for creativity, if the right environment is created and participants support each other to explore their individual ideas. Workshops and books can also provide platforms. For example, *Print, Make, Wear* by Melanie Bowles and the People's Print guides makers through different methods of originating textile designs to be digitally printed and then used to create totally one-off garments.[37] Similarly, Felicity Ford's *Knitsonik Stranded Colourwork Sourcebook* supports knitters to design their own patterned knits, taking inspiration from their local surroundings.[38]

A New Role

Designers who shift their practices from producing ready-made garments or conventional patterns to supporting folk fashion design can experience a striking change in activity, and even identity. I have experienced this shift myself: whereas in the past I had designed collections of knitwear, in the reknitting project I was designing fragments of knit processes, developing instructions and advice, and creating a structure within which to present these resources. Some, such as design writer Jos de Mul, describe this new role as that of 'metadesigner'.[39] It also corresponds closely with the notion of the 'hacktivist' designer described by Otto von Busch:

> This role is not the one of a classic unique genius of fashion.
> Instead it is in the form of orchestrator and facilitator, as an agent of
> collaborative change. It is not the divine creator of the original and
> new, but a negotiator, questioning and developing design as a skill
> and practical production utility. [...] It is a combination of designing
> material artefacts as well as social protocols.[40]

This facilitating role changes my relationship with finished objects; it also changes my relationship with other makers. Design expert John Chris Jones describes this new role (as adopted by a designer of his acquaintance) in a particularly engaging way: 'His role, once he'd given up part of the design function to his clients, became, as he said, that of professional encourager.'[41] I have found this challenge to be most satisfying, and would recommend that other designers take the plunge.

Notes

1 Maggie Righetti, *Sweater Design in Plain English* (New York: St Martin's Press, 1990), p. ix.
2 Future Museum, 'Sanquhar knitting' (2012). Available at futuremuseum. co.uk/collections/life-work/key-industries/textiles/sanquhar-knitting.aspx (accessed 8 April 2016).

3 Richard Rutt, *A History of Hand Knitting* (London: B.T. Batsford, 1987).

4 Joy Spanabel Emery, *A History of the Paper Pattern Industry* (London: Bloomsbury, 2014), p. 40.

5 Ibid.

6 Sandy Black, *Knitting: Fashion, Industry, Craft* (London: V&A Publishing, 2012).

7 Manfred Max-Neef, 'Development and human needs', in Paul Ekins and Manfred Max-Neef (eds), *Real-Life Economics: Understanding Wealth Creation* (London: Routledge, 1992), pp. 197–213.

8 David Gauntlett, *Making Is Connecting* (Cambridge: Polity, 2011).

9 Jonathan Meuli, 'Writing about objects we don't understand', in Peter Dormer (ed.), *The Culture of Craft: Status and Future* (Manchester: Manchester University Press, 1997), pp. 202–18.

10 June Freeman, 'Sewing as a woman's art', in Gillian Elinor, Su Richardson, Sue Scott, Angharad Thomas and Kate Walker (eds), *Women and Craft* (London: Virago, 1987), pp. 55–63. Kirsty Robertson, 'Textiles and activism', in Jessica Hemmings (ed.), *In the Loop: Knitting Now* (London: Black Dog Publishing, 2010), pp. 68–79.

11 Pen Dalton, 'Housewives, leisure craft and ideology: de-skilling in consumer craft', in Elinor et al., *Women and Craft*, pp. 31–6.

12 Kevin Wehr, *DIY: The Search for Control and Self-Reliance in the 21st Century* (Abingdon: Routledge, 2012), p. 3.

13 Gauntlett, *Making Is Connecting*, p. 17.

14 Kathryn Harriman, 'Understanding the individual craftsperson: creativity in Northeast Scotland', conference paper, New Craft Future Voices: Proceedings of the 2007 International Conference (Duncan of Jordanstone College of Art and Design, Dundee, 4–6 July 2007), pp. 470–85.

15 Rozsika Parker, *The Subversive Stitch: Embroidery and the Making of the Feminine* (London: I.B. Tauris, [1984] 2010).

16 Ferne Geller Cone, *Knitting for Real People* (Loveland: Interweave, 1989), p. 1, original emphasis.

17 Maggie Whiting, *The Progressive Knitter* (London: B.T. Batsford, 1988), p. 7.

18 Marcia McLean, '"I dearly loved that machine": women and the objects of home sewing in the 1940s', in Maureen Daly Goggin and Beth Fowkes Tobin (eds), *Women and the Material Culture of Needlework and Textiles, 1750–1950* (Farnham: Ashgate, 2009), pp. 69–89, p. 78.

19 Margarethe Szeless, 'Burda fashions – a wish that doesn't have to be wishful thinking: home-dressmaking in Austria 1950–1970', *Cultural Studies* 16/6 (2002), pp. 848–62.

20 Rachel Kinnard, 'Disruption through download: BurdaStyle.com and the home sewing community', *Journal of Design Strategies* 7 (2015), pp. 98–104, p. 104. Available at sds.parsons.edu/designdialogues/?post_type=article&p=716 (accessed 6 October 2016).

21 Victoria Elliott, 'Competition time! #Patternhackathon', By Hand London (16 October 2014). Available at byhandlondon.com/blogs/by-hand-london/15655956-competition-time-patternhackathon (accessed 6 October 2016).

22 Herbert Alexander Simon, *The Sciences of the Artificial*, 3rd edn (Cambridge, MA: MIT Press, 1996), p. 129.

23 Victor Papanek, *Design for the Real World: Human Ecology and Social Change*, 2nd edn (London: Thames & Hudson, 1984), p. 3.

24 Philip Pacey, '"Anyone designing anything?" non-professional designers and the history of design', *Journal of Design History* 5/3 (1992), pp. 217–25, p. 217.

25 Oenone Cave, *Traditional Smocks and Smocking* (London: Mills & Boon, 1979), p. 71.

26 Kate Davies, 'From Muhu Island', Kate Davies Designs (12 January 2012). Available at katedaviesdesigns.com/2012/01/12/from-muhu-island (accessed 6 October 2016), original emphasis.

27 Carol Tulloch, 'There's no place like home: home dressmaking and creativity in the Jamaican community of the 1940s to the 1960s', in Barbara Burman (ed.), *The Culture of Sewing: Gender, Consumption and Home Dressmaking* (Oxford: Berg, 1999), pp. 111–28.

28 Emery, *A History of the Paper Pattern Industry*.

29 Claire Montgomerie, *The Yarn Palette* (London: A&C Black, 2008), p. 7.

30 Righetti, *Sweater Design in Plain English*, p. 112.

31 Barbara Walker, *Knitting From the Top* (New York: Charles Scribner's Sons, 1972), pp. 10–11.

32 Pamela Church Gibson, 'Redressing the balance: patriarchy, post-modernism and feminism', in Stella Bruzzi and Pamela Church Gibson (eds), *Fashion Cultures: Theories, Explorations and Analysis* (Abingdon: Routledge, 2000), pp. 349–62, p. 356.

33 Rosie Martin, 'Is that new season Thierry Mugler?', DIYcouture (8 March 2012). Available at diy-couture.blogspot.co.uk/2012/03/is-that-new-season-thierry-mugler.html (accessed 6 October 2016).

34 Lou Cabeen, 'Home work', in Joan Livingstone and John Proof (eds), *The Object of Labor: Art, Cloth and Cultural Production* (Chicago: School of the Art Institute of Chicago Press, 2007), pp. 197–218, p. 216.

35 Stephen Knott, *Amateur Craft: History and Theory* (London: Bloomsbury, 2015), p. 5.

36 David Gauntlett, 'Platforms for creativity: introduction', blog post (3 July 2015). Available at davidgauntlett.com/creativity/platforms-for-creativity-introduction/ (accessed 6 October 2016).

37 Melanie Bowles and the People's Print, *Print, Make, Wear: Creative Projects for Digital Textile Design* (London: Laurence King, 2015).

38 Felicity Ford, *Knitsonik Stranded Colourwork Sourcebook* (Reading: Knitsonik, 2014).

39 Jos de Mul, 'Redesigning design', in Bas van Abel, Lucas Evers, Roel Klaassen and Peter Troxler (eds), *Open Design Now: Why Design Cannot Remain Exclusive* (Amsterdam: BIS Publishers, 2011), pp. 34–9.

40 Otto von Busch, *Fashion-Able* (Gothenburg: Camino, 2009), p. 63.

41 John Chris Jones, 'Continuous design and redesign', in John Chris Jones (ed.), *Designing Designing* (London: Architecture Design & Technology Press, 1991), pp. 190–216, p. 205.

Making the Wardrobe

Years ago, a series of serendipitous discoveries sparked my interest in the relationship between fashion and sustainability. One of these discoveries was a short article in the textile industry journal *View on Colour* which, after discussing over-production of clothing, proposed: 'The more definitive solution is to keep.' This simple statement inspired an interest in longevity which eventually crystallised into the design philosophy of my knitwear label, Keep & Share.[1] I happened across a fading photocopy of this article in a stack of papers while the idea for this book was germinating. This time, another paragraph caught my eye:

> Putting together a wardrobe and a home will become a life-long process and something of a quest. We will have to hunt for the rare item. A gorgeous silk slip found five years ago in Florence, the definitive tuxedo hit upon two years ago in New York, the perfect jeans you found and bought two pairs of because you knew you would always want to wear them, the socks you had always wished for but couldn't find.[2]

The notion of building a wardrobe of clothes as a slow, considered and creative act appealed to me greatly. It sparked a question: what would happen if I stretched the definition of folk fashion to embrace the shaping of the wardrobe?

Approaching the Wardrobe

Research for a recent report by British recycling organisation WRAP asked adults to estimate the number of clothing items (including

underwear) in their wardrobes: the average was 115.[3] Actual figures show a wide variation: as part of her work on everyday dress habits, Sophie Woodward counted the garments (not including underwear) in the wardrobes of 27 women, finding a total number of items ranging from 35 to 182.[4] The wardrobe plays a vital role in the dynamic, ongoing process of identity construction. Saulo Cwerner describes a person's collection of clothes as 'a safely stored *pool* of identity tokens'; like a miniature version of the fashion commons, the owner selects clothes from this resource to construct the person they feel themselves to be each day.[5] By housing items that embody all of our potential selves, the wardrobe represents, and can even help us to understand, the multiplicity and complexity of contemporary identity. Woodward links these potential selves to the idea of 'personhood in aesthetic form' proposed by social anthropologist Alfred Gell.[6]

Although a wardrobe will inevitably include possessions from the past, it is important to note that it is not a static museum; rather, it is a resource always in a state of flux. As our tastes and needs change, we acquire new items and others fall out of wear. In order to prevent ourselves becoming overwhelmed with what Cwerner describes as 'sartorial waste' – clothes for which we no longer have a use – some of these garments must be discarded from the wardrobe.[7] Thus, as Nicky Gregson and Vikki Beale explain:

> Wardrobes become less the possessions of individuals and more temporary, transitory, spatial junctures, holding-places in the lives of things. Moreover, they also become spaces which facilitate exitings and which are therefore as much about passages, flows and divestment as they are about accumulated memorials and mementos.[8]

The flow of garments into the wardrobe has increased significantly in recent years. This leads to an ever-larger personal reservoir of clothes being kept – journalist Harry Wallop reports that 'women have four times as many clothes [...] as they did back in 1980' – and also an increase in the rate at which items are discarded.[9] As geographer Andrew Brooks explains in his study of fast fashion and secondhand

33. A towering pile of t-shirts, uncovered during an inventory of my own wardrobe.

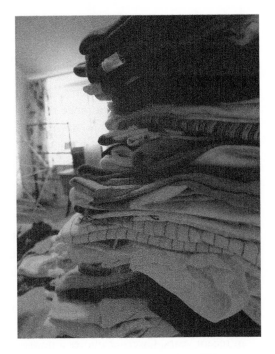

clothes, the majority of these discarded garments end up in landfill. Of those that enter the secondhand market, most are shipped overseas, often to the detriment of textile industries and traditions in the places where they end up. Thus, as he argues, consumers in rich countries 'are complicit in a process that locks many of the world's poor in Africa, Asia and Latin America into a partial dependency on second-hand clothing imports'.[10] When thinking about the individual's experience of shaping the wardrobe, therefore, the implications of acquiring, keeping and discarding need to be considered in a broader context.

I am proposing that the construction of the wardrobe is a type of folk fashion. This corresponds with the notion, proposed by sociologist Colin Campbell, of the 'craft consumer'. As he explains, 'the craft consumer is a person who typically takes any number of mass-produced products and employs these as the "raw materials" for the creation of a new "product", one that is typically intended for self-consumption'.[11] Campbell identifies the building of the wardrobe as one opportunity

for this mode of consumption. He suggests that the craft consumer, in contrast to others, sees this as a long-term activity involving specialised skills and knowledge, and an opportunity for creativity and self-expression. A 'successful' collection of clothing will, of course, vary dramatically from person to person. Yet it will surely enable the wearer to feel at ease in a range of situations, and to deal effectively with the uncertainty that is inherent in contemporary fashion. The building of this resource is an ongoing process: clothes flow in and out as we acquire and discard, reject and rediscover, wear out and renew. Thus, the crafting of the wardrobe is as much about what we remove as what we bring in, and what we do with the items while they are in our possession. All of these practices – acquiring, sorting, storing and discarding – are crucial in terms of identity construction. Woodward explains that 'when women are ordering their clothing, they may also be ordering their lives and their biographies in order to make sense of their current identity'.[12]

It is worth noting that the activity of organising the wardrobe and purging it of unworn clothes has become something of an obsession in recent years. Cwerner quotes a newspaper article from 2000 which describes 'dejunking' the home as 'an almost spiritual movement in the USA'.[13] Also writing about the USA, Elizabeth Bye and Ellen McKinney suggest that a 'well-organized closet is the new status symbol'.[14] They highlight the role in this trend of makeover reality television programmes which guide participants to purge unsuitable items from their wardrobes. I have also noticed the influence of minimalist style blogs that fetishise a clutter-free lifestyle and veer close to the unhelpful attitude that portrays 'stuff' as a negative, contaminating influence. Outside this bubble, attitudes to sorting and tidying clothes are mixed: while some may enjoy the process of reviewing and ordering the wardrobe, others treat it as a boring but necessary household chore, or even approach it with dread. Many of us might aspire to a well-ordered wardrobe which enables us to see the clothing options available, and the creation of such a system could be a potent opportunity for creativity. Yet the reality is that, as Bye and McKinney describe, 'closets often become chaotic spaces of forgetfulness'.[15]

Frosting and Cake

Although Colin Campbell is concerned with individuals using mass-produced goods to create a unique and meaningful 'ensemble', my conversations with people who make their own clothes highlighted a similar need to consider the construction of the wardrobe as a whole. Homemade garments are sometimes made in isolation, without much consideration for the items they will sit alongside or the styles favoured by the wearer on a day-to-day basis. There is a good chance that these 'stand-alone' pieces will fail to pass into wear. Rosie Martin explained that she had experienced this problem herself. When she started sewing she found it exciting to create unique garments from outlandish printed fabrics, but came to realise this was not how she usually wanted to dress:

> At first, you're so enthusiastic, and you've got this whole world presented to you, because you can make anything with any fabric. I definitely was making, like, I've got a wardrobe of mad trousers. And then I thought, I don't want to necessarily stand out ... I don't want to feel self-conscious in this stuff.

She described this realisation as a common experience amongst sewers:

> Often I think people get to a point where they say, I've made all these wonderful clothes – and they've even taken the photos of themselves wearing them to show the world on the internet – but then they just stay in their wardrobe, and when it comes to the weekend, they're just wearing their leggings and T-shirt or whatever.

Rosie went on to explain that this distinction, between the items people like to sew but never wear and the 'boring' pieces that make up the core of their wardrobe, is known in the sewing blogging world as the difference between 'frosting' (or 'icing', in British English) and 'cake'. This engaging metaphor was first proposed by Canadian designer and blogger Tasia St Germaine, who recognised that she had a wardrobe full of 'fun, bright, pretty, exciting things' and 'novelty tops' – which

she described as frosting – and a distinct lack of the 'dark, solid pieces' that she felt were needed to coordinate with such items – which she described as cake.[16] Having reached this realisation, Tasia started to think about ways she could address the problem: planning 'anchor' pieces alongside novelty items and sewing more classic pieces overall. As Rosie explained, makers often go through this process, resolving to take a more considered approach to their projects. They start from the wardrobe and their own wearing preferences as they plan the creation of individual pieces:

> They're like, actually, what do I wear? Oh, it's jeans and shirts and jumpers. So if I want to wear homemade clothes, I have to make those things. And they have to be plain, and look boring. If I want to say, yes, I'm wearing homemade, that's what I need to make.

While the situations described so far relate primarily to the style of clothing, a similar reflective process can take place in terms of quality. Christine Cyr Clisset, for example, told me about choosing to improve the finish and durability of the items she was making:

> I would make a couple of pieces of clothing a week, actually, which was really fun, but I think what I ended up realising is that … you can only do that so much, because then your closet is full of all these clothes that you've made, and you maybe haven't spent the most time on them, and haven't really made them as beautiful as they could be. I realised, I want to spend more time on better projects, I want to make beautiful pieces of clothing that really live up to the vintage clothing that I always have loved. And it's become more important to me to buy fabric that's going to actually be durable and last a long time and look nice, rather than just buying something cheap that's pretty, but that won't last very long.

This process of realisation can potentially support the creation of more satisfying garments which eventually combine into a more dependable collection of clothing. It can have an impact on consumption

levels, too, as garments which better suit a wearer's needs are less likely to be swiftly discarded and replaced. Although the intense engagement of the making process might help us to reflect on our personal clothing preferences and habits, the ability to reflect – and to apply the awareness gained through this reflection – is not confined to makers, nor to the acquisition of new clothes. The skill and creativity involved in building the wardrobe is largely the same, whether those garments are homemade or mass-produced – and whether an individual is looking to add to their collection of clothes or to review what they already own.

Structured projects can help people to reflect; many of those minimalist style blogs I mentioned earlier, for example, offer advice to guide individuals through the process of reviewing the wardrobe. The Wardrobe Architect initiative by indie pattern company Colette offers a detailed online toolkit to support home sewers through a more extended wardrobe review incorporating reflections on personal style, a clothing clear-out and carefully planned sewing projects. Sarai Mitnick, founder of Colette, explains the ethos of the project:

> Let's go from being builders to being architects as well. Let's think about form and function, the deeper implications of our choices, how clothing reflects each of our identities, and how we can sew more and buy less. This year, let's work to build wardrobes that reflect each of us, and let's do it together! It'll be fun.[17]

The entire scheme is framed as an opportunity for creativity, with design and styling tasks built into each instalment. Like other successful folk fashion projects, it connects participants together to encourage discussion and provide a sense of belonging.

Some people, of course, will prefer to work without the 'pattern' of a structured project and develop their own way of reviewing the wardrobe. Data designers Giorgia Lupi and Stefanie Posavec, for example, found highly inventive ways of graphically representing the contents of their wardrobes for their Dear Data blog, each covering multiple factors in a single postcard-sized diagram.[18] I carried out my own wardrobe inventory a couple of years ago, documenting the

experience via a series of blog posts.[19] The primary finding of this process was that I have a notably large collection of clothes: even after discarding a significant number of items, I counted 312 garments – 68 per cent bigger than the biggest wardrobe documented by Sophie Woodward.[20] More importantly, I gained new realisations about my preferences (headline: yes to frocks, no to skirts) and was inspired to set up a new system of organisation which helped me, at least for a while, to make more use of the lovely pieces I have collected over the years.

34. Sketch of wardrobe contents for the Dear Data project by Giorgia Lupi.

Stopping the Flow

In the past few years a slew of blogs have sprung up which document the activities of people who have decided to stop the flow of garments into the wardrobe. This is commonly a year-long commitment, although self-proclaimed mending activist Jonnet Middleton dramatically raised the bar in terms of 'zero-consumption' challenges in 2008 when she pledged to wear nothing but the clothes she already owned for the rest of her life. Individual rules vary: some people choose to eschew any additions to the wardrobe, while others allow concessions such as knitting or sewing new items, receiving pieces as gifts or buying secondhand. Yet they all, essentially, seek to interrupt the normal mode of consumption-based fashion participation. An alternative approach is to temporarily restrict your wardrobe to a select number of pieces, thus setting yourself the challenge of constructing your identity – and dressing appropriately for a range of contexts – with a limited garment palette. Consider, for example, Project 333, which invites participants 'to dress with 33 items or less for 3 months'; Matt Souveny, who spent an entire year wearing just ten items; and the six-week-long Six Items Challenge run by Labour Behind the Label (an organisation supporting garment workers across the world).[21]

While these projects may not seem to be particularly creative acts in themselves, they can lead to great ingenuity as wearers work within the restriction of the materials already at hand, just like makers who plan projects to use up their fabric or yarn stash. You need to be creative to construct your identity and solve outfit 'problems' without recourse to the easiest option, of purchasing something new. Further opportunities for creativity can also be identified: selecting the garments that will comprise a heavily edited wardrobe and, for those who initiate their own project or incorporate additional elements into a group challenge, setting the rules of the game.

I dipped into some of the blogs about these various projects to gain an insight into the authors' experiences of their self-imposed restrictions. I got the sense of a diverse range of people choosing to challenge themselves, with differing attitudes to fashion and differing motivations. Many – though not all – touched on the issue of overconsumption and

its effects on both the planet and the individual. More prosaically, they often mentioned the attraction of saving money. Like others, one blogger talked about the need to see what she already had as enough, and to gain greater enjoyment from these possessions: 'It was an opportunity for me to explore contented living: being satisfied, complete, and fine with what I already own.'[22] Researcher Rebecca Earley – known in sustainable design circles for her influential work with the Textiles Environment Design project – discussed her intention to use her period of zero consumption to learn about herself and the desires which drive the urge to consume:

> I think for me, my year of not buying new has got more to do with working on finding other ways to feel good – to be my best self – and to use the resources and materials I have at hand to express that, rather than purchasing in order to define it.[23]

Others, such as writer Sarah Peck, treated the challenge they had set themselves as an experiment, primarily driven by curiosity: 'As a female in a clothes-and-image-centric society, I wanted to see what it was like to live without shopping for a while.'[24] Nannet, one of the participants in the Free Fashion Challenge, which first started in Amsterdam in 2010 and was billed as '365 days without shopping to rediscover your creativity and personal style', decided to take part precisely because the thought horrified her so much:

> I imagined myself participating and not shopping, and all of a sudden my palms got sweaty just from the idea. [...] if you get a physical reaction like that it's really a sign of addiction. I also thought I should do the challenge not to get rid of something, but to gain something from it: I wanted to get back to my creative self.[25]

Living with Less

The blogs make fascinating reading, illustrating the challenges the writers face and the ways in which they manage to meet the physical

and emotional needs so often satisfied by consumption and brand-new garments. With shopping for new items off limits, alternative practices come to the fore. Fellow Free Fashion Challenge participant Frank, for example, discovered an alternative to the thrill of purchasing something new, describing the joy of 'shopping in your own wardrobe' and rediscovering long-forgotten clothes.[26] Rebecca Earley found that creating a 'styling wall' helped her to see the potential in her existing wardrobe and to remix the contents into new outfits.[27] It is evident from the blogs that mending becomes an important and valued activity when new items are not an option, as greater attention is focused on the value and potential of the items that are available for wear. As Saulo Cwerner points out, 'In order to *signify* a sign must be in good shape. That is, the signification of dress and fashion is intimately related to the materiality of clothes.'[28] Jonnet Middleton suggests that in this situation mending moves beyond its usual status as household chore and into the realms of creativity and enjoyment, explaining that 'The desire to shop soon fades, and mending, as well as making, gains currency as "the new shopping".'[29]

I would suggest that the value of digging out hidden gems and mending does not lie just in having more options for what to wear, but in the fact that these practices – along with other non-shopping activities such as swapping, borrowing and making – offer potent means of constructing identity, connecting with others and finding novelty. In other words, these wardrobe practices can satisfy the needs that are so often met by a consumerist mode of fashion. Just as the experience of designing and remaking energised the relationship between the Hereford knitters and their wardrobes, the experience of avoiding shopping during the Free Fashion Challenge unexpectedly reconnected Frank with fashion:

I had my personal challenge of wearing a different outfit every day, so I have become extremely aware of my clothing behaviour [...] I've become more back in touch with fashion by not shopping, which is sort of a paradox.[30]

Nannet, too, found great potential for fashion expression in her existing selection of clothes: 'Fashion-wise, I really want to keep on inspiring myself with what I have, that's the bottom line.'[31]

While some people break their resolutions and others choose to extend a challenge after the initial period, the blog posts suggest that they all learn something from the process (although, of course, these reflections are volunteered by a self-selecting group who feel they have something to say). The accounts frequently reveal a newfound perspective on consumption, even from those who treated the exercise as a personal experiment rather than a conscious attempt at sustainable living, such as Sarah Peck:

> It was the attitude change that made the most difference: looking through my things and realizing I already had enough – that I didn't have to rush out and buy something new to fill a hole or a need – let me breathe again.[32]

Eirlys Penn took part in the Six Items Challenge in 2015. Following the challenge, she reflected on her ability to adapt and change – an ability which could be connected with the ongoing and creative process of identity construction:

> I'm far more adaptable than I thought. It was nice to discover, as a middle-aged woman, that I can still change. [...] I found this was a golden opportunity to keep myself on my toes and move out of my comfort zone, to exercise my adaptability. And this doesn't just apply to clothes or material goods. It made me challenge the way I'm doing things generally.[33]

Although there appear to be plenty of positive personal outcomes from these wardrobe challenges, I do have a concern about 'rebound effects'. The money saved by avoiding clothes shopping may be diverted to buying other goods, be used for a massive shopping splurge after the period of abstinence, or even fund another activity with a far greater environmental impact than the clothes that might otherwise

have been purchased (celebratory short-haul weekend away, anyone?). From the blog accounts I have seen, however, it seems that a holiday from shopping does lead to a genuine shift in attitude and a definite intention to take a more considered approach to selecting items in the future. Nadia, a third Free Fashion Challenge participant, described how her thinking had changed:

> I used to buy a lot of clothes, and to me quantity was always more important than the quality. I didn't have a lot of basic key items, and that's what I don't like about my wardrobe: I used to buy a lot of trendy clothes over the changing seasons, and I want to change that now. I guess my attitude towards fashion was quite immature in that sense, but now my goal is to build my wardrobe along more sustainable, timeless lines.[34]

Following his year with a wardrobe of just ten items, Matt Souveny explained that he would like to acquire new clothing once again, but would not be returning to his previous pattern of consumption:

> I'm looking forward to wearing some new clothes and having some diversity in my life. [...] it will be fun to get a chance to experiment with fashion again. I'm not going to enact any strict rules on what I can wear or the number of clothes I can own. However, the way I approach material goods has likely changed forever, I'm no longer interested in hoarding fast fashion or filling my drawers and cupboards with cheap trinkets.[35]

Frank described how his new attitude had spread beyond clothing to other domains:

> It has really changed my consumption pattern. Even in the super-market when I start throwing things in the basket, I tend to take them out in the end, thinking that I still have some vegetables left which I otherwise would have to throw out.[36]

35. Matt Souveny's ten-item wardrobe.

Zero-consumption challenges can also cause ripples in the practices of others. As people change their wardrobe habits they talk about their experiences to those around them, as well as documenting their projects online. In some cases this communication is an integral part of the initiative: participants in the Six Items Challenge, for example, are encouraged to raise funds for Labour Behind the Label and to discuss the issues associated with globalised garment manufacturing in the process. Yet even projects that are not explicitly political or activist in nature can have a quietly disruptive effect. Fast fashion is sufficiently entrenched in our culture that, for many people, opting out of the conventional mode of consumption is a surprising and thought-provoking act. Spreading these ideas can, in turn, lead to behaviour change. The accounts written by those undertaking challenges include numerous examples of friends and acquaintances being inspired to slow their own rate of acquisition, or even joining in with the projects themselves. The experiences of those

undertaking challenges can affect others in a more practical way, too. After his year-long project, Souveny started publishing detailed reviews of the ten garments that made up his wardrobe, demonstrating how well they stood up to such intense wear. This information will, in turn, be of use to people looking to invest in durable pieces for themselves – even if not as part of such a strictly framed project.

Unworn Clothes

A key element of the process of sorting the wardrobe is identifying unworn clothes – often defined as those items that have not been worn in the past year. Respondents to the WRAP survey estimated, on average, that 30 per cent of their clothing fell into this category,[37] while a 2013 study in Australia found that as much as 68 per cent of the wardrobe was described as inactive.[38] The WRAP study also asked respondents why their items had not been worn; responses showed that it was frequently because they were considered unsuitable, either in terms of style and fashion or because they did not fit. Another common response referred to clothing wear and tear, with respondents indicating that their items were worn out, stained, shrunk or damaged. Unworn clothes – especially those still in good condition – are commonly seen as a problem, representing a waste of money and an unhealthy hoarding instinct. Advice on reorganising the wardrobe invariably recommends discarding these items, whether in stricter or more sympathetic terms. As geographer Rebecca Collins points out, 'keeping might be more problematic than beneficial from the point of view of sustainability'. After all, when items are discarded from the wardrobe, they become available for re-use by others.[39] Clearing out the wardrobe can also bring personal benefits. One blogger, writing about her recently slimmed-down collection of clothes, described its advantages:

> I am enjoying having a smaller wardrobe. It's easy to see at a glance, I can find things instantly, and with less clutter, I am more tempted to try out different combinations. The best thing, though, is knowing

that every single item is in good condition and actually fits me – not last year or next year, but now![40]

Discarding clothes could have unexpected consequences, however: while someone may sincerely intend to live with less, it is quite possible that the space cleared will soon be used as an excuse for a new round of consumption. In fact, this could become a regular habit. As another blogger argued when reflecting on her wardrobe inventory project, 'minimalist style blogs seem to be peddling the notion of restraint while simultaneously hiding a shopping addiction by periodically purging'.[41]

Could there be positive reasons for keeping clothes that we do not intend to wear again? I believe so; as Maura Banim and Ali Guy explain, our deeply significant relationship with clothes goes far beyond the time they are on our bodies. They suggest that unworn items 'help provide continuity or discontinuity with women's current identities', thus playing an important role in the reflexive, continuous process of identity construction.[42] They describe, for example, how kept clothes 'allow women to maintain a connection with former, important aspects of themselves and their lives'.[43] This was particularly apparent in the case of Hereford knitter Catherine, who described a special drawer of treasured items. These garments provided an important and emotional link with her life before she became a full-time carer for her disabled son:

> In this drawer, I have things that are really special, that I've really liked. That's almost like the 'old me' drawer, if that makes sense. It's what I would have worn to work, or … Because you've been seen for years and years and years as the person who changes all the catheters, or whatever. But once upon a time, I was somebody.
> [Q: And does that drawer help you to feel that?]
> Yeah, I suppose so, yeah.

Banim and Guy suggest that we also keep garments that represent the person we want to be: items that offer a sense of aspiration or even escapism. Elizabeth Bye and Ellen McKinney similarly describe one role of the wardrobe as being 'a hope chest for future selves'.[44] With this idea in

mind, the frivolous 'frosting' clothes created by home sewers make more sense: they reflect the fact that these sewers are constructing – physically constructing, in this case – the person that they feel themselves to be. While everyday items may get a great deal more wear, these aspirational garments – even if never seen by others – help them to feel that their 'everyday self' is not all of who they are. Although these clothes may never be worn, they can still play a crucial role in identity construction. For me, this is a compelling argument for cutting ourselves some slack when it comes to clearing unworn but emotionally significant garments from the wardrobe. It may make sense, however, to do as Bye and McKinney suggest and 'remove these garments from the active wardrobe, resulting in a more functional and less emotionally charged closet'.[45]

The Resilient Wardrobe

Although some unworn clothes are kept in full recognition of the fact that they will not be worn again, this is not always the case. My conversations with the Hereford knitters indicated an impulse to keep items 'just in case': there was an implicit expectation, or hope, of future use. In her study of young people's divestment practices, Rebecca Collins describes this activity as 'hedging'.[46] In some cases the wearer would need to change for these garments to return to wear: many people hold onto clothes that do not currently fit them in case their bodies change in the future. Hereford knitter Kiki described keeping some items in case she became more adventurous in her sense of dress. In other cases it is the fashion context – or the individual's tastes, influenced by the fashion context – that would need to shift. We are well aware of the cyclical nature of fashion and so might choose to save currently unappealing items until the next time they 'come round' or because, as Hereford knitter Margaret put it, 'your mood might change'.

Are these changes likely to happen? Perhaps not: for many, those one-size-out clothes will remain aspiration rather than reality, and an item that feels too daring for you today will probably remain so in the days to come. On the other hand, we all dress within a context that is shaped by

fashion, and is therefore ever-shifting: changes in dress are required to maintain a consistent sense of identity. With this in mind, the wardrobe might be considered as a store of potential items that could be returned to wear at any time, depending on the conditions at that moment. In other words, the mini-commons of the wardrobe can be seen as a source of resilience – not the environment-related resilience discussed in Chapter 1, but rather a fashion-specific version of the same concept. The resilient wardrobe helps the wearer to deal with the uncertainty of contemporary fashion and dress-related social norms, and the anxiety associated with that uncertainty. The bigger and more diverse the store, the greater the resilience, with more opportunities for 'shopping in the wardrobe'. It is perhaps because Jonnet Middleton already owned a collection of clothes that, in her own words, 'far exceeded what I can physically wear out in my own lifetime' that she felt confident in her pledge to buy no more.[47] Without this resilience – if we were to trim our wardrobes regularly to just the items that appealed at that particular moment – we would need to acquire new garments in order to cope with the stylistic shifts that would inevitably come along sooner or later. Thus, an attempt at minimalism could rather unexpectedly lead to increased consumption – or frustration, if the options on offer in the shops at that time did not meet our needs.

There are potential pitfalls in this theoretical resilience. It depends on the variety and suitability of the clothing gathered in the wardrobe, for – as Elizabeth Bye and Ellen McKinney explain – 'Depending on its contents, the wardrobe may serve as a limiter or enabler in creative self-presentation.'[48] Then there is the familiar view that while fashions may return periodically, no one should return to styles that they wore 'the first time round'. While certain styles do return to fashion time after time, they tend to be reinvented with each iteration, meaning that previous versions are in danger of looking sadly dated. Rebecca Collins found that the teenagers in her study 'rarely, if ever, returned to the possessions they stored away'.[49] She points out that 'the cultural obsolescence that pushes these possessions out of use in the first place constitutes the main force that precludes them from being brought back into (regular) active use'.[50] From this perspective, the unworn clothes in the wardrobe can offer only a false sense of security and should, indeed, be sent on their way. Despite

these arguments, experience shows that many people do 'reactivate' garments they have not worn for a period of time. Sophie Woodward describes multiple instances of this in her wardrobe research.[51] Saulo Cwerner, meanwhile, observes, 'Stored clothes may remain "dormant" for years before their use is dictated by new circumstances.'[52] I can certainly vouch for reactivation as a regular element of my own fashion practice. To take just one example, I have recently returned to a number of tie-dyed shirts and loose Indian tops, which I have had since my early teens (think early 1990s grunge), over twenty years later.

What happens when we revisit these clothes from earlier periods of our lives? Are we in danger of looking out of touch with contemporary culture? Not necessarily; for one thing, fashion moves much more slowly than its mythology suggests, meaning that styles can remain 'current' for a reasonably extended period. Furthermore, many garments – especially those originating outside the mainstream fast fashion shops – are much harder to connect to a specific era than we might think. More importantly, the meanings of clothes are both multiple and mobile: they change over time, and according to context. When we reactivate garments we are able to take advantage of this mutability, experimenting with new combinations and discovering hidden potentials in familiar items. As Cwerner explains, 'By picking from various items of clothing stored in the wardrobe, [people] behave like *bricoleurs*, experimenting with bits and parts, and forming renewed packages for body and self.'[53] We are doing on a micro level what happens in the fashion commons as a whole: remixing, adapting and reinventing. As Maura Banim, Eileen Green and Ali Guy point out, people 'can and do re-appropriate and subvert the meanings imbued in clothes'.[54] When I wear an item from my past it does not mean I am trying to be the person that I was then, but rather that I am using this personally significant 'raw material' to construct the person that I am now. As Woodward puts it, 'In these instances of re-wearing older items of clothing [...] the past [...] is made present as the clothing is recombined to help construct a contemporary identity.'[55]

The resilient wardrobe not only provides us with the material to deal with the uncertainty of fashion; it also enables us to challenge the enclosure of the fashion commons. Fashion retailers influence our

dress because they control the items which are physically available for purchase. If we draw items from the wardrobe, rather than purchasing new garments, then we are exercising a degree of independence: in the process, we challenge this enclosure. As Cwerner suggests, 'Because the wardrobe is a kind of clothing library, it could be regarded as the guardian of free thinking as far as dress is concerned.'[56] Of course, the skill and creativity of the 'craft consumer' are needed to do this successfully. As with any practice which takes us away from the reassuring sanctioning of the mainstream fashion system, a degree of risk is involved. Yet the reward on offer is a satisfying sense of agency and achievement – and the opportunity to overcome the feelings of waste associated with unworn clothes.

The Wardrobe and Well-Being

All of these approaches to shaping the wardrobe are – or could be – framed as personal wardrobe projects. The act of undertaking a project – whether that is knitting a jumper, taking part in a zero-consumption initiative, or any other strategy that facilitates activity beyond the everyday – carries inherent benefits by offering a sense of purpose and connecting you to others. Projects, structures and rules also support creativity, thus further contributing to well-being. From the examples I have reviewed, it seems that consciously created initiatives invigorate the relationship between wearer and wardrobe, bringing the ongoing and positive process of identity construction to life. Fashion participation and shopping are often thought of as, basically, the same thing. But these projects offer other opportunities to demonstrate fashion literacy, showing that it is possible to exercise know-how through styling, editing and remixing. Those who feel less confident in their fashion knowledge, meanwhile, can benefit from the 'alternative dress codes' – guidelines that support decisions over what to wear – offered by these projects.[57] Just like other alternative sources of validation, these codes can lessen the anxiety about ever-shifting and uncertain trends by providing a different, more sturdy, source of guidance and a more personal rationale for clothing choices.

While I have examined various instances where the shaping of the wardrobe connects with the practices of sewing, knitting and mending, I wonder whether there might be scope to strengthen this connection. Too often, I think, our lives as makers and as wearers are conducted in parallel, rather than being fully intertwined. The majority of making activity feeds new items into the wardrobe, which feels somewhat lopsided. We should surely aim to use our craft skills to deal with items as they fall out of wear as much as – or even more than – we use them to fashion virgin materials into yet another garment. The reknitting project involving the Hereford knitting group is one example of this approach. The same idea is explored by artist and blogger Pat Otto, who in 2011 decided 'to use only what I already have in reforming my wardrobe [...] I switched consciousness and started to see my existing wardrobe of ill-fitting, unwanted stuff as potential supplies for reconstructing clothing I liked'.[58] I would argue that there is great potential for further activity that treats the detritus of the wardrobe as the fuel for our creative making projects. To do so, practices of mending and remaking need to be fundamentally reframed in our collective mindset.

Notes

1 More detail on my design philosophy can be found in Amy Twigger Holroyd, *Keep & Share: The First Ten Years* (Leeds: Keep & Share, 2014). Available at keepandshare.co.uk/sites/default/files/downloads/Keep-and-Share-the-first-ten-years.pdf (accessed 5 May 2016).

2 voc 20, 'Sustainable style', *View on Colour* 20 (2002), p. 54.

3 Faye Gracey and David Moon, *Valuing Our Clothes: The Evidence Base* (Waste & Resources Action Programme, 2012). Available at wrap.org.uk/sites/files/wrap/10.7.12 VOC- FINAL.pdf (accessed 6 October 2016).

4 Sophie Woodward, *Why Women Wear What They Wear* (Oxford: Berg, 2007).

5 Saulo B. Cwerner, 'Clothes at rest: elements for a sociology of the wardrobe', *Fashion Theory* 5/1 (2001), p. 80, original emphasis.

6 Woodward, *Why Women Wear What They Wear*, p. 11. Alfred Gell, *Art and Agency: Towards an Anthropological Theory* (Oxford: Clarendon Press, 1998), p. 157.

7 Cwerner, 'Clothes at rest', pp. 79–92, p. 83.

8 Nicky Gregson and Vikki Beale, 'Wardrobe matter: the sorting, displacement and circulation of women's clothing', *Geoforum* 35/6 (2004), pp. 689–700, p. 699.

9 Harry Wallop, 'The secret life of your charity shop cast-offs', *Telegraph*, 12 July 2014. Available at telegraph.co.uk/finance/newsbysector/retailand consumer/10961849/The-secret-life-of-your-charity-shop-cast-offs.html (accessed 6 October 2016).

10 Andrew Brooks, *Clothing Poverty: The Hidden World of Fast Fashion and Second-Hand Clothes* (London: Zed Books, 2015), p. 251.

11 Colin Campbell, 'The craft consumer: culture, craft and consumption in a postmodern society', *Journal of Consumer Culture* 5/1 (2005), pp. 23–42, pp. 27–8.

12 Woodward, *Why Women Wear What They Wear*, p. 12.

13 Maureen Rice, 'Dejunk your life', *Observer Magazine*, 23 January 2000. Available at theguardian.com/theobserver/2000/jan/23/newyou.life1 (accessed 6 October 2016).

14 Elizabeth Bye and Ellen McKinney, 'Sizing up the wardrobe – why we keep clothes that do not fit', *Fashion Theory* 11/4 (2007), pp. 483–98, p. 484.

15 Ibid., p. 486.

16 Tasia St Germaine, 'Too much frosting, not enough cake', Sewaholic (10 April 2012). Available at sewaholic.net/too-much-frosting-not-enough-cake (accessed 6 October 2016).

17 Sarai Mitnick, 'Introducing the wardrobe architect: crafting a small wardrobe that reflects who you are', blog post, Colette (9 January 2014). Available at blog.colettehq.com/wardrobe-architect/introducing-the-wardrobe-architect (accessed 6 October 2016).

18 Giorgia Lupi and Stefanie Posavec, 'A week of wardrobe', Dear Data (2015). Available at dear-data.com/week-16-a-week-of-wardrobe (accessed 6 October 2016).

19 My wardrobe inventory blog posts can be found at keepandshare.co.uk/tags/wardrobe-project.

20 Woodward, *Why Women Wear What They Wear*.

21 Courtney Carver, 'Project 333', Be More With Less (2016). Available at http://bemorewithless.com/project-333 (accessed 21 October 2016). Matt Souveny, '1 year 1 outfit – 365 days all done', This Stylish Life

(2015). Available at thisstylishlife.com/1-year-1-outfit-365-days-all-done (accessed 6 October 2016). Labour Behind the Label, 'The six items challenge 2016 '(2015). Link no longer working.

22 Mrs Frugalwoods, 'What a year without clothes did for me', Frugalwoods (5 January 2015). Available at frugalwoods.com/2015/01/05/what-a-year-without-clothes-did-for-me (accessed 6 October 2016).

23 Rebecca Earley, 'Week 1: intention setting', B.Earley (12 January 2015). Available at beckyearley.com/weekly-diary/2015/1/12/week-1-setting-my-intention (accessed 6 October 2016).

24 Sarah Peck, 'The story of enough: giving up (new) clothes for one year', Becoming Minimalist (2014). Available at becoming minimalist.com/minimalist-enough (accessed 6 October 2016).

25 Free Fashion Challenge, 'At Nannet's office' (15 November 2011). Link no longer working.

26 Free Fashion Challenge, 'Chat with Frank' (29 November 2011). Link no longer working.

27 Rebecca Earley, 'Weeks 37–41: from having, to borrowing, to being', B.Earley (20 October 2015). Available at beckyearley.com/weekly-diary/2015/10/15/sweet-sweet-sweden (accessed 6 October 2016).

28 Cwerner, 'Clothes at rest', p. 88, original emphasis.

29 Jonnet Middleton, 'Mending', in Kate Fletcher and Mathilda Tham (eds), *Routledge Handbook of Sustainability and Fashion* (Abingdon: Routledge, 2015), pp. 262–74, p. 267.

30 Free Fashion Challenge, 'Chat with Frank'.

31 Free Fashion Challenge, 'At Nannet's office'.

32 Peck, 'The story of enough'.

33 Eirlys Penn, 'How I gave up clothing', Scrapiana (14 April 2014). Available at scrapiana.com/2015/04/14/gave-clothing (accessed 6 October 2016).

34 Free Fashion Challenge, 'On the phone with Nadia' (16 November 2011). Link no longer working.

35 Souveny, '1 year 1 outfit – 365 days all done'.

36 Free Fashion Challenge, 'Chat with Frank'.

37 Gracey and Moon, *Valuing Our Clothes*.

38 ahm by Medibank, 'Australians have over 100 items in their wardrobes they don't wear' (2013). Available at savvy.ahm.com.au/files/ahm-fashion-exchange-launch-release.pdf (accessed 6 October 2016).

39 Rebecca C. Collins, 'Excessive… but not wasteful? Exploring young people's material consumption through the lens of divestment', PhD thesis, University College London, 2013, p. 203.

40 An Exacting Life, 'Wardrobe project update 2013' (5 December 2013). Available at anexactinglife.com/2013/12/05/wardrobe-project-update-2013 (accessed 6 October 2016).

41 Amanda, 'The wardrobe inventory', Assembled Hazardly (2 July 2013). Available at assembledhazardly.com/2013/07/wardrobe-inventory.html (accessed 6 October 2016).

42 Maura Banim and Ali Guy, 'Dis/continued selves: why do women keep clothes they no longer wear?', in Ali Guy, Eileen Green and Maura Banim (eds), *Through the Wardrobe: Women's Relationships with Their Clothes* (Oxford: Berg, 2001), pp. 203–20, p. 205.

43 Ibid., p. 207.

44 Bye and McKinney, 'Sizing up the wardrobe', p. 484.

45 Ibid., p. 497.

46 Collins, 'Excessive… but not wasteful?', p. 196.

47 Middleton, 'Mending', p. 262.

48 Bye and McKinney, 'Sizing up the wardrobe', p. 484.

49 Collins, 'Excessive… but not wasteful?', p. 198.

50 Ibid., p. 240.

51 Woodward, *Why Women Wear What They Wear*.

52 Cwerner, 'Clothes at rest', p. 83.

53 Ibid., p. 89.

54 Maura Banim, Eileen Green and Ali Guy, 'Introduction', in Guy, Green and Banim, *Through the Wardrobe*, p. 7.

55 Woodward, *Why Women Wear What They Wear*, p. 13.

56 Cwerner, 'Clothes at rest', p. 89.

57 Local Wisdom, 'Alternative dress codes' (2015). Available at localwisdom.info/use-practices/view/358/citizen-of-planet-earth (accessed 6 October 2016).

58 Pat Otto, 'About Project Minima', Project Minima (2014). Available at projectminima.blogspot.co.uk/p/about-project-minima.html (accessed 6 October 2016).

8

Folk Fashion and the Future

At the start of this book I set out to understand folk fashion: a vibrant, complex and sometimes contradictory strand of contemporary culture. Because the concept of sustainability has long been central to my work, this quest has been guided by a seemingly straightforward question: is folk fashion sustainable? Or, perhaps: could it be?

Is Folk Fashion Political?

Before I get stuck into the relationship between folk fashion and sustainability, I would like to consider the related question of whether making is political. In Chapter 1, I explained that I was considering ways in which folk fashion might be 'incidentally sustainable'. Could it, I wonder, also be 'incidentally political'? I certainly see my own practice – designing, making, researching and writing – as political. I am aiming, as much as I can, to disrupt the dominant paradigm of industrial production and overconsumption in fashion, and to contribute to the construction of an appealing alternative. Others see making as a political act, too; consider the craftivists, who are using craft as a means of activism, and those who are choosing to make their own clothes as a conscious alternative to fast fashion. But what about those folk fashion makers who do not see their hobby as a political statement? Are their actions, as Stephen Knott argues, 'devoid of subversive political content'?[1] Amanda Williams and Joshua Tanenbaum suggest otherwise:

'hedonistic' and 'political' activities can [...] be one and the same. [...] Many practices of making can be considered a sort of 'everyday resistance', not just to a consumerist culture but also to a political

system increasingly controlled by corporate interests and difficult for normal people to influence directly.[2]

I agree: I see making clothes for ourselves as political because it gives us independence from powerful fashion brands and retailers. By engaging in this alternative means of production, we are challenging the dominance of the mass-produced mainstream, its shaping of the fashion landscape, and the social and environmental impacts of this system. Hence, our actions as folk fashion makers are inherently political – and entangled with sustainability – even if we do not think of them in that way ourselves and our motivations for making are purely personal. Jonnet Middleton emphasises the same point in terms of mending:

> These new menders may not be engaged in conscious political action, but their behaviour clearly sits within practices of commodity activism. In fact, I suggest that mending within fashion is a particularly complex and compelling form of commodity activism that is layered with tension and irony. New practices of mending go beyond ethical consumerism and boycotts, by offering an alternative to consumption itself.[3]

These are, however, rather inconspicuous political acts. Jack Bratich and Heidi Brush describe craft as 'innocuous, the unconventional hidden in convention';[4] Fiona Hackney similarly suggests the resurgence of making to be a 'quiet revolution'.[5] I see this quietness as the strength of making. Craft can fly under the radar of dominant forces and therefore potentially be more transgressive than more flamboyant acts of resistance. And non-confrontational acts that offer individual benefits are both accessible and appealing, meaning that many people can get involved and contribute to a hidden groundswell of change.

Is Folk Fashion Sustainable?

In order to tackle the multifaceted question of whether folk fashion contributes to sustainability, I would like to revisit the arguments that

I briefly outlined in Chapter 1. I will draw on the understandings of homemade clothes that I have developed throughout the book, along with further insights and counter-arguments that have emerged through my research. I like to think of sustainability as flourishing, and I see individual well-being as an important element of this flourishing. Therefore, I will be considering the personal satisfactions of making and wearing homemade clothes, as well as more obvious aspects of sustainability.

The first claim, that folk fashion minimises the environmental and social impacts associated with garment manufacture, needs little discussion. After all, making our own clothes allows us to bypass the entire industry of garment production. Although there will still be impacts associated with the manufacture and transportation of the materials we use, these can be reduced by prioritising local and pre-used fabrics and yarns, and particularly by reworking garments from our own wardrobes. The argument that making contributes to resilience is also relatively straightforward. By gaining craft skills, we not only reduce our dependence on globalised garment production, but also build a 'can do' attitude and the sense – essential when dealing with change – that we can adapt, creatively solve problems and develop new skills, as required. In her research, Rebecca Collins found that individuals with experience of making were more able to mend and rework their possessions, and that engaging in these processes 'can broaden perceptions of how objects of all sorts might be used'.[6]

The argument that the satisfactions of making and wearing homemade clothes contribute to well-being – and, therefore, sustainability more broadly – can be dealt with reasonably concisely. The intrinsic motivations of the craft process meet our needs for identity and participation and create a positive sense of well-being. This positive feeling can be heightened by integrating a greater sense of creativity into the activity. In many cases, these satisfactions extend to the wearing stage; makers enjoy wearing the one-off, personalised garments they have worked hard to produce. But it is important to acknowledge that the experience of wearing homemade clothes is often rather less positive than we would hope. There are anxieties associated with contemporary fashion, and because homemade clothes carry conflicting meanings –

being seen as creative and desirable in some contexts, old-fashioned and unappealing in others – there is a danger that folk fashion could exacerbate these anxieties. The same issue affects the potential of repair and alteration to keep our clothes in use for longer. In order for this to work, we have to see our mending – and our mended garments – in a positive light, overcoming the enduring association between repair and poverty.

The remaining three arguments – relating to slowness, critical thinking and alternative ways of participating in fashion – need to be unpacked a little more; I will look at them one by one.

The slowness of making and the increased emotional attachment felt towards a homemade item slow the rate at which we consume clothing.

This idea – that the time involved in making carries benefits in terms of sustainability – is widespread, yet unfortunately these benefits are far from clear cut. It is true that the process of making is usually slow; this issue emerges in many conversations with folk fashion makers. And certainly, durability has long been discussed as a valuable strategy for sustainable fashion. It is logical to think that a slower making process leads to a slower rate of consumption, with each step of the process being rather more considered than the instant gratification of purchasing ready-made items. People are frequently motivated to make because they want to opt out of the rapid turnover of fast fashion, and it is fair to assume that many are managing to follow through on this intention. On the other hand, making generally involves the purchase of materials: to some extent consumption is not avoided but transferred. Rosie Martin reckoned that 'for every project you make, most sewers buy, like, four different fabrics and three of them stay on their shelves'. We also need equipment to facilitate our making; while those who successfully embrace a hobby will make regular use of this equipment, for many it will be gathering dust in a corner, forgotten after the initial good intentions which led to its purchase have faded away. As Rosie went on to point out, 'it's easier to buy stuff than to do stuff, in a way'.

The notion that we are more emotionally attached to items that we have made ourselves, or that have been made for us, is a familiar

one. Sustainable consumption researcher Tim Cooper suggests that when people are involved in the making of their possessions, they may appreciate them more and want to keep them in use.[7] In many cases, I am sure that is true: the experience of making is a memorable process which can imbue a garment with personal meanings and consequently the piece may remain in wear far longer than an item with less emotional resonance. It is important to remember, though, that we can form strong emotional attachments to shop-bought items; this is by no means the sole preserve of the homemade. Furthermore, a positive making experience is not guaranteed; it is quite common for folk fashion garments to fail to turn out well for a variety of reasons. Not only are these items unlikely to support positive personal meanings, they are unlikely to be worn for long, and so the realistic chances of their helping to slow consumption are rather slim.

In her interview, Christine Cyr Clisset described some of the reasons that she has now discarded many of her early projects:

> As I've become better at sewing, I've actually gotten rid of many of my first makes because they didn't fit correctly, or I made them with cheap fabrics that pilled, or I'd put them together so quickly that they weren't staying together well.

She went on to link this fast and furious type of making with fast fashion:

> In a way, that stage of just making stuff really quickly – it's almost at a level of going to H&M and buying, like, a bunch of shirts! Just because you make your own clothing doesn't necessarily mean that you're not contributing to that fast fashion world. If you're just making stuff that's really trendy that you're not going to wear very long, then you've basically just wasted a bunch of fabric, you know? In some ways fast sewing can be just as wasteful as fast fashion.

Though it is rather shocking to think of homemade clothes as fitting within the fast fashion paradigm, I entirely agree with Christine. Her words serve as a vital reminder that making for ourselves is not

necessarily as slow, conscientious and sustainable as we often like to think. As Huelo Dunn-Estébanez argues, 'sometimes we're a little too comfortable in the assumption that knitting for fun necessarily challenges consumerism, instead of being another expression of it'.[8] Similarly, Kate Orton-Johnson outlines a critical view of knitting as 'a form of individualistic consumerism [...] which may in fact celebrate consumption and fetishism of desirable knitting products'.[9] Although we might feel virtuous as we knit and stitch away, it is quite possible that we are simply transferring our consumption from finished items to materials, and churning out items which, to put it bluntly, no one is going to wear. Perhaps the more important point is that making creates a valuable *sense* of slowness – even if that making does not produce treasured garments that enjoy a long lifetime of wear. Jack Bratich and Heidi Brush argue that crafts 'offer a critique of the regime of technology and the culture of speed. Crafting creates slow space, a speed at odds with the imperative toward hyperproduction.'[10] Given that, as Kate Fletcher indicates, the 'struggle between long-term and short-term reward is at the heart of many of the conflicts around consumption',[11] experiencing the slow space of making could provide important 'training' in the benefits of delayed gratification and long-term thinking.

Making prompts critical thinking and behaviour change.

In Chapter 1, I mentioned the suggestion that making helps us to think critically about the objects that surround us and changes our consumption behaviour. Philosopher Albert Borgmann presents an argument which supports this notion and offers a compelling alternative to the focus on slowness. He explains that in pre-modern and early modern times (that is, before the Industrial Revolution in Britain), production and consumption – whether of food, objects or entertainment – took place in close proximity. As technology progressed, they became increasingly separated. This has certainly been the case with clothing; Robert Ross explains that in the eighteenth century in England clothing was commonly made by women within the household or made to measure by a local tailor or dressmaker.[12]

Ready-made clothes – stitched initially by hand and later by machine – became popular in the nineteenth century, particularly in sectors such as men's outerwear.[13] Although domestic making of clothing was still relatively widespread in the first half of the twentieth century, a developing consumer culture dramatically increased the proportion of ready-made clothes in people's wardrobes in the decades after World War II.[14] The subsequent growth of offshore manufacturing has taken production even further from the location of its eventual use.

Borgmann argues that this separation has degraded the 'natural symmetry' of production and consumption and 'detached pleasures from their context of exertion'.[15] When we can enjoy the pleasure of use without experiencing, or even witnessing, the effort of production, he argues, we begin to perceive goods as being available without limits, and consume at an accordingly rapid rate. In contrast, when production and consumption take place within close proximity – as with what Borgmann describes as 'focal things and practices', such as homemade clothes – our appetites are kept within bounds, naturally limiting the rate at which we wish to consume.[16] Furthermore – to reconnect with the theme of well-being – he suggests that these focal practices, which require effort, are far more satisfying than the hollow pleasure of unencumbered consumption.

Borgmann's argument appeals to me; I agree that there are genuine benefits in bringing making closer to use. On many occasions I have heard about, or even witnessed, the experience of making provoking reflection about the origins of mass-produced clothes and the impacts of clothing production. In her *Guardian* article on homemade clothes, for example, Sarah Ditum describes how her thinking changed after learning to knit:

> I don't make all my own clothes, but at least having tried to be my own sweatshop means I know what garments are [...] 'worth' in terms of what another person had to do to make the things I wear. It means I buy well and buy less.[17]

Christine Cyr Clisset described a similar shift in attitude:

Making my own clothing as an adult has made me so much more appreciative of well-made clothing. I'm not a knitter, so I recently bought a beautiful sweater from a small designer. I would have never spent that much money on something before I started sewing, but now that I sew, and I have a better appreciation of well-made garments, I was willing to spend that, you know?

Jonnet Middleton, meanwhile, argues that 'to experience mending first-hand pushes the mending ethic deep inside our consciousness and rewires our consumer brains'.[18]

The critical thinking provoked by making can potentially spread beyond the immediate context of clothing. It has been suggested that because the fashion system sets the pace for consumer attitudes more widely, change in this area could influence other sectors and ultimately have a powerful impact.[19] David Gauntlett suggests that makers feel more connected to the world and more likely to take an active role in caring for it.[20] On a similar note, Sarah Ditum argues that 'To think of ourselves as makers, rather than just consumers, is the first part of refusing to accept everything in our culture as obvious and inevitable.'[21] Matthew Crawford, too, proposes that if we feel our world is 'intelligible' through the material engagement of making, we can then start to take proper responsibility for it.[22]

Making provides us with an alternative means of participating in fashion.

In Chapter 1, I highlighted both the pressing need to reduce clothing consumption dramatically and the important social function of fashion. In order to address the first issue without compromising the second, we need to develop – or rediscover – versions of fashion which are not dependent on a rapid turnover of clothing. Many people would suggest that this is impossible: that fashion and consumption are fundamentally intertwined. Adam Briggs, for example, argues that the commercial fashion system is so dominant that 'culture and economy become mutually constitutive to the extent of being analytically inseparable'.[23] I believe that these elements can, however, be pulled apart. When we make, mend and rework our own garments and undertake personal

wardrobe projects, we energise our relationships with our clothes, without engaging directly with the commercial fashion system. As Kate Fletcher observes, remaking activities 'gesture that fashion is as much process, practice and performance as garment'.[24] Eirlys Penn proposes that mending can 'be a way […] to slow down and engage in a dialogue with our wardrobes, with ourselves and others'.[25] This dialogue is based on material engagement rather than aspirational images: touch and feel, rather than purely vision. We are still able to construct our identities and connect with those around us, even when we are not buying new clothes – and making gives us the opportunity to explore the endless diversity of the fashion commons more fully than the limited interpretations offered to us by the commercial system. Folk fashion, therefore, does not just offer a different way of producing garments to mainstream manufacturing, but – more importantly – presents a satisfying and positive alternative means of participating in fashion, which is not dependent on ever-increasing consumption.

With all this in mind, folk fashion can be seen as one example of what Pascale Gatzen and Otto von Busch describe as 'socially sustainable alternatives to the dominant models of clothing provision and the dissemination of style'.[26] Kate Fletcher has collected a broad range of stories that represent a variety of such alternatives in her large-scale research project, Local Wisdom. As she explains, these stories 'provide numerous examples of people who effectively regulate their consumption of fashion without in any way diminishing their joy in experiencing it'.[27] Furthermore, the 'craft of use' demonstrated in these stories provides 'a diversified view of fashion beyond the market and the market's purpose, trading in the economies of time, creativity and community.'[28] This is incredibly positive in terms of sustainability. Joanne Finkelstein observes that 'if we are relying upon the properties of procured goods for our sense of identity, then we are compelled to procure again and again'.[29] Alternative fashion practices flip this logic upside-down: if we have an alternative means of constructing our identity, we are free from the need to procure goods again and again.

Limitations

Some people claim that amateur making – of any type – simply piggybacks on mainstream industry, without ever achieving any significant change in terms of sustainability. McKenzie Wark, for example, suggests that amateur making 'nibbles around the edges of a world that is made elsewhere. [...] The handicraft part depends on an industrial part that remains unseen.'[30] Jack Bratich and Heidi Brush, meanwhile, point out that craft culture has been commodified, 'fully integrated into consumer culture in the likes of Martha Stewart, the Style Network, and even the DIY Network'.[31] Thus, as Stephen Knott proposes, amateur activity 'facilitates moments of individual production free of the constraints associated with capitalist production, yet it entirely depends on these systems for its survival'.[32] Chris Csikszentmihályi argues that rather than laying the seeds of an alternative system, making is an ineffectual distraction:

> What is called 'making' in North America and Europe is, frankly, a luxurious pastime of wealthy people who rightly recognize that their lives are less full because they are alienated from material culture, almost all of which is products produced by corporate interests. Sadly, rather than address the problem, makers develop a hobby that solves the symptom for them, but if anything slightly strengthens the disease.[33]

These criticisms are valid and should give pause to anyone assuming that making in general, and folk fashion specifically, contribute to sustainability. Even so, I do feel that the contemporary resurgence of making is offering the seeds of an important alternative to the established fashion system, and a place from which we can view that system through fresh eyes. While the impact of each individual's activity may be negligible, the cumulative effect of action by many individuals can be transformative. David Gauntlett describes the way in which these 'small steps' can create genuine societal change:

I think change happens, step-by-step, little step by little step, as people do things differently. [...] this gets absorbed into the more macro-level context of how people in government, or visible in the media, do things, and what they expect things to be like, and then this macro level sets the tone of what is then assumed and expected down at the micro level, which then means the envelope can be pushed a tiny bit more, and so on, and the whole thing goes on in a cycle.[34]

John Thackara presents a related argument about change towards sustainability:

Transformation can unfold quietly as a variety of changes, interventions and disruptions accumulate across time. At a certain moment – a moment that is impossible to predict – a tipping point, or phase shift, is reached, and the system as a whole changes.[35]

36. Tools for change?

Essentially, I choose to take an optimistic position, seeing the value in individual practices and small-scale actions – especially those, such as making our own clothes, which produce practical items we use in our everyday lives – and the potential for this activity to build up and bring about change.

Looking Forward

What does the future hold for folk fashion? To answer this tricky question, it makes sense first to consider the outlook for the revival of interest in making more generally. Susan Luckman suggests that the use of the term 'craft' as a marketing gimmick by big business (think hand-crafted sandwiches and artisan crisps) will soon go out of fashion. Yet, she argues, 'craft and making will persist'.[36] Benedict Dellot agrees, proposing that making is not merely 'part of a hobbyist craze that may soon fizzle out', but rather 'a reaction to significant technological upheaval and indicative of a desire among people to have more control over their lives'.[37] Likewise, it seems inevitable that the development of repair will gather pace. While this is still a niche endeavour at present, I sense an increasing frustration at our collective inability to mend our possessions, and I take heart from Scott Burnham's suggestion that there is 'a public will to re-purpose the objects they own and [...] a desire for a new relationship with the objects and systems they buy and use'.[38]

When I talked to Rosie Martin, Rachael Matthews and Tom van Deijnen, we discussed the ways in which we thought folk fashion would unfold in the years to come. We all felt that concerns about the social and environmental impacts of mainstream fashion would continue to grow, inspiring more people to investigate making and mending their own clothes. Awareness of the abhorrent conditions faced by garment workers is becoming increasingly mainstream, with the global Fashion Revolution campaign encouraging wearers to ask brands: 'Who made my clothes?' I wonder whether this movement might soon start to affect the shared meanings of fast fashion garments, and thus their usefulness

in terms of positive identity construction. According to Christopher Breward, the move towards ready-made clothing in Britain in the late nineteenth century was limited by 'a residual suspicion of the social worth of cheap ready-made goods'.[39] Might the same suspicion take hold once again?

Another point of agreement was that folk fashion would stick around rather than dying back after the current resurgence. This is particularly interesting, considering that sewing and knitting have tended to wax and wane in terms of activity and fashionableness. The internet, we thought, would make a massive difference to this familiar pattern. The web has already transformed folk fashion culture; it does an incredible job of connecting people around niche interests. In fact, Kate Orton-Johnson argues that for many makers, digital and hands-on making practices are now intertwined: 'The material, tactile processes of knitting are integrated with digital practices of lifestreaming and the boundaries and practices of knitting are extended as material handicrafts converge with web 2.0 technologies.'[40] She goes on to explain that these social media platforms 'have given users new ways to think about and engage with their creativity that, in turn, have become an embedded part of their construction and enjoyment of their knitting'.[41] There can surely be no turning back from this shift: making is now bound up with the processes of connecting online for many people, with each practice giving purpose to the other. This digital sharing spreads inspiration between like-minded enthusiasts and thus stimulates continuing activity. It also builds an incredibly rich and easily accessible archive of information, which supports the transmission of craft knowledge. This is crucial: ongoing craft activity is no longer dependent on people in local communities teaching each other, nor on knowledge being formally recorded in books. Instead, an array of instruction and support is available to anyone with internet access, wherever and whenever they choose.

Will participation continue to increase? My feeling is that it will reach a plateau. Sewing and knitting are not going to appeal to everyone; these activities are subject to various limitations, including time, space and

interest – and for many the attraction of folk fashion will be restricted by the accessibility and ease of ready-made clothes. People have busy lives, and other leisure pursuits competing for their time. Activity may intensify, however: should our hunch prove correct and folk fashion does become a constant element of fashion culture, then more makers will have the opportunity to develop their practices over an extended period. As they do, skills will increase and tastes will mature. I expect that more people will reach the point of making items they are happy to wear, become more ambitious with their projects and produce a greater proportion of their clothing themselves.

Taking Control

Despite folk fashion presenting an important alternative mode of fashion participation, I feel that there is scope for it to deliver greater satisfaction and to become more disruptive of the status quo. Song collector Alan Lomax expressed concern in the mid-twentieth century that localised folk music cultures were 'threatened to be engulfed by the roar of our powerful society with its loudspeakers all turned in one direction'.[42] I have a similar concern about folk fashion: that despite the diverse whirlwind of activity I have examined, and the current resurgence of interest in making clothes at home, this activity is being drowned out by the powerful forces of mass-produced fashion. Rather than accept this state of affairs, I would like to consider ways in which we might switch the loudspeakers: challenging the factors which limit the potential of homemade clothes, helping folk fashion culture to grow, and finding ways in which to maximise its subversive impact.

With this in mind, I have come up with five strategies for folk fashion practice that I hope will support people to feel happier with their homemade items and shift perceptions of the homemade in a positive direction. The strategies are based on the premise that action by many individuals will aggregate and contribute to change. Drawing on the 'double dividend' concept that connects individual and

collective benefits, they are intended to support personal satisfaction as well as contribute to sustainability. Essentially, these are the ideas that I am trying to integrate into my own domestic making practice, informed by the stories, arguments and insights I have shared within the book.

If you are a maker yourself, I hope you find some suggestions here which inspire new ways of approaching the activity of making and mending your own clothes. If you are not yet a maker, I hope you may be inspired to join in. And if you are a designer or facilitator, I hope the strategies prompt you to think a little differently about ways to support and encourage individual folk fashion makers. In any case, do get in touch: I would love to hear your story.[43]

1. Make to suit the maker, the wearer and the materials.
This strategy encourages me to strike a harmonious balance between my tastes and preferences as a maker, those as a wearer, and the inherent properties of the materials used, in order to create a garment that I deem to be a success. It is partly inspired by the positive stories I have heard, but even more by the sorrowful tales of garments not turning out well due to a poor fabric choice, and of items which, despite having delivered a pleasurable making experience, are too outlandish ever to be worn in real life.

To strike this balance, I need to take a step back to reflect on my preferences. How do I like to make? How much time do I have? Do I prefer an epic project or a quick reward? Do I like to switch off and engage in a rhythmic mode of making, or do I enjoy tricksy challenges at every turn? To try out new skills with each item, or perfect a technique by using it time after time? Similarly, I can think about my preferences during the wearing phase: what garment styles and details make me feel like me? What are the needs of my unique body? What do I love to wear? What colours or patterns appeal to me, are suitably practical (or impractical) and complement or contrast with the other items in my wardrobe?

Finally, I need to ask: what sort of materials would suit the project I have in mind? I can think about fibres, yarns and fabrics: how they

hang and drape, how they feel to work with, how they feel to wear, how they wash and age. Along the way, I can think about the origins of my materials and their social and environmental impacts. Alternatively – particularly if I want to re-use materials or work from my stash, rather than buy new – I can choose to put the materials first and then ask: what sort of garment would make them sing?

2. *Spread your wings.*

My second strategy takes advantage of the incredibly broad scope of folk fashion. To borrow a metaphor from Mitch Resnick and Brian Silverman, it has a low floor, high ceiling and wide walls – meaning that while it is easy to get started, there is always more to learn, and endless room for creative exploration.[44] I can spread my wings first in terms of the *way* in which I make. Rather than rushing to finish a garment in the only way I know how, I can look for alternatives; I can try out different techniques and make a habit of playfully sampling different options. I can take time to develop my skills, and rather than always looking to an expert for the 'correct' option, develop confidence in my own assessment of what works, and why.

I can spread my wings in terms of *what* I am making, too. I like to imagine myself roaming through the immense meadow of the fashion commons, picking up different styles, traditions and textile techniques as I go. In selecting these elements, I keep in mind the dynamics of fashion – the social norms, passing trends and processes of identification and differentiation – but do not allow these factors to restrict me. I choose to go beyond the normal habitat of homemade clothes, challenging enclosure by digging in the territories of industrial fashion. I might make styles that are usually mass-produced in a way that celebrates their homemadeness; I might use the products of mainstream fashion as a resource, whether by reworking individual garments or by pillaging the high street for ideas on style and construction. I might even adopt the 'Hacking Couture' approach promoted by Giana Pilar González, by identifying a luxury brand's 'DNA' and remixing the relevant design elements to create my own unique interpretation.[45]

In following this path I might need to adapt a pattern or design something new. Folk fashion design is a quite different task from commercial fashion design. To succeed I need to draw on my tacit making knowledge, think about those preferences discussed in Strategy 1, and – most importantly – give myself room to make mistakes. Spreading your wings, after all, takes space.

3. Enjoy the journey.
Time is a central issue for many makers; again and again I have observed a desire to produce things quickly, to move on to the next stitch, the next seam, the next project. I have also witnessed guilt over taking things slow. In this urge I perceive the silent influence of industrial production and its emphasis on efficiency, as well as consumerism and its promise of instant gratification. If I really want to challenge the dominant paradigm of overconsumption, I need to embrace the journey of making, with all of its twists and turns. I need to celebrate the inefficiency of craft and demonstrate to myself that I am not a machine, nor a sweatshop worker. In fact, I can choose to lavish time on my projects, enjoying the fact that, as Stephen Knott suggests, 'amateur craft can be economically aberrant, it provides a space for forms of practice that need not pay heed to market concerns'.[46]

I might choose to slow down my making by working intricate pieces rather than simple projects, or by taking the time to experiment before settling on a final option. I could choose to avoid labour-saving devices and instead enjoy the scenic route. Tom van Deijnen described a lovely example of this approach: 'I've got a ball winder, but I now wind balls by hand. You get a really good appreciation of the yarn. If it's something I've not used before, by just winding it on, I already learn something about it.' I embrace the fact that every time I make I am engaging with the workmanship of risk; I do not beat myself up when a project goes awry. If I do need to cheer myself up, though, I remind myself of all that I am getting out of the process of making, quite apart from the finished item. As artist Celia Pym once said to me, 'mending helps the mender more than the mended'. I enjoy the journey of my making career, too, seeing project after project as stops along the way. Each one, even the

false starts and abandoned misadventures, helps me to learn and to progress, becoming – as Peter Korn puts it – 'a springboard for the genesis of its successors'.[47]

4. Seek and give validation.

As makers, we can sometimes lack confidence in our homemade clothes. Even if they turn out as hoped and we see them in a positive light, it is hard to know whether those around us will perceive them in the same way. While shop-bought clothes have been sanctioned by a chain of professionals, our homemade items represent the decisions we have made while hidden away, alone, at home. It is difficult to be sure that our creations stand up to the scrutiny of the outside world. In order to overcome this problem, I look for other sources of validation. The folk fashion community can be a fantastic source of sanctioning; if I share my initial ideas, work in progress and finished items with fellow makers – whether in person or online – I can gain constructive feedback as well as praise on a job well done. Folk fashion facilitators, too, can provide a sense of validation. I can draw on their experience and expertise to give me confidence in my own creative decisions. I can also gain confidence from the structure of a project and the rules I set for myself, as well the objective standards of making: all provide me with a steady mooring post in an uncertain world. In turn – as both a maker and a facilitator – I can help to validate other people's projects, whether by commenting, congratulating or coveting.

I can contribute to the validation of folk fashion as a whole, raising its status in our shared consciousness, by making my activities visible. Making and mending have traditionally been carried out in the privacy of the domestic sphere; they are invisible to the outside world. With visibility comes a sense of positivity and celebration, which encourages others to join in. Jonnet Middleton points out that 'Visibility does not mean insisting that every mend be "hi-vis". Traces of repair can linger in our conversations, our status updates and the mending basket in the lounge.'[48] As we showcase our practices – by chatting about our projects, through Instagram images and hashtags, by wearing our garments and telling their stories – we collaboratively create spaces where making is normal.

5. Share, reflect and act.

Although making my own clothes is an individual and personal act of creativity, there is strength in numbers. As participation increases, folk fashion culture becomes even more diverse and vibrant, and the cultural perception of amateur making shifts further away from the stigma of the past. In turn, this positive environment helps me to feel pleased with my homemade garments – which may then inspire others to get involved. I can contribute to the growth and evolution of the folk fashion community by sharing my knowledge, ideas and enthusiasm, passing on the skills that have been taught to me by earlier generations of makers. If I have solved a problem, come up with a new variation on an old technique or developed an excellent hack, I can document it and stick it up on the web for others to discover. I can share my passion for making by talking to people about the incredible sense of satisfaction I get by seeing a garment come together in my hands.

37. Share, reflect and act.

I need to take time to look inwards, too: reflecting on what motivates me to make, the progress of my folk fashion career, the significance of making things by hand in a world of mass production. In doing so, I might choose to alter my course, to amplify aspects of my activity or to set myself further challenges. And when I have reflected, I need to act – pick up my needles and get stuck in.

A Thriving Fashion Commons

The fashion commons is like land: it can host a thriving and diverse ecosystem, or a standardised and predictable monoculture. An ancient wildflower meadow, teeming with an array of flora and fauna, or an intensively farmed field of a single crop, viable only through the use of artificial fertilisers and pesticides. I know which I prefer. A richly diverse fashion commons reflects and sustains the world's varied, overlapping and intermingling cultures. It is a source of resilience, helping us to weather the storms of social change. It enables us to express and understand who we are, to connect and to stand out. Exploring this incredible resource is endlessly fascinating and personally satisfying – and, crucially, helps the resource to be sustained. Diversity feeds further diversity. Yet the globalised fashion system that has emerged in recent decades is stultifying the incredible variety of dress styles and practices that has built up over many centuries. It is making us anxious about our decisions and causing us to doubt our ability to act independently. The economic logic guiding this trade drives standardisation and homogeneity, dressed with a thin veneer of choice. The making of all this stuff in distant countries endangers lives and keeps people locked in poverty. The scale of the waste it produces is breathtaking.

As folk fashion makers, we are helping to restore a thriving fashion commons: in a way, we *are* the flora and fauna. While the current system may seem entrenched, it can be changed. Every person, every project, every stitch is building an alternative fashion culture. The good news – as I have endeavoured to show throughout the book – is that making is an intrinsically rewarding process. Yes, it can be frustrating.

Rather than being 'quick and easy', as is so often claimed, I would say that making your own clothes is usually slow, often difficult and always culturally complicated. But therein, for me, lies the challenge, and thus the satisfaction. We do not have to make every garment to influence change: any action, however small, that steps outside of the expected buy–wear–throw treadmill makes a contribution. Yet we can gain greater leverage by changing our mindsets, increasing the visibility of our practices and influencing others. The further we shift outside the mainstream – quietly or loudly, with neatly finished seams or ragged edges – the more transgressive these 'everyday' folk practices become.

Notes

1 Stephen Knott, *Amateur Craft: History and Theory* (London: Bloomsbury, 2015), p. 97.

2 Amanda Williams and Joshua Tanenbaum, 'Palettes, punchcards and politics: beyond practicality and hedonism', in Garnet Hertz (ed.), *Critical Making: Terms* (Hollywood: Telharmonium Press, 2012), pp. 1–8, pp. 6–7. Available at conceptlab.com/criticalmaking (accessed 6 October 2016).

3 Jonnet Middleton, 'Mending', in Kate Fletcher and Mathilda Tham (eds), *Routledge Handbook of Sustainability and Fashion* (Abingdon: Routledge, 2015), pp. 262–74, p. 267.

4 Jack Z. Bratich and Heidi M. Brush, 'Fabricating activism: craft-work, popular culture, gender', *Utopian Studies* 22/2 (2011), pp. 233–60, p. 252.

5 Fiona Hackney, 'Quiet activism and the new amateur: the power of home and hobby crafts', *Design and Culture* 5/2 (2013), pp. 169–93, p. 172.

6 Rebecca C. Collins, 'Excessive... but not wasteful? Exploring young people's material consumption through the lens of divestment', PhD thesis, University College London, 2013, p. 211.

7 Tim Cooper, 'Slower consumption: reflections on product life spans and the "throwaway society"', *Journal of Industrial Ecology* 9/1–2 (2005), pp. 51–67.

8 Huelo Dunn-Estébanez, 'Knitting is a right, not a privilege', Work Even (2 February 2015). Available at workeven.com/2015/02/02/knitting-is-a-right-not-a-privilege (accessed 6 October 2016).

9 Kate Orton-Johnson, 'Knit, purl and upload: new technologies, digital mediations and the experience of leisure', *Leisure Studies* 33/3 (2014), pp. 305–21, p. 308.

10 Bratich and Brush, 'Fabricating activism', pp. 235–6.

11 Kate Fletcher, 'In the hands of the user: the Local Wisdom Project and the search for an alternative fashion system', *Journal of Design Strategies* 7 (2015), pp. 10–17, pp. 12–13. Available at http://sds.parsons.edu/design dialogues/?post_type=article&p=630 (accessed 6 October 2016).

12 Robert Ross, *Clothing: A Global History* (Cambridge: Polity, 2008).

13 Ibid.

14 Christopher Breward, *Fashion* (Oxford: Oxford University Press, 2003).

15 Albert Borgmann, 'The moral complexion of consumption', *Journal of Consumer Research* 26/4 (2000), pp. 418–22, p. 420.

16 Ibid., p. 421.

17 Sarah Ditum, 'Knitting offers welcome relief from fashion lust', *Guardian*, 22 February 2012. Available at theguardian.com/commentisfree/2012/feb/22/knitting-fashion-lust (accessed 6 October 216).

18 Middleton, 'Mending', p. 271.

19 Dilys Williams, Nina Baldwin and Kate Fletcher, *Tactics for Change* (London: Centre for Sustainable Fashion, 2009). Available at ualresearch online.arts.ac.uk/2751/1/CSF_Volume_3_Tactics_for_Change.pdf (accessed 6 October 2016).

20 David Gauntlett and Amy Twigger Holroyd, 'On making, sustainability and the importance of small steps: a conversation', *Conjunctions: Transdisciplinary Journal of Cultural Participation* 1/1 (2014), p. 13. Available at http://dx.doi.org/10.7146/tjcp.v1i1.18602 (accessed 26 October 2016).

21 Ditum, 'Knitting offers welcome relief from fashion lust'.

22 Matthew Crawford, *The Case for Working with Your Hands: Or Why Office Work Is Bad for Us and Fixing Things Feels Good* (London: Penguin, 2009), p. 8.

23 Adam Briggs, 'Response' [to Chapter 3], in Christopher Breward and Caroline Evans (eds), *Fashion and Modernity* (Oxford: Berg, 2005), pp. 79–81, p. 81.

24 Kate Fletcher, *Craft of Use: Post-Growth Fashion* (Abingdon: Routledge, 2016), p. 114.

25 Eirlys Penn, 'Mending: the ancient art of making wHOLE', *Selvedge* 70 (May/June 2016), p. 46.

26 Pascale Gatzen and Otto von Busch, 'Letter from the editors', *Journal of Design Strategies* 7 (2015), pp. 5–7, p. 5. Available at sds.parsons. edu/designdialogues/?post_type=article&p=629 (accessed 6 October 2016).

27 Fletcher, 'In the hands of the user'.

28 Fletcher, *Craft of Use*, p. 17.

29 Joanne Finkelstein, *The Fashioned Self* (Cambridge: Polity, 1991), p. 145.

30 McKenzie Wark, 'Making New York', in Garnet Hertz (ed.), *Critical Making: Places* (Hollywood: Telharmonium Press, 2012), p. 1. Available at conceptlab.com/criticalmaking (accessed 6 October 2016).

31 Bratich and Brush, 'Fabricating activism', p. 246.

32 Knott, *Amateur Craft*, p. 49.

33 Chris Csikszentmihályi, 'Sixteen reflective bits', in Garnet Hertz (ed.), *Critical Making: Manifestos* (Hollywood, CA: Telharmonium Press, 2012), p. 31. Available at conceptlab.com/criticalmaking (accessed 8 September 2015).

34 Gauntlett and Twigger Holroyd, 'On making, sustainability and the importance of small steps', pp. 7–8.

35 John Thackara, 'A whole new cloth: politics and the fashion system', in Kate Fletcher and Mathilda Tham (eds), *Routledge Handbook of Sustainability and Fashion* (Abingdon: Routledge, 2015), pp. 43–51, p. 45.

36 Susan Luckman, *Craft and the Creative Economy* (Basingstoke: Palgrave Macmillan, 2015), p. 155.

37 Benedict Dellot, *Ours to Master: How Makerspaces Can Help Us Master Technology for a More Human End* (London: RSA, 2015), p. 5.

38 Scott Burnham, 'Finding the truth in systems: in praise of design-hacking', (London: *RSA*, 2009), p. 16.

39 Breward, *Fashion*, p. 54.

40 Orton-Johnson, 'Knit, purl and upload', p. 305.

41 Ibid., p. 319.

42 Quoted in John Szwed, *The Man Who Recorded the World* (London: Arrow Books, 2010), p. 274.

43 Please do get in touch! Email me at amy@keepandshare.co.uk.

44 Mitchel Resnick and Brian Silverman, 'Some reflections on designing construction kits for kids', in *Proceedings of the 2005 Conference on Interaction Design and Children - IDC '05* (New York: ACM Press, 2005), pp. 117–22.

45 Giana Pilar González, 'Fashion codes hacked, indexed, and shared', *Journal of Design Strategies* 7 (2015), pp. 60–2. Available at sds.parsons.edu/designdialogues/?post_type=article&p=678 (accessed 6 October 2016).

46 Stephen Knott, 'Labour of love', *Crafts* 255 (July/August 2015), pp. 48–51, p. 51.

47 Peter Korn, *Why We Make Things and Why It Matters: The Education of a Craftsman* (London: Square Peg, 2015), p. 60.

48 Middleton, 'Mending', p. 268.

Bibliography

Abbott, Pamela and Francesca Sapsford, 'Young women and their wardrobes', in Ali Guy, Eileen Green and Maura Banim (eds), *Through the Wardrobe: Women's Relationships with Their Clothes* (Oxford: Berg, 2001), pp. 21–38.

ahm by Medibank, 'Australians have over 100 items in their wardrobes they don't wear' (2013). Available at savvy.ahm.com.au/files/ahm-fashion-exchange-launch-release.pdf (accessed 6 October 2016).

Alexander, Christopher, *The Timeless Way of Building* (New York: Oxford University Press, 1979).

——— *The Production of Houses* (Oxford: Oxford University Press, 1985).

Allen, Katie, 'Quilty pleasures', *The Bookseller*, 29 October 2010.

Allwood, Julian M., Søren Ellebaek Laursen, Cecilia Malvido de Rodriguez and Nancy M. P. Bocken, *Well Dressed? The Present and Future Sustainability of Clothing and Textiles in the United Kingdom* (Cambridge: Institute for Manufacturing, University of Cambridge, 2006). Available at ifm.eng.cam.ac.uk/resources/sustainability/well-dressed/ (accessed 6 October 2016).

Amanda, 'The wardrobe inventory', Assembled Hazardly (2 July 2013). Available at assembledhazardly.com/2013/07/wardrobe-inventory.html (accessed 6 October 2016).

An Exacting Life, 'Wardrobe project update 2013' (5 December 2013). Available at anexactinglife.com/2013/12/05/wardrobe-project-update-2013 (accessed 6 October 2016).

Andersen, Kurt, 'You say you want a devolution?', *Vanity Fair (USA)* (January 2012). Available at vanityfair.com/style/2012/01/prisoners-of-style-201201 (accessed 6 October 2016).

Avital, Michel, 'The generative bedrock of open design', in Bas van Abel, Lucas Evers, Roel Klaassen and Peter Troxler (eds), *Open Design Now: Why Design Cannot Remain Exclusive* (Amsterdam: BIS Publishers, 2011), pp. 48–58.

Bain, Jessica, '"Darn right I'm a feminist ... sew what?", The politics of contemporary home dressmaking: sewing, slow fashion and feminism', *Women's Studies International Forum* 54 (2016), pp. 57–66.

Banim, Maura and Ali Guy, 'Dis/continued selves: why do women keep clothes they no longer wear?', in Ali Guy, Eileen Green and Maura Banim (eds), *Through the Wardrobe: Women's Relationships with Their Clothes* (Oxford: Berg, 2001), pp. 203–20.

———, Eileen Green and Ali Guy, 'Introduction', in Ali Guy, Eileen Green and Maura Banim (eds), *Through the Wardrobe: Women's Relationships with Their Clothes* (Oxford: Berg, 2001), pp. 1–17.

Black, Sandy, *Knitting: Fashion, Industry, Craft* (London: V&A Publishing, 2012).

Blaszczyk, Regina Lee, 'Rethinking fashion', in Regina Lee Blaszczyk (ed.), *Producing Fashion: Commerce, Culture, and Consumers* (Philadelphia: University of Pennsylvania Press, 2008), pp. 1–18.

Borgmann, Albert, 'The moral complexion of consumption', *Journal of Consumer Research* 26/4 (2000), pp. 418–22.

Bowles, Melanie and the People's Print, *Print, Make, Wear: Creative Projects for Digital Textile Design* (London: Laurence King, 2015).

Bratich, Jack Z. and Heidi M. Brush, 'Fabricating activism: craft-work, popular culture, gender', *Utopian Studies* 22/2 (2011), pp. 233–60.

Breward, Christopher, *Fashion* (Oxford: Oxford University Press, 2003).

Briggs, Adam, 'Response' [to Chapter 3], in Christopher Breward and Caroline Evans (eds), *Fashion and Modernity* (Oxford: Berg, 2005), pp. 79–81.

Brooks, Andrew, *Clothing Poverty: The Hidden World of Fast Fashion and Second-Hand Clothes* (London: Zed Books, 2015).

Brown, Roni, 'Designing differently: the self-build home', *Journal of Design History* 21/4 (2008), pp. 359–70.

Brundtland, Gro Harlem, *Our Common Future: Report of the World Commission on Environment and Development* (1987). Available at un-documents.net/our-common-future.pdf (accessed 6 October 2016).

Buckley, Cheryl, 'On the margins: theorizing the history and significance of making and designing clothes at home', *Journal of Design History* 11/2 (1998), pp. 157–71.

Burke, Peter J. and Jan E. Stets, *Identity Theory* (Oxford: Oxford University Press, 2009).

Burnham, Scott, 'Finding the truth in systems: in praise of design-hacking', (London: RSA, 2009).

Bye, Elizabeth and Ellen McKinney, 'Sizing up the wardrobe – why we keep clothes that do not fit', *Fashion Theory* 11/4 (2007), pp. 483–98.

Cabeen, Lou, 'Home work', in Joan Livingstone and John Proof (eds), *The Object of Labor: Art, Cloth and Cultural Production* (Chicago: School of the Art Institute of Chicago Press, 2007), pp. 197–218.

Campbell, Colin, 'The meaning of objects and the meaning of actions', *Journal of Material Culture* 1/1 (1996), pp. 93–105.

———— 'The craft consumer: culture, craft and consumption in a postmodern society', *Journal of Consumer Culture* 5/1 (2005), pp. 23–42.

Campbell, Jane, 'It's a knit-in', *Independent Review*, 23 March 2004. Available at independent.co.uk/news/uk/this-britain/its-a-knitin-65547.html (accessed 6 October 2016).

Carr, Chantel and Chris Gibson, 'Geographies of making: rethinking materials and skills for volatile futures', *Progress in Human Geography* 40/3 (2016), pp. 297–315.

Carver, Courtney, 'Project 333', Be More With Less (2016). Available at http://bemorewithless.com/project-333 (accessed 21 October 2016).

Cave, Oenone, *Traditional Smocks and Smocking* (London: Mills & Boon, 1979).

Cerny, Catherine, 'Quilted apparel and gender identity: an American case study', in Ruth Barnes and Joanne B. Eicher (eds), *Dress and Gender: Making and Meaning in Cultural Context* (Oxford: Berg, 1992), pp. 106–20.

Clarke, Alison and Daniel Miller, 'Fashion and anxiety', *Fashion Theory* 6/2 (2002), pp. 191–213.

Cline, Elizabeth L., *Overdressed: The Shockingly High Cost of Cheap Fashion* (New York: Penguin, 2013).

Collins, Rebecca C., 'Excessive... but not wasteful? Exploring young people's material consumption through the lens of divestment', PhD thesis, University College London, 2013.

Cone, Ferne Geller, *Knitting for Real People* (Loveland: Interweave, 1989).

Cooper, Tim, 'Slower consumption: reflections on product life spans and the "throwaway society"', *Journal of Industrial Ecology* 9/1–2 (2005), pp. 51–67.

Cox, Christine and Jennifer Jenkins, 'Between the seams, a fertile commons: an overview of the relationship between fashion and intellectual property', conference paper, Ready to Share: Fashion and the Ownership of Creativity

(USC Annenberg School for Communication and Journalism, Los Angeles, 29 January 2005). Available at learcenter.org/pdf/RTSJenkinsCox.pdf (accessed 6 October 2016).

Craft & Hobby Association, *2012 State of the Craft Industry: Key Insights* (2012). Available at craftandhobby.org/eweb/docs/2012.State.of.the.Craft.Industy. Public.pdf (accessed 6 October 2016).

Craft Yarn Council, 'Crocheters and knitters of all ages are an active and creative group' (2014). Available at craftyarncouncil.com/sites/default/files/press/D586_ResearchOneSheet_1.pdf (accessed 6 October 2016).

Crane, Diana, *Fashion and Its Social Agendas: Class, Gender and Identity in Clothing* (Chicago: University of Chicago Press, 2000).

Crawford, Matthew, *The Case for Working with Your Hands: Or Why Office Work is Bad for Us and Fixing Things Feels Good* (London: Penguin, 2009).

Csíkszentmihályi, Chris, 'Sixteen reflective bits', in Garnet Hertz (ed.), *Critical Making: Manifestos* (Hollywood: Telharmonium Press, 2012), pp. 23–32. Available at conceptlab.com/criticalmaking (accessed 6 October 2016).

Csíkszentmihályi, Mihály, *Flow: The Psychology of Optimal Experience* (New York: HarperCollins, 1990).

——— and Eugene Rochberg-Halton, *The Meaning of Things: Domestic Symbols and the Self* (Cambridge: Cambridge University Press, 1981).

Cwerner, Saulo B., 'Clothes at rest: elements for a sociology of the wardrobe', *Fashion Theory* 5/1 (2001), pp. 79–92.

Dalton, Pen, 'Housewives, leisure craft and ideology: de-skilling in consumer craft', in Gillian Elinor, Su Richardson, Sue Scott, Angharad Thomas and Kate Walker (eds), *Women and Craft* (London: Virago, 1987), pp. 31–6.

Dant, Tim, *Material Culture in the Social World: Values, Activities, Lifestyles* (Buckingham: Open University Press, 1999).

——— 'The work of repair: gesture, emotion and sensual knowledge', *Sociological Research Online* 15/3 (2010). Available at socresonline.org.uk/15/3/7.html (accessed 6 October 2016).

Davies, Kate, 'From Muhu Island', Kate Davies Designs (12 January 2012). Available at katedaviesdesigns.com/2012/01/12/from-muhu-island (accessed 6 October 2016).

Davis, Fred, *Fashion, Culture, and Identity* (Chicago: University of Chicago Press, 1992).

Deller, Jeremy, 'A la mode', *Observer*, 15 October 2006. Available at theguardian. com/arts/features/story/0,,1920726,00.html (accessed 30 April 2016).

—— and Alan Kane, *Folk Archive: Contemporary Popular Art from the UK* (London: Book Works, 2005).

Dellot, Benedict, *Ours to Master: How Makerspaces Can Help Us Master Technology for a More Human End* (London: RSA, 2015).

de Mul, Jos, 'Redesigning design', in Bas van Abel, Lucas Evers, Roel Klaassen and Peter Troxler (eds), *Open Design Now: Why Design Cannot Remain Exclusive* (Amsterdam: BIS Publishers, 2011), pp. 34–9.

Devlin, Paul, *Restoring the Balance: The Effect of Arts Participation on Wellbeing and Health* (Newcastle upon Tyne: Voluntary Arts England, 2010).

Dissanayake, Ellen, 'The pleasure and meaning of making', *American Craft* 55/2 (1995), pp. 40–5.

Ditum, Sarah, 'Knitting offers welcome relief from fashion lust', *Guardian*, 22 February 2012. Available at theguardian.com/commentisfree/2012/feb/22/ knitting-fashion-lust (accessed 6 October 2016).

Dormer, Peter, 'The ideal world of Vermeer's little lacemaker', in John Thackara (ed.), *Design After Modernism* (London: Thames & Hudson, 1988), pp. 135–44.

DuFault, Amy, 'Using your hands to soothe the brain: part 2', *Ecosalon* (19 January 2011). Available at ecosalon.com/using-your-hands-to-soothe-the-brain-part-2 (accessed 6 October 2016).

Dundes, Alan, 'Foreword', in Philip V. Bohlman, *The Study of Folk Music in the Modern World* (Bloomington: Indiana University Press, 1988), pp. ix–x.

Dunn-Estébanez, Huelo, 'Knitting is a right, not a privilege', Work Even (2 February 2015). Available at workeven.com/2015/02/02/knitting-is-a-right-not-a-privilege (accessed 6 October 2016).

Earley, Rebecca, 'Week 1: intention setting', B.Earley (12 January 2015). Available at beckyearley.com/weekly-diary/2015/1/12/week-1-setting-my-intention (accessed 6 October 2016).

—— 'Weeks 37–41: from having, to borrowing, to being', B.Earley (20 October 2015). Available at beckyearley.com/weekly-diary/2015/10/15/ sweet-sweet-sweden (accessed 6 October 2016).

Edwards, Zoe, 'Thoughts on forgiveness', So, Zo ... What Do You Know? (20 June 2010). Available at sozowhatdoyouknow.blogspot.co.uk/2010/06/thoughts-on-forgiveness.html (accessed 10 May 2016).

Ehrenfeld, John R., 'Searching for sustainability: no quick fix', *Reflections: The SoL Journal* 5/8 (2004), pp. 1–13.

——— *Sustainability by Design: A Subversive Strategy for Transforming Our Consumer Culture* (New Haven: Yale University Press, 2008).

Elliott, Victoria, 'Competition time! #Patternhackathon', By Hand London (16 October 2014). Available at byhandlondon.com/blogs/by-hand-london/15655956-competition-time-patternhackathon (accessed 6 October 2016).

Emery, Joy Spanabel, *A History of the Paper Pattern Industry* (London: Bloomsbury, 2014).

Entwistle, Joanne, *The Fashioned Body: Fashion, Dress, and Modern Social Theory* (Cambridge: Polity, 2000).

Escobar-Tello, Carolina and Tracy Bhamra, 'Happiness and its role in sustainable design', conference paper, 8th European Academy of Design Conference (Robert Gordon University, Aberdeen, 1–3 April 2009), pp. 149–54. Available at researchgate.net/publication/256841848_Happiness_and_its_Role_in_Sustainable_Design (accessed 6 October 2016).

Euromonitor, *Apparel and Footwear in the United Kingdom: Industry Overview* (London: Euromonitor International, 2015).

Federici, Silvia, 'Feminism and the politics of the commons', The Commoner (2011). Available at commoner.org.uk/wp-content/uploads/2011/01/federici-feminism-and-the-politics-of-commons.pdf (accessed 11 August 2015).

Felsted, Andrea, 'Asda overtakes Marks and Spencer in clothing market', *Financial Times*, 14 August 2014. Available at ft.com/cms/s/0/4d90a934-23cc-11e4-be13-00144feabdc0.html (accessed 28 September 2015).

Fenn, Dominic (ed.), *Key Note Clothing & Footwear Industry: Market Review 2010*, 13th edn (Teddington: Key Note Ltd, 2010).

Fernandez, Nancy Page, 'Innovations for home dressmaking and the popularization of stylish dress', *Journal of American Culture* 17/3 (1994), pp. 23–33.

Fields, Corey D., 'Not your grandma's knitting: the role of identity processes in the transformation of cultural practices', *Social Psychology Quarterly* 77/2 (2014), pp. 150–65.

Findlay, Rosie, 'O HAI GUYZ: between personal style bloggers, their readers, and modern fashion', PhD thesis, University of Sydney, 2014.

Fine, Ben and Ellen Leopold, *The World of Consumption* (London: Routledge, 1993).

Finkelstein, Joanne, *The Fashioned Self* (Cambridge: Polity, 1991).

Fisher, Tom, Tim Cooper, Sophie Woodward, Alex Hiller and Helen Goworek, *Public Understanding of Sustainable Clothing* (London: DEFRA, 2008). Available at http://randd.defra.gov.uk/Default.aspx?Module=More&Location=None&ProjectID=15626 (accessed 26 October 2016).

———— and Janet Shipton, *Designing for Re-Use: The Life of Consumer Packaging* (London: Earthscan, 2010).

Fletcher, Kate, *Sustainable Fashion and Textiles* (London: Earthscan, 2008).

———— 'In the hands of the user: the Local Wisdom Project and the search for an alternative fashion system', *Journal of Design Strategies* 7 (2015), pp. 10–17. Available at http://sds.parsons.edu/designdialogues/?post_type=article&p=630 (accessed 6 October 2016).

———— *Craft of Use: Post-Growth Fashion* (Abingdon: Routledge, 2016).

Fletcher, Kate and Lynda Grose, 'Fashion that helps us flourish', conference paper, Changing the Change: Design, Visions, Proposals and Tools (Turin, 10–12 July 2008).

———— *Fashion & Sustainability: Design for Change* (London: Laurence King, 2011).

Ford, Felicity, *Knitsonik Stranded Colourwork Sourcebook* (Reading: Knitsonik, 2014).

Forum for the Future, *Fashioning Sustainability: A Review of the Sustainability Impacts of the Clothing Industry* (Forum for the Future, 2007). Available at forumforthefuture.org/sites/default/files/project/downloads/fashionsustain. pdf (accessed 6 October 2016).

Free Fashion Challenge, 'At Nannet's office' (15 November 2011). Link no longer working.

———— 'On the phone with Nadia' (16 November 2011). Link no longer working.

———— 'Chat with Frank' (29 November 2011). Link no longer working.

Freeman, Hadley, 'Why do people bother keeping up with fashion?', *Guardian*, 13 November 2011. Available at theguardian.com/lifeandstyle/2011/nov/13/people-bother-keeping-up-fashion (accessed 6 October 2016).

―――― 'Flares are ridiculous. Pity the desperate designers who bring them back into fashion', *Guardian*, 19 January 2015. Available at theguardian.com/fashion/2015/jan/19/flares-designers-fashion (accessed 6 October 2016).

Freeman, June, 'Sewing as a woman's art', in Gillian Elinor, Su Richardson, Sue Scott, Angharad Thomas and Kate Walker (eds), *Women and Craft* (London: Virago, 1987), pp. 55–63.

Future Museum, 'Sanquhar knitting' (2012). Available at futuremuseum.co.uk/collections/life-work/key-industries/textiles/sanquhar-knitting.aspx (accessed 8 April 2016).

Gardner, Howard, *Intelligence Reframed: Multiple Intelligences for the 21st Century* (New York: Basic Books, 1999).

Gatzen, Pascale and Otto von Busch, 'Letter from the editors', *Journal of Design Strategies* 7 (2015), pp. 5–7. Available at sds.parsons.edu/designdialogues/?post_type=article&p=629 (accessed 6 October 2016).

Gauntlett, David, *Making Is Connecting* (Cambridge: Polity, 2011).

―――― 'Platforms for creativity: introduction' (3 July 2015). Available at davidgauntlett.com/creativity/platforms-for-creativity-introduction (accessed 6 October 2016).

―――― and Amy Twigger Holroyd, 'On making, sustainability and the importance of small steps: a conversation', *Conjunctions: Transdisciplinary Journal of Cultural Participation* 1/1 (2014). Available at http://dx.doi.org/10.7146/tjcp.v1i1.18602 (accessed 26 October 2016).

Gell, Alfred, *Art and Agency: Towards an Anthropological Theory* (Oxford: Clarendon Press, 1998).

Gibson, Pamela Church, 'Redressing the balance: patriarchy, postmodernism and feminism', in Stella Bruzzi and Pamela Church Gibson (eds), *Fashion Cultures: Theories, Explorations and Analysis* (Abingdon: Routledge, 2000), pp. 349–62.

Giddens, Anthony, *Modernity and Self-Identity: Self and Society in the Late Modern Age* (Stanford: Stanford University Press, 1991).

Girard, Stefanie, *Sweater Surgery: How to Make New Things with Old Sweaters* (Beverly: Quarry Books, 2008).

González, Giana Pilar, 'Fashion codes hacked, indexed, and shared', *Journal of Design Strategies* 7 (2015), pp. 60–2. Available at sds.parsons.edu/designdialogues/?post_type=article&p=678 (accessed 6 October 2016).

Gordon, Sarah A., '"Boundless possibilities": home sewing and the meanings of women's domestic work in the United States, 1890–1930', *Journal of Women's History* 16/2 (2004), pp. 68–91.

Gracey, Faye and David Moon, *Valuing Our Clothes: The Evidence Base* (Waste & Resources Action Programme, 2012). Available at wrap.org.uk/sites/files/wrap/10.7.12 VOC- FINAL.pdf (accessed 6 October 2016).

Greer, Betsy (ed.), *Craftivism: The Art and Craft of Activism* (Vancouver: Arsenal Pulp Press, 2014).

Greer, Betsy, 'What is craftivism, anyway?', Craftivism (2015). Available at craftivism.com/what-is-craftivism-anyway (accessed 6 October 2016).

Greer, Germaine, 'Who says knitting is easy? One of my bedsocks is bigger than the other', *Guardian*, 13 December 2009. Available at theguardian.com/artanddesign/2009/dec/13/germaine-greer-knitting-cultural-olympiad (accessed 6 October 2016).

Gregson, Nicky and Vikki Beale, 'Wardrobe matter: the sorting, displacement and circulation of women's clothing', *Geoforum* 35/6 (2004), pp. 689–700.

———— and Louise Crewe, *Second-Hand Cultures* (Oxford: Berg, 2003).

Grose, Lynda, 'Future visions: making the links', conference paper, Towards Sustainability in the Fashion and Textile Industry, Copenhagen, 26–27 April 2011.

Gwilt, Alison, 'Fashion and sustainability: repairing the clothes we wear', in Alison Gwilt (ed.), *Fashion Design for Living* (Abingdon: Routledge, 2015), pp. 61–77.

Hackney, Fiona, 'Quiet activism and the new amateur: the power of home and hobby crafts', *Design and Culture* 5/2 (2013), pp. 169–93.

Harriman, Kathryn, 'Understanding the individual craftsperson: creativity in Northeast Scotland', conference paper, New Craft Future Voices: Proceedings of the 2007 International Conference (Duncan of Jordanstone College of Art and Design, Dundee, 4–6 July 2007), pp. 470–85.

Hazeldine, Tom, 'Foreword', in Andrew Hopton (ed.), *Gerrard Winstanley: A Common Treasury* (London: Verso, 2011), pp. vii–xix.

Hethorn, Janet and Connie Ulasewicz (eds), *Sustainable Fashion: Why Now? A Conversation about Issues, Practices, and Possibilities* (New York: Fairchild, 2008).

Ivarsson, Anna-Stina Lindén, Katarina Brieditis and Katarina Evans, *Second-Time Cool: The Art of Chopping Up a Sweater* (Toronto: Annick Press, 2005).

Jackson, Andrew, 'Constructing at home: understanding the experience of the amateur maker', *Design and Culture* 2/1 (2010), pp. 5–26.

Jackson, Steven J., 'Rethinking repair', in Tarleton Gillespie, Pablo J. Boczkowski and Kirsten A. Foot (eds), *Media Technologies: Essays on Communication, Materiality, and Society* (Cambridge, MA: MIT Press, 2014), pp. 221–40.

Jackson, Tim, 'Live better by consuming less? Is there a "double dividend" in sustainable consumption?', *Journal of Industrial Ecology* 9/1–2 (2005), pp. 19–36.

Johnson, Joyce Starr and Laurel E. Wilson, '"It says you really care": motivational factors of contemporary female handcrafters', *Clothing & Textiles Research Journal* 23/2 (2005), pp. 115–30.

Jones, John Chris, 'Continuous design and redesign', in John Chris Jones (ed.), *Designing Designing* (London: Architecture Design & Technology Press, 1991), pp. 190–216.

Kaiser, Susan B., *The Social Psychology of Clothing: Symbolic Appearances in Context*, revised 2nd edn (New York: Fairchild, 1997).

———— 'Minding appearances', in Joanne Entwistle and Elizabeth Wilson (eds), *Body Dressing* (Oxford: Berg, 2001), pp. 79–102.

———— 'Mixing metaphors in the fiber, textile and apparel complex: moving toward a more sustainable fashion', in Janet Hethorn and Connie Ulasewicz (eds), *Sustainable Fashion: Why Now? A Conversation about Issues, Practices, and Possibilities* (New York: Fairchild, 2008), pp. 139–64.

Karlin, Susan, 'Urban graffiti knitters are the new, cozier Christo and Jeanne-Claude', Fast Company (28 March 2011). Available at fastcompany. com/1742637/urban-graffiti-knitters-are-new-cozier-christo-and-jeanne-claude (accessed 6 October 2016).

Kenrick, Justin, 'Commons thinking', in Arran Stibbe (ed.), *The Handbook of Sustainability Literacy* (Totnes: Green Books, 2009), pp. 51–7.

Kinder Visitor Group Centre, 'Kinder mass trespass' (undated). Available at kindertrespass.com (accessed 10 May 2016).

Kinnard, Rachel, 'Disruption through download: BurdaStyle.com and the home sewing community', *Journal of Design Strategies* 7 (2015), pp. 98–104. Available at sds.parsons.edu/designdialogues/?post_type=article&p=716 (accessed 6 October 2016).

Klein, Naomi, *No Logo: Taking Aim at the Brand Bullies* (London: Flamingo, 2000).

Knott, Stephen, *Amateur Craft: History and Theory* (London: Bloomsbury, 2015).

——— 'Labour of love', *Crafts* 255 (July/August 2015), pp. 48–51.

König, René, *The Restless Image: A Sociology of Fashion* (London: Allen and Unwin, 1973).

Korn, Peter, *Why We Make Things and Why It Matters: The Education of a Craftsman* (London: Square Peg, 2015).

Kuznetsov, Stacey and Eric Paulos, 'Rise of the expert amateur: DIY projects, communities, and cultures', conference paper, 6th Nordic Conference on Human–Computer Interaction (Reykjavik, 16–20 October 2010). Available at staceyk.org/hci/KuznetsovDIY.pdf (accessed 6 October 2016).

Labour Behind the Label, 'The six items challenge 2016' (2015). Link no longer working.

Layard, Richard, *Happiness: Lessons from a New Science*, 2nd edn (London: Penguin, 2011).

Lewis, Perri, 'Pride in the wool: the rise of knitting', *Guardian*, 6 July 2011. Available at theguardian.com/lifeandstyle/2011/jul/06/wool-rise-knitting (accessed 6 October 2016).

Lewis-Hammond, Sarah, 'The rise of mending: how Britain learned to repair clothes again', *Guardian*, 19 May 2014. Available at theguardian.com/lifeandstyle/2014/may/19/the-rise-of-mending-how-britain-learned-to-repair-clothes-again (accessed 6 October 2016).

Local Wisdom, 'Alternative dress codes' (2015). Available at localwisdom.info/use-practices/view/358/citizen-of-planet-earth (accessed 6 October 2016).

Loschek, Ingrid, *When Clothes Become Fashion* (Oxford: Berg, 2009).

Luckman, Susan, *Locating Cultural Work: The Politics and Poetics of Rural, Regional and Remote Creativity* (Basingstoke: Palgrave Macmillan, 2012).

——— *Craft and the Creative Economy* (Basingstoke: Palgrave Macmillan, 2015).

Lupi, Giorgia and Stefanie Posavec, 'A week of wardrobe', Dear Data (2015). Available at dear-data.com/week-16-a-week-of-wardrobe (accessed 6 October 2016).

Lyubomirsky, Sonja, Kennon M. Sheldon and David Schkade, 'Pursuing happiness: the architecture of sustainable change', *Review of General Psychology* 9/2 (2005), pp. 111–31.

McCracken, Grant D., *Culture and Consumption: New Approaches to the Symbolic Character of Consumer Goods and Activities* (Bloomington: Indiana University Press, 1990).

McDowell, Colin, *Forties Fashion and the New Look* (London: Bloomsbury, 1997).

McFadden, David Revere, 'Knitting and lace: radical and subversive?', in David Revere McFadden, Jennifer Scanlen and Jennifer Steifle Edwards (eds), *Radical Lace and Subversive Knitting* (New York: Museum of Arts & Design, 2007), pp. 8–19.

McLean, Marcia, '"I dearly loved that machine": women and the objects of home sewing in the 1940s', in Maureen Daly Goggin and Beth Fowkes Tobin (eds), *Women and the Material Culture of Needlework and Textiles, 1750–1950* (Farnham: Ashgate, 2009), pp. 69–89.

Maher, Samantha, *Taking Liberties: The Story Behind the UK High Street* (London/Bristol: War on Want/Labour Behind the Label, 2010). Available at https://cleanclothes.org/resources/national-cccs/taking-liberties-systematic-exploitation-in-indian-garment-hub (accessed 26 October 2016).

Martin, Rosie, *How to Make a Cloak* (London: Street Stroke Hothouse Press, 2010).

———— 'Is that new season Thierry Mugler?', DIYcouture (8 March 2012). Available at diy-couture.blogspot.co.uk/2012/03/is-that-new-season-thierry-mugler.html (accessed 6 October 2016).

Max-Neef, Manfred, 'Development and human needs', in Paul Ekins and Manfred Max-Neef (eds), *Real-Life Economics: Understanding Wealth Creation* (London: Routledge, 1992), pp. 197–213.

Metcalf, Bruce, 'Craft and art, culture and biology', in Peter Dormer (ed.), *The Culture of Craft: Status and Future* (Manchester: Manchester University Press, 1997), pp. 67–82.

Meuli, Jonathan, 'Writing about objects we don't understand', in Peter Dormer (ed.), *The Culture of Craft: Status and Future* (Manchester: Manchester University Press, 1997), pp. 202–18.

Miall, Agnes, *Economy Knitting and Patchwork* (London: John Gifford, 1944).

Middleton, Jonnet, 'Mending', in Kate Fletcher and Mathilda Tham (eds), *Routledge Handbook of Sustainability and Fashion* (Abingdon: Routledge, 2015), pp. 262–74.

Miller, Daniel, *Material Culture and Mass Consumption* (Oxford: Blackwell, 1987).

—— *Stuff* (Cambridge: Polity, 2009).

Minahan, Stella and Julie Wolfram Cox, 'Stitch'nBitch: cyberfeminism, a third place and the new materiality', *Journal of Material Culture* 12/1 (2007), pp. 5–21.

Mister Jalopy, 'Owner's manifesto', Make (2005). Link no longer working.

Mitnick, Sarai, 'Introducing the wardrobe architect: crafting a small wardrobe that reflects who you are', Colette (9 January 2014). Available at blog. colettehq.com/wardrobe-architect/introducing-the-wardrobe-architect (accessed 6 October 2016).

Montgomerie, Claire, *The Yarn Palette* (London: A&C Black, 2008).

Mookychick, 'Men who knit – part 3' (3 September 2014). Available at mookychick.co.uk/how-to/arts-and-crafts/men-who-knit-part-3.php (accessed 6 October 2016).

Moseley, Rachel, 'Respectability sewn up: dressmaking and film star style in the fifties and sixties', *European Journal of Cultural Studies* 4/4 (2001), pp. 473–90.

Mrs Frugalwoods, 'What a year without clothes did for me', Frugalwoods (5 January 2015). Available at frugalwoods.com/2015/01/05/what-a-year-without-clothes-did-for-me (accessed 6 October 2016).

Murnane, Ingrid, 'Just an instruction leaflet?', Knit on the Net (2008). Link no longer working.

Murray, Margaret and Jane Koster, *Complete Home Knitting Illustrated* (London: Odhams Press, 1946).

Myzelev, Alla, 'Whip your hobby into shape: knitting, feminism and construction of gender', *Textile: The Journal of Cloth and Culture* 7/2 (2009), pp. 148–63.

National Endowment for the Arts, 'National Endowment for the Arts presents highlights from the 2012 Survey of Public Participation in the Arts' (26 September 2013). Available at arts.gov/news/2013/national-endowment-arts-presents-highlights-2012-survey-public-participation-arts (accessed 6 October 2016).

National NeedleArts Association, *The State of Specialty NeedleArts 2013: Market Summary USA* (2013). Available at tnna.org/resource/collection/386A6007-6C3F-4D15-A864-6D0DBD47FB40/TNNA-2013-Market-Summary-Final.pdf (accessed 6 October 2016).

Neeson, J. M., *Commoners: Common Right, Enclosure and Social Change in England, 1700–1820* (Cambridge: Cambridge University Press, 1993).

Neuberg, Emma, 'Foreword', in Melanie Bowles and the People's Print, *Print, Make,Wear* (London: Laurence King, 2015), pp. 6–7.

New Economics Foundation, *National Accounts of Well-Being: Bringing Real Wealth onto the Balance Sheet*, (2009). Available at nationalaccountsofwell being.org/public-data/files/national-accounts-of-well-being-report.pdf (accessed 6 October 2016).

New Materialism, The, *Manifesto for the New Materialism*, (2012). Available at thenewmaterialism.org/newmaterialismmanifesto (accessed 6 October 2016).

Office for National Statistics, *Social Trends 27* (London: Stationery Office, 1997).

—— *Retail Sales,August 2015* (17 September 2015). Available at ons.gov.uk/ons/rel/rsi/retail-sales/august-2015/index.html (accessed 6 October 2016).

Orton-Johnson, Kate,'Knit, purl and upload: new technologies, digital mediations and the experience of leisure', *Leisure Studies* 33/3 (2014), pp. 305–21.

Otto, Pat, 'About Project Minima', Project Minima (2014). Available at projectminima.blogspot.co.uk/p/about-project-minima.html (accessed 6 October 2016).

Pacey, Philip, '"Anyone designing anything?" non-professional designers and the history of design', *Journal of Design History* 5/3 (1992), pp. 217–25.

Papanek, Victor, *Design for the Real World: Human Ecology and Social Change*, 2nd edn (London:Thames & Hudson, 1984).

Parker, Rozsika, *The Subversive Stitch:Embroidery and the Making of the Feminine* (London: I.B.Tauris, [1984] 2010).

Parkins, Wendy, 'Celebrity knitting and the temporality of postmodernity', *Fashion Theory* 8/4 (2004), pp. 425–42.

—— and Geoffrey Craig, *Slow Living* (Oxford: Berg, 2006).

Partington, Angela, 'Popular fashion and working-class affluence', in Juliet Ash and Elizabeth Wilson (eds), *Chic Thrills: A Fashion Reader* (Berkeley: University of California Press, 1992), pp. 145–61.

Pearson, Michael R. R., *Traditional Knitting of the British Isles:The Fisher Gansey Patterns of North East England* (Newcastle: Esteem Press, 1980).

Peck, Sarah, 'The story of enough: giving up (new) clothes for one year', Becoming Minimalist (2014). Available at becomingminimalist.com/minimalist-enough (accessed 6 October 2016).

Penn, Eirlys, 'How I gave up clothing', Scrapiana (14 April 2014). Available at scrapiana.com/2015/04/14/gave-clothing (accessed 6 October 2016).

——— 'The big mend', Scrapiana (2016). Available at scrapiana.com/the-big-mend (accessed 6 May 2016).

——— 'The big mend's 4th birthday', Scrapiana (26 April 2016). Available at scrapiana.com/2016/04/26/big-mends-4th-birthday (accessed 6 May 2016).

——— 'Mending: the ancient art of making wHOLE', *Selvedge* 70 (May/June 2016), p. 46.

Peretti, Jacques, 'Knits his brows at a loopy trend', *Guardian Guide*, 23 March 2002. Available at castoff.info/press/pages/guardian_guide_29-3-02.html (accessed 6 October 2016).

Perry, Grayson (@Alan_Measles), 'Day 41, another view, I have to adjust to reality of it now after imagining how it would look all this time', Twitter (19 February 2015). Available at twitter.com/Alan_Measles/status/56839 0597653999616 (accessed 6 October 2016).

Pye, David, *The Nature and Art of Workmanship* (Cambridge: Cambridge University Press, 1968).

Qureshi, Huma, 'From the high life to the good life: cutting one's cloth is back in fashion', *Observer*, 25 January 2009. Available at theguardian.com/business/2009/jan/25/cooking-sewing-hen-keeping-economising-credit-crunch (accessed 6 October 2016).

Ravelry, 'Community eye candy: 5 million!' (3 February 2015). Available at blog.ravelry.com/2015/02/03/community-eye-candy-5-million (accessed 6 October 2016).

Reisch, Lucia A., 'Time and wealth: the role of time and temporalities for sustainable patterns of consumption', *Time & Society* 10/2–3 (2001), pp. 367–85.

Resnick, Mitchel and Brian Silverman, 'Some reflections on designing construction kits for kids', in *Proceedings of the 2005 Conference on Interaction Design and Children - IDC '05* (New York: ACM Press, 2005), pp. 117–22.

Reynolds, Richard, *On Guerrilla Gardening: A Handbook for Gardening Without Boundaries* (London: Bloomsbury, 2008).

Rice, Maureen, 'Dejunk your life', *Observer Magazine*, 23 January 2000. Available at theguardian.com/theobserver/2000/jan/23/newyou.life1 (accessed 6 October 2016).

Righetti, Maggie, *Sweater Design in Plain English* (New York: St Martin's Press, 1990).

Robertson, Kirsty, 'Textiles and activism', in Jessica Hemmings (ed.), *In the Loop: Knitting Now* (London: Black Dog Publishing, 2010), pp. 68–79.

Rogers, Kimberly B. and Lynn Smith-Lovin, 'Action, interaction, and groups', in George Ritzer (ed.), *The Wiley-Blackwell Companion to Sociology* (Oxford: Blackwell, 2011), pp. 121–38.

Ross, Robert, *Clothing: A Global History* (Cambridge: Polity, 2008).

Rushmore, Jenny, 'Sewing my clothes is an escape from fashion's dictates. I no longer hate my body', *Guardian*, 3 August 2015. Available at theguardian. com/commentisfree/2015/aug/03/sewing-clothes-escape-fashion-dictates-no-longer-hate-my-body (accessed 6 October 2016).

Rutt, Richard, *A History of Hand Knitting* (London: B.T. Batsford, 1987).

Ryff, Carol D. and Corey Lee M. Keyes. 'The structure of psychological well-being revisited', *Journal of Personality and Social Psychology* 69/4 (1995), pp. 719–29.

St Germaine, Tasia, 'Too much frosting, not enough cake', Sewaholic (10 April 2012). Available at sewaholic.net/too-much-frosting-not-enough-cake (accessed 6 October 2016).

Sawchuk, Kim, 'A tale of inscription/fashion statements', in Arthur Kroker and Marilouise Kroker (eds), *Body Invaders: Sexuality and the Postmodern Condition* (Basingstoke: Macmillan Education, 1988), pp. 61–77.

Schaeffer, Claire B., *Couture Sewing Techniques* (Newton: Taunton Press, 2007).

Searle, Beverley A., *Well-Being: In Search of a Good Life?* (Bristol: Policy Press, 2008).

Sennett, Richard, *The Craftsman* (London: Penguin, 2008).

Shercliff, Emma, 'A poetics of waste: evaluating time and effort spent sewing', *Making Futures* 1 (2009), pp. 186–97. Available at mfarchive.plymouthart. ac.uk/journalvol1/papers/emma-shercliff.pdf (accessed 6 October 2016.

——— 'Hidden values in human inconsistencies: ways in which hand skills enable prized encounters between matter and thought', paper presented at TRIP: An International Symposium Exploring the Role and Relevance of Traditional 'Hand Skills' in Contemporary Textiles, and the Value and Status of Craft Process (Loughborough University, 16–17 November 2011).

——— and Amy Twigger Holroyd, 'Making with others: working with textile craft groups as a means of research', *Studies in Material Thinking* 14 (2016),

Paper 07, pp. 3–17. Available at materialthinking.org/sites/default/files/papers/0176_SMT_V14_P07_FA.pdf (accessed 5 May 2016).

Simmel, Georg, 'Fashion', *International Quarterly* 10 (1904), pp. 130–55.

Simon, Herbert Alexander, *The Sciences of the Artificial*, 3rd edn (Cambridge, MA: MIT Press, 1996).

Singer, Maya, 'Hear us roar: finding feminism in fashion', *Vogue* (5 September 2014). Available at vogue.com/13268564/finding-feminism-in-fashion (accessed 6 October 2016).

Snyder, Charles R. and Harold L. Fromkin, *Uniqueness* (New York: Plenum, 1980).

Souveny, Matt, '1 year 1 outfit – 365 days all done', This Stylish Life (2015). Available at thisstylishlife.com/1-year-1-outfit-365-days-all-done (accessed 6 October 2016).

Stalp, Marybeth C., *Quilting: The Fabric of Everyday Life* (Oxford: Berg, 2008).

Stevens, Dennis, 'Validity is in the eye of the beholder: mapping craft communities of practice', in Maria Elena Buszek (ed.), *Extra/ordinary: Craft and Contemporary Art* (Durham: Duke University Press, 2011), pp. 43–58.

Stitchlinks, 'Guide to our theories so far' (April 2008). Available at stitchlinks.com/pdfsNewSite/research/Our%20theories%20so%20far%20New_%20unshuffled%20watermarked_4.pdf (accessed 6 October 2016).

———— 'Where are we now?'. Available at stitchlinks.com/research.html (accessed 6 October 2016).

Sundbø, Annemor, *Everyday Knitting: Treasures from a Ragpile* (Norway: Torridal Tweed, 2000).

Szczelkun, Stefan, *The Conspiracy of Good Taste* (London: Working Press, 1993).

Szeless, Margarethe, 'Burda fashions – a wish that doesn't have to be wishful thinking: home-dressmaking in Austria 1950–1970', *Cultural Studies* 16/6 (2002), pp. 848–62.

Szwed, John, *The Man Who Recorded the World* (London: Arrow Books, 2010).

Taylor, Lou, 'State involvement with peasant crafts in East/Central Europe 1947–97: the cases of Poland and Romania', in Tanya Harrod (ed.), *Obscure Objects of Desire: Reviewing the Crafts in the Twentieth Century* (London: Crafts Council, 1997), pp. 53–65.

Thackara, John, 'A whole new cloth: politics and the fashion system', in Kate Fletcher and Mathilda Tham (eds), *Routledge Handbook of Sustainability and Fashion* (Abingdon: Routledge, 2015), pp. 43–51.

Transition Town Totnes, 'What is resilience?' Available at transitiontowntotnes. org/about/what-is-transition/what-is-resilience/ (accessed 6 October 2016).

Tseëlon, Efrat, *The Masque of Femininity: The Presentation of Woman in Everyday Life* (London: Sage, 1995).

Tulloch, Carol, 'There's no place like home: home dressmaking and creativity in the Jamaican community of the 1940s to the 1960s', in Barbara Burman (ed.), *The Culture of Sewing: Gender, Consumption and Home Dressmaking* (Oxford: Berg, 1999), pp. 111–28.

Turney, Jo, 'Here's one I made earlier: making and living with home craft in contemporary Britain', *Journal of Design History* 17/3 (2004), pp. 267–82.

——— *The Culture of Knitting* (Oxford: Berg, 2009).

——— 'Fashion's victim', *Crafts* 222 (January/February 2010), pp. 46–9.

Twigger Holroyd, Amy, 'Folk fashion: amateur re-knitting as a strategy for sustainability', PhD thesis, Birmingham City University, 2013. Available at bit.ly/folk-fashion (accessed 21 October 2016).

——— *Keep & Share: The First Ten Years* (Leeds: Keep & Share, 2014). Available at keepandshare.co.uk/sites/default/files/downloads/Keep-and-Share-the-first-ten-years.pdf (accessed 5 May 2016).

Tzanidaki, Despina and Frances Reynolds, 'Exploring the meanings of making traditional arts and crafts among older women in Crete, using interpretative phenomenological analysis', *British Journal of Occupational Therapy* 74/8 (2011), pp. 375–82.

UK Hand Knitting Association, 'About us' (2015). Available at ukhandknitting. com/about-us (accessed 6 October 2016).

voc 20, 'Sustainable style', *View on Colour* 20 (2002), p. 54.

von Busch, Otto, *Fashion-Able* (Gothenburg: Camino, 2009).

Walker, Barbara, *Knitting from the Top* (New York: Charles Scribner's Sons, 1972).

Walker, Stuart, *Sustainable by Design: Explorations in Theory and Practice* (London: Earthscan, 2006).

Wallop, Harry, 'The secret life of your charity shop cast-offs', *Telegraph*, 12 July 2014. Available at telegraph.co.uk/finance/newsbysector/retailandconsumer/ 10961849/The-secret-life-of-your-charity-shop-cast-offs.html (accessed 6 October 2016).

Wark, McKenzie, 'Making New York', in Garnet Hertz (ed.), *Critical Making: Places* (Hollywood: Telharmonium Press, 2012), pp. 1–7. Available at conceptlab.com/criticalmaking (accessed 6 October 2016).

Wehr, Kevin, *DIY: The Search for Control and Self-Reliance in the 21st Century* (Abingdon: Routledge, 2012).

West, Tom, 'What my knitting means to me', Not So Granny (20 August 2014). Available at notsogranny.com/2014/08/what-my-knitting-means-to-me-tom-west.html (accessed 26 October 2016).

Whiting, Maggie, *The Progressive Knitter* (London: B.T. Batsford, 1988).

Williams, Amanda and Joshua Tanenbaum, 'Palettes, punchcards and politics: beyond practicality and hedonism', in Garnet Hertz (ed.), *Critical Making: Terms* (Hollywood: Telharmonium Press, 2012), pp. 1–8. Available at conceptlab.com/criticalmaking (accessed 6 October 2016).

Williams, Dilys, Nina Baldwin and Kate Fletcher, *Tactics for Change* (London: Centre for Sustainable Fashion, 2009). Available at ualresearchonline.arts.ac.uk/2751/1/CSF_Volume_3_Tactics_for_Change.pdf (accessed 6 October 2016).

Williams, Rhiannon, 'How to kiss: the most Googled questions', *Telegraph*, 28 October 2014. Available at telegraph.co.uk/technology/google/11192191/How-to-kiss-the-most-Googled-questions.html (accessed 6 October 2016).

Wilson, Elizabeth, *Adorned in Dreams: Fashion and Modernity* (Berkeley: University of California Press, 1987).

Winkler, Fredericke, 'Fashion is bad for your health', *J'N'C* 1/12 (2012), pp. 59–63.

Woodward, Sophie, *Why Women Wear What They Wear* (Oxford: Berg, 2007).

Zimmermann, Elizabeth, *Knitting Without Tears* (New York: Fireside, 1971).

Index